THE PRADO

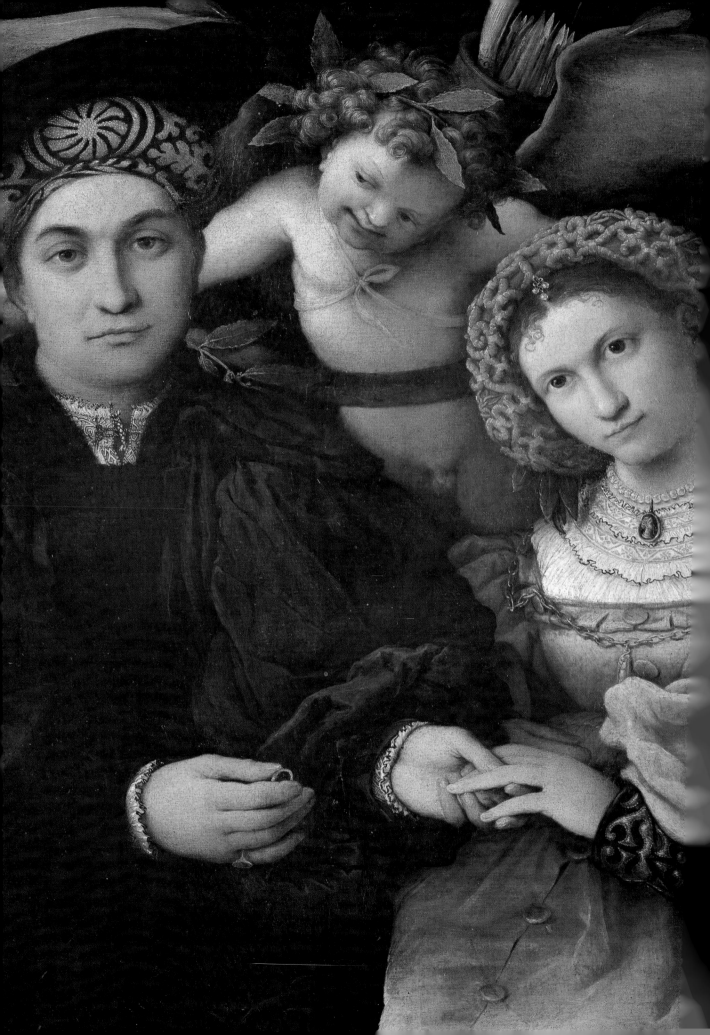

THE PRADO

ALFONSO E. PÉREZ SÁNCHEZ
MANUELA MENA MARQUÉS
JUAN J. LUNA
JOAQUÍN DE LA PUENTE
MATÍAS DÍAZ PADRÓN

SCALA

© Scala Publishers Ltd, 2000

Fully revised by Juan J. Luna, 1998

First published in 2000 by
Scala Publishers Ltd
143–149 Great Portland Street
London WIN 5FB

Distributed in the USA and Canada by
Antique Collectors' Club
Market Street Industrial Park
Wappingers Falls, NY 12590

ISBN 1 85759 208 5

Translation from the Spanish revised by
Joanna Martinez
Designed by Anikst Design
Edited by Moira Johnston
Photographs by Gonzalo de la Serna
Printed in Spain by KSG Elkar

All the photographs in this book are credited to
Gonzalo de la Serna, with the exception of those
supplied by the archives listed below:

© Museo el Prado, Madrid, pp. 8, 12, 15, 20, 21
(3), 22 (3), 26 (1, 3), 27 (5), 33, 34, 41 (2, 4), 46–7
(2, 3), 48, 52, 60, 69 (3), 72 (1), 75 (2), 77 (3), 81,
83, 97, 101, 102 (2), 103, 109, 112 (2), 121–2, 131,
138, 144, 149, 154, 156 (2), 159 (3), 166 (2),
167–8, 170 (1, 3), 171 (4), 174, 176, 182, 184–5,
189, 190–1 (3), 197 (3, 4), 198 (2), 201, 212–13
(2), 217, 222 (2), 226 (2), 228 (1, 3), 229, 233,
238–9, 241, 243 (5, 6), 246, 249 (3), 250, 252
(2), 253.
© Oronoz, pp. 25 (3), 35, 47 (4), 75 (1), 76, 80,
111 (2, 4), 115 (2), 163 (5), 193, 220 (1), 228 (2),
242 (2), 243 (7), 244, 252 (1).

Frontispiece illustration: Lorenzo Lotto, *Signor
Marsilio and his Wife* (detail), 1523

CONTENTS

1775 Charles III commissions the architect Juan de Villanueva to draw up the initial plans for a Natural History Museum.

1809 Joseph Bonaparte issues a royal decree with the aim of founding a Museum of Painting.

1810 Royal decree by Joseph Bonaparte establishing a painting gallery in the Buenavista Palace, originally owned by the Duchess of Alba and later by Godoy, Prime Minister under Charles IV.

1811 Death of Juan de Villanueva, when the construction of the Prado is almost finished. The French occupying forces convert the building into stables during the Peninsular Wars (1808–13). The lead roof is removed for use as war material and is later replaced by tiles.

1814 At the suggestion of Queen María Isabel de Braganza and Isidoro Montenegro, Ferdinand VII decides to set up a gallery in the empty building.

1818 Founding of the Royal Museum.

1819 Official opening of the Royal Museum by Ferdinand VII.

1819–29 A considerable part of the royal collection is transferred to the Prado.

1829 The Duke of San Fernando makes the first donation: *Christ Crucified* by Velázquez.

1835 Disentailment of the Church's properties by Mendizábal. Many paintings are taken from churches and monasteries to the convent of La Trinidad, which becomes a temporary art gallery and eventually the Museo de la Trinidad.

1938 Because of the threat by the Carlist army, a large number of paintings from the Escorial and other palaces around Madrid are taken to the Prado.

1843 1,949 works are listed in the catalogue of the Prado.

1868 The Royal Museum is nationalized after Isabella II is deposed.

1879–2 The entire collection from the Museo de la Trinidad, together with Goya's tapestry cartoons from the Royal Palace in Madrid, are transferred to the Prado.

1881 Donation of Goya's 'Black Paintings' by Baron d'Erlanger.

1883–9 The building is enlarged and new rooms are opened.

1889 Donation of over 200 pictures by the Duchess of Pastrana.

1898 With the inauguration of the Museum of Modern Art, most of the nineteenth-century works in the Prado were transferred there.

1912 The Museum's Board of Trustees is set up.

1914–30 Further rooms are added to the building.

1915 A number of important paintings are bequeathed to the Museum by Pablo Bosch.

1930 A further collection of significant paintings is bequeathed by Don Pedro Fernández Durán.

1936–9 Pablo Picasso is the Director of the Prado. The principal paintings are removed during the Civil War and, with

the help of an International Council set up to protect important works of art in Spain, are sent to Switzerland via Valencia.

1939 Exhibition at the Museum of Art and History in Geneva of a selection of paintings from the Prado. The pictures sent to Switzerland are returned to Spain.

1940 Donation of an exceptional collection of paintings by Don Francisco Cambó.

1955–6 Further extensions to the building.

1969 Celebration of the Prado's 150th anniversary, with the opening of new rooms.

1971 The Casón del Buen Retiro becomes part of the Prado Museum and houses the nineteenth-century section.

1976 Start of the renovation of Juan de Villanueva's building.

1980 The first air-conditioned rooms are opened. The Friends of the Prado foundation is established. Publication of the first issue of the *Boletín del Museo del Prado,* initially planned on a quarterly basis.

1981 The Picasso legacy, with its centrepiece *Guernica,* arrives at the Prado. This and other bequests of twentieth-century art, together with a number of nineteenth-century pieces, are later transferred to the Centro de Arte Reina Sofía between 1993 and 1995.

1982 The 'El Greco' and 'Murillo' exhibitions form the start of a programme of large exhibitions, to be followed later by those dedicated to Velázquez and Goya and many other artists of the Spanish and foreign schools.

1985 The Prado Museum becomes an independent institution under a Royal Board of Trustees. The Villahermosa Palace is annexed to the Prado, housing a section of the Museum dedicated to Goya and eighteenth-century painting.

1986 The various departments of the Museum are set up.

1988 The Villahermosa Palace is separated from the Prado, to be used as a different type of museum.

1990–6 Publication of the three volumes of the Inventory of Paintings.

1991 The Manuel Villaescusa bequest is handed over, consisting of a large sum of money, possessions and properties.

1992 The renovation work is completed.

1994 Celebration of the 175th anniversary of the opening of the Museum.

1996 Amendments to the royal decree establishing the Prado as an independent entity. Start of the renovation of the roof of Juan de Villanueva's building.

1998 Closure of the Casón del Buen Retiro for complete refurbishment.

1999 Presentation of the first phase of the plans to enlarge the Museum, which will consist of five buildings: the Juan de Villanueva building, the Casón del Buen Retiro, a modern office building (1959), a new building that will include the cloister of the nearby church of the Jerónimos, and the Armed Forces Museum containing the refurbished Hall of the Kingdoms from the old Buen Retiro Palace.

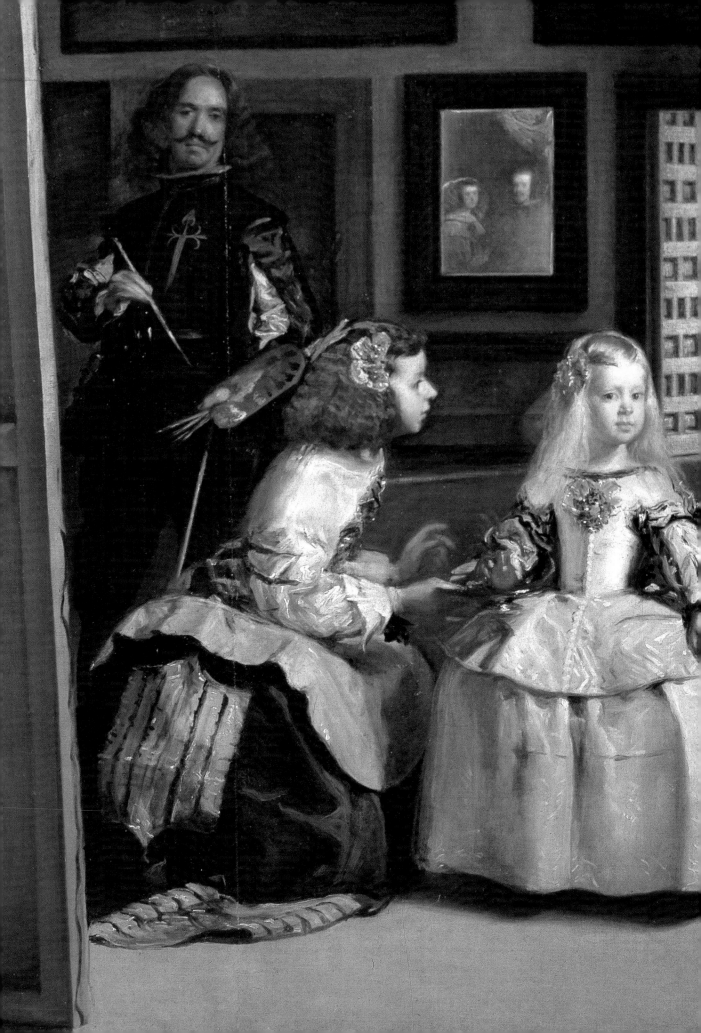

Diego Velázquez da Silva
Las Meninas, 1656 (detail)

INTRODUCTION

The Prado owes its existence to the Spanish monarchy's love of art, for it is the royal collection that is the backbone of the museum, and the Spanish collection its core. This is the reason for the presence of so many artists connected with the court – painters and official portraitists from Sánchez Coello at the court of Philip II to Goya at the court of Charles IV, and throughout the nineteenth century from Vicente López onwards. The court also acquired many paintings by artists who were in fashion even though they worked far from Madrid. This was the case with Queen Isabel Farnese, who sought out works by Murillo in Seville in 1729 and managed to obtain a number of his paintings. However, the work of the regional schools and medieval religious painters were poorly represented in the royal collections, either because they had no connections with the court or else were not yet fully appreciated.

When the contents of the Museo de la Trinidad were incorporated into the Royal Museum in 1872, the Prado received many religious works of the Madrid and Toledo Schools along with a number of important 'Primitives'. However, there were still large gaps in its collections and it is only recently that these have begun to be filled. It was not until 1946, for example, that any Romanesque paintings were hung in the Prado, although Romanesque art had figured prominently in the museum in Barcelona since 1926. In recent years Castilian, Andalusian, Aragonese, Catalan and Valencian Primitives have been acquired. Similarly, as a result of purchases and donations over the last 50 years, some outstanding examples of the Baroque schools of Valencia, Córdoba, Granada, Seville and other regions have been added. The growing interest in Spanish eighteenth-century art has led to the acquisition of works from this period, and a similar policy has been followed with respect to the nineteenth century, the number of paintings from which has increased considerably.

FROM THE PRIMITIVES
TO EL GRECO

The frescos from the chapels of San Baudilio de Berlanga and Santa Cruz de Maderuelo, the oldest works at the Prado, are excellent examples of the severe figurative order of the Spanish Romanesque, filled with Byzantine and oriental allusions, and with an almost abstract inclination towards plain tones and linear repetition. Over the last few decades other works have been added, mainly altar panels, that illustrate the move towards a more emotive form of pictorial narrative in the thirteenth century – notably one altar front representing St Stephen and an altarpiece depicting St Christopher. The tone is already Gothic, though they still have the simple forms and outlines of the Romanesque. The Gothic world is represented at the Prado by several excellent altarpieces in the International Gothic style, which are a blend of Sienese and French motifs in a delightful play of calligraphic forms, elegant postures and lively details that bring an atmosphere of chivalry and romance to religious narrative. Works such as the Catalan panels by the Serra brothers and the large altarpiece by Nicolás Francés date from this period of outstanding elegance.

From the second half of the fifteenth century, the influence of Flemish realism, originating with the Van Eycks, had a considerable impact on Spanish painting and contributed to the formation of the first Spanish artists of international renown. The implacable objectiveness of such painters as Jan van Eyck and Robert Campin resulted in a poetical, almost expressionist, spirit in the work of certain Spanish artists. However, their vigour and harshness, together with the oriental profusion of gold, link them unquestionably to the Primitive masters. The Prado possesses a number of outstanding anonymous works, as well as important panels by two of the greatest masters of this period, Fernando Gallego from Castile, and Bartolomé Bermejo from Córdoba who worked in Aragon.

Pedro Berruguete, who also owed much to the Flemish influence that predominated at the time in Castile, is in a class of his own. His visit to Italy at the height of the Renaissance brought him in contact with the work of Piero della Francesca and Melozzo da Forlì, aroused in him a new awareness of space and pattern, and led him to adopt decorative details from the language of classical motifs that opened the way to the Renaissance in Castile. There was a parallel revolution elsewhere in Spain, perhaps accelerated by the presence of Italian artists. In Valencia, for example, the anonymous Master of the Knight of Montesa, who was most probably the Italian Paolo de San Leocadio, represented one further step in the triumph of the new style.

In the first few years of the sixteenth century in Valencia, coinciding with this tentative introduction of new elements, we find the work of Fernando Yáñez de la Almedina with its vivid echoes of the art of Leonardo da Vinci combined with a typically Venetian wealth of colour. Among other paintings by Yáñez at the Prado is the exquisite *St Catherine*. However, the century that began so promisingly failed later to produce anything comparable and remains one of the least distinguished periods in the entire history of Spanish painting. In fact, the Prado has almost no examples of Andalusian painting, which particularly in the second half of the century had close affinities with Italian art. Nevertheless, this period is represented by Pedro Machuca, who studied in Italy and absorbed many of the subtleties of Mannerism. More or less his contemporaries were the Valencian artists Vicente Masip and his son Juan de Juanes, whose work reflects the Florentine and Roman forms of the High Renaissance – pure and lucid in the father's work, gentler in the son's.

During the same period, Luis de Morales from Extremadura formed his own personal style incorporating elements of Da Vinci and of Flemish art. Meanwhile, at the court of Philip II, the arrival of the Dutch painter Anthonis Mor van Dashorts (known in Spain as Antonio Moro) played a large part in the creation of the school of official portrait painters, of whom Sánchez Coello was the most distinguished. Portraits by this artist combine a consistently objective style with a sombre elegance in the pose of the sitters, while they also show a certain Venetian influence. Coello left a considerable stylistic legacy to his successors – notably Pantoja de la Cruz and Bartolomé González – which was to continue almost until the time of Velázquez.

El Greco was also painting at this time, in Toledo, though he was somewhat isolated from court circles. He had arrived in Spain in 1577, perhaps attracted by the chance of working on the decorations at the Escorial. He failed to produce any paintings for the monastery, although it does contain his extraordinary *Martyrdom of St Maurice*, commissioned by Philip II but subsequently rejected despite the generous remuneration. In the intellectual, passionate and somewhat pessimistic milieu of Toledo, El Greco created a highly personal pictorial world of an unequalled Mannerist intensity, for which he was acclaimed as one of the most original artists in his adopted country. The royal collection contained several portraits by him, which we know were held in high esteem by Velázquez. When the paintings from the Museo de la Trinidad were transferred to the Prado, several religious compositions by El Greco were added, and subsequent acquisitions and donations have made the Prado a haven for the study of the work of this great Cretan artist.

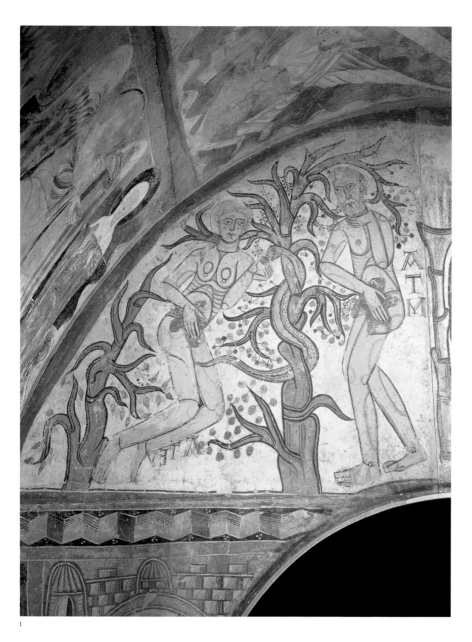

I

2

I
Mural paintings from the chapel of Santa Cruz, Maderuelo (Segovia)
The Creation of Adam.
The Original Sin
The anonymous artist was active in Catalonia and Castile in the mid-twelfth century
Fresco transferred to canvas
Installation, 498 × 430 cm
Entered the Prado in 1947

2
Anonymous Catalan artist
Late thirteenth century
Altar frontal from Guills
Panel, 92 × 175 cm
From the church of Sant Esteve, Guills (Girona)
Acquired in 1963
Cat. no. 3055

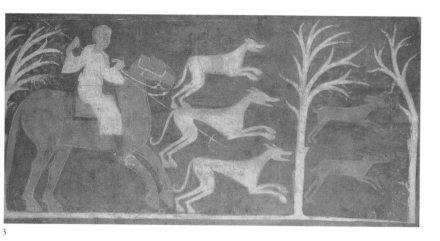

3

3
Anonymous master,
known as the **Master of Berlanga**
Active in Soria in the early twelfth
century
A Huntsman
Fresco transferred to canvas
290 × 134 cm
From the chapel of San Baudilio,
Berlanga; on permanent loan
from the Metropolitan Museum
of Art, New York
Entered the Prado in 1957
No catalogue number

4
Anonymous master
of the Castilian School
Active in Castile during the
fourteenth century
Altarpiece showing *St Christopher*
and the Infant Jesus, The Deposition,
and Scenes from the Lives of St
Peter, St Blaise and St Millan
Panel, 207 × 149 cm
Donated in 1969 by Don José Luis
Várez Fisa
Cat. no. 3150

Rodríguez de Toledo
Active in Castile during the first
quarter of the fifteenth century
Panel, 150 3 82 cm, from an altar-
piece depicting *The Virgin and
Child with Angels, Dominican
Saints, Ferdinand IV of Aragon and
Archbishop Sancho de Rojas*
From the chapel at the monastery
of San Benito, Valladolid
Entered the Prado in 1929
Cat. no. 1321

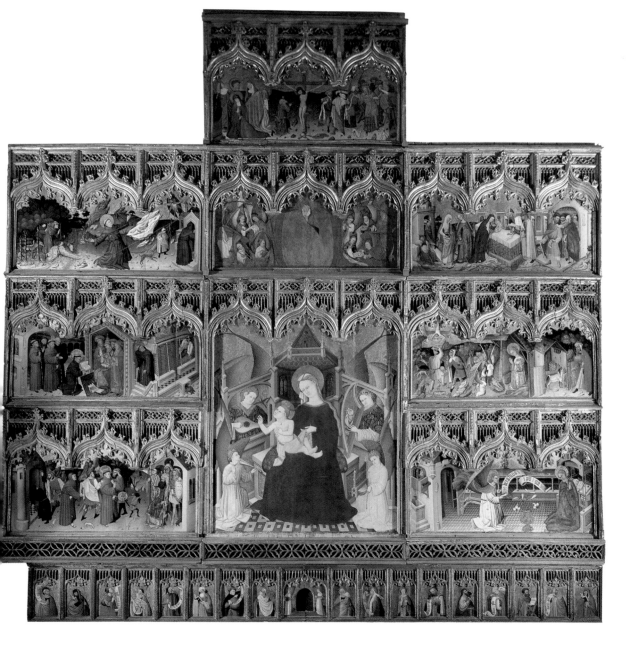

Nicolás Francés
Active in León from before
1424 to 1468, the year of his death
Altarpiece, showing *Scenes from
the Life of the Virgin and St Francis*
Panel, 557 × 558 cm
From the chapel of La Esteva de
Las Delicias, La Bañeza, León
Entered the Prado between 1930
and 1932
Cat. no. 2545

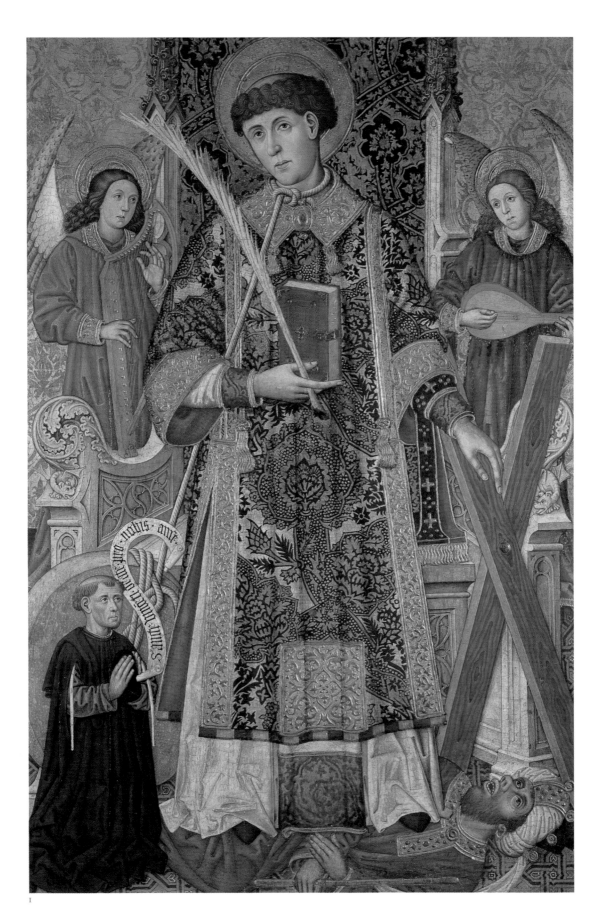

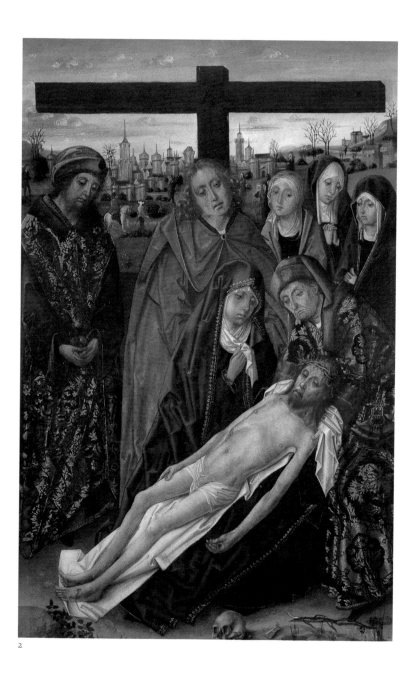

2

1
Tomás Giner
Active in Aragon during the
second half of the fifteenth century
(1454–80)
*St Vincent, Deacon and Martyr,
with a Donor*
Panel, 185 × 117 cm
From the archdeacon's chapel in
Zaragoza Cathedral
Entered the Prado in 1920
Cat. no. 1334

2
Hispano-Flemish master,
known as the **Master of the chapel
of Alvaro de Luna**
Active during the last quarter of
the fifteenth century
*The Burial of Christ (Seventh Sor-
row of the Blessed Virgin Mary)*,
*c.*1488/90
Panel, 105 × 71 cm
From the Museo de la Trinidad
Cat. no. 2425

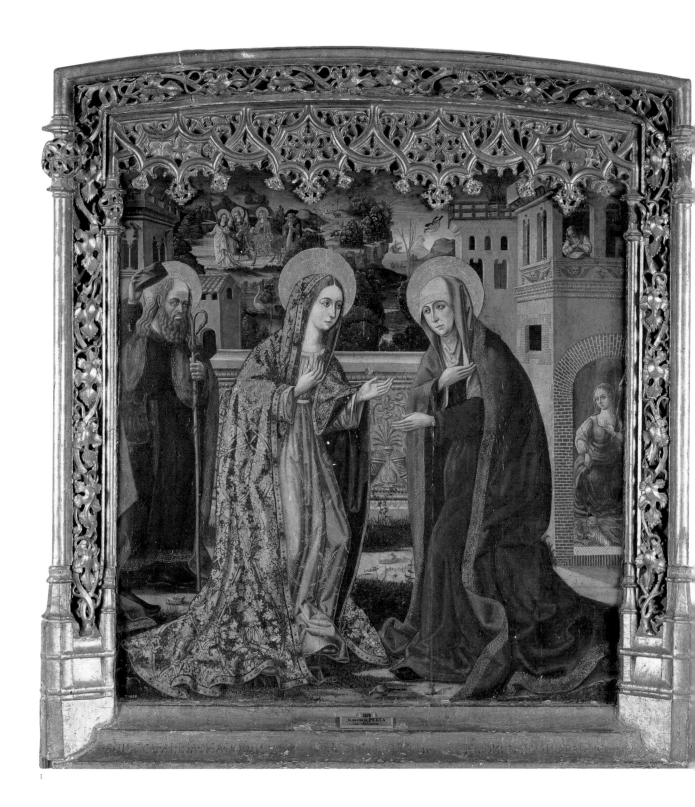

I

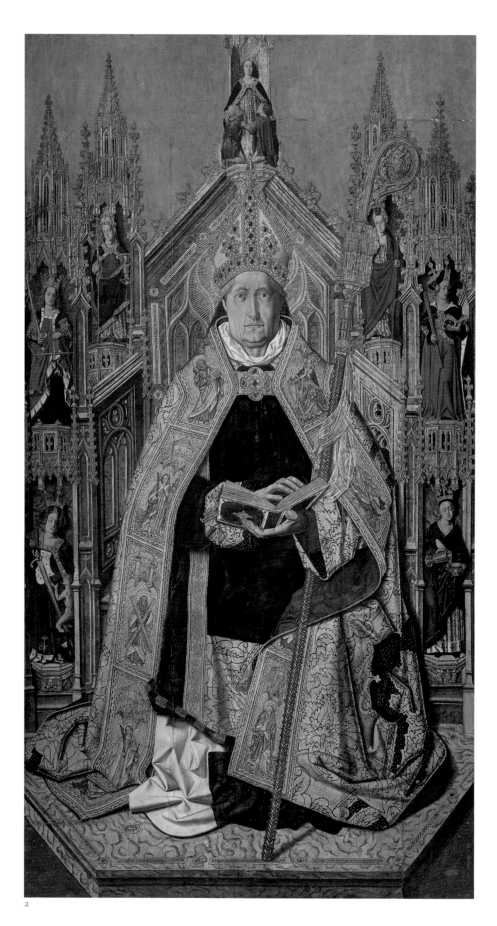

Valencian master,
known as the **Master of Perea**
active towards the end of the
fifteenth century
The Visitation
Panel, 126 × 155 cm
Bequeathed by Don Pablo Bosch
in 1915
Cat. no. 2678

Bartolomé Bermejo
Born in Córdoba; active between
1474 and 1495
St Dominic of Silos, c.1474/7
Panel, 242 × 130 cm
Entered the Prado in 1920
Cat. no. 1323

2

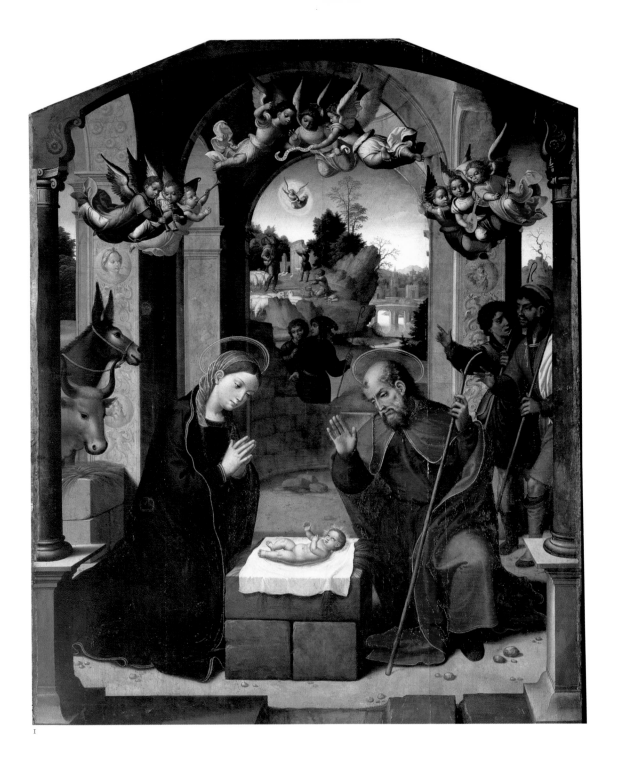

1

1
Juan Correa de Vivar
Died 1566 in Toledo
*The Adoration of the Child, c.*1533/5
Panel, 228 × 183 cm
Probably from the monastery
of Guisando, Avila
Cat. no. 690

2
León Picardo
Active in Burgos between 1514
and 1530; died 1547
*The Presentation of the Child Jesus
in the Temple*
Panel, 170 × 139 cm
From the monastery of Támara,
Palencia
Acquired in 1947
Cat. no. 2172

3
Pedro Berruguete
Born *c.*1450 in Paredes de Navas (?);
died before 1504
*St Dominic Guzmán presiding
over an Auto de Fe*
Panel, 154 × 92 cm
From the church of Santo Tomás,
Avila
Acquired in 1867
Cat. no. 618

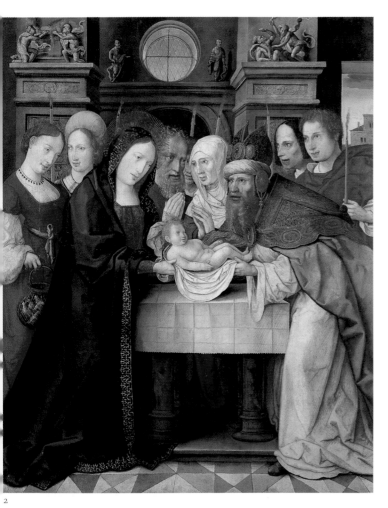

2

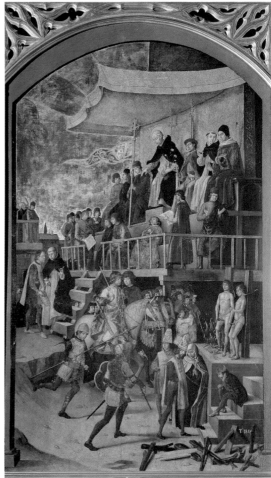

3

4

Fernando Gallego
Active between 1466 and 1507
Pietà
Panel, 118 × 102 cm
From the Weibel collection, Madrid
Acquired in 1959
Cat. no. 2998

This work, signed by Fernando
Gallego, shows very clearly the
influence of fifteenth-century
Flemish painting. It is particularly
apparent in the very rigid body of
Christ, in the Virgin's sorrowful
expression, and also in the land-
scape, with its carefully depicted
town. The fanciful rock forma-
tions and the diminutive donors
are not specifically Flemish but
typical of the altarpieces produced
throughout Europe in the late
Middle Ages.

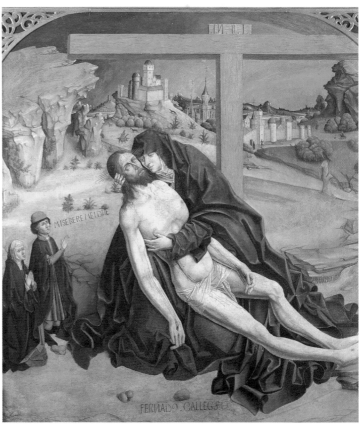

4

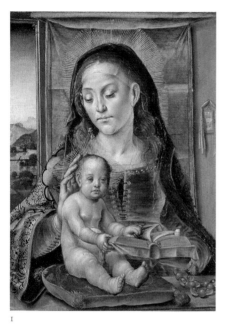

1

2

3

1
Pedro Berruguete
Born c.1450 in Paredes de Navas
(?); died before 1504
The Virgin and Child
Panel, 58 × 43 cm
Bequeathed by
Don Pablo Bosch in 1915
Cat. no. 2709

2
Alejo Fernández
Córdoba, c.1475–Granada,
c.1545/6
The Scourging of Christ at the Pillar
Panel, 42 × 35 cm
In the collection of Queen Isabel
Farnese by 1746
Cat. no. 1925

3
Juan Sánchez de San Román
Active in Seville in the late
fifteenth and early sixteenth
centuries
Christ the Man of Sorrows, c.1500
Panel, 45 × 30 cm
Acquired in 1987
Cat. no. 7289

4
Vicente Juan Masip,
known as **Juan de Juanes**
Fuente La Higuera (?)
1523–Bocairente, 1579
The Last Supper (Institution of the Eucharist)
Panel, 116 × 191 cm
From the church of San Esteban,
Valencia
Charles IV collection
Removed by Joseph Bonaparte
Entered the Prado in 1818
Cat. no. 846

5
Vicente Masip
Born c.1475; died in Valencia, 1545
The Visitation
Panel, 60 cm diameter
From the convent of San Julián,
Valencia
Later in the collection of the
Marquis of Jura Real
Acquired in 1826
Cat. no. 851

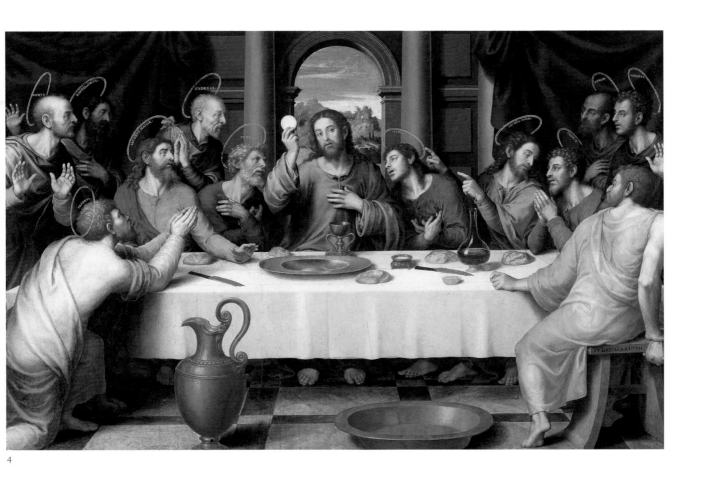

4

5

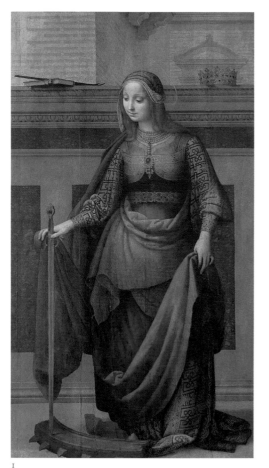

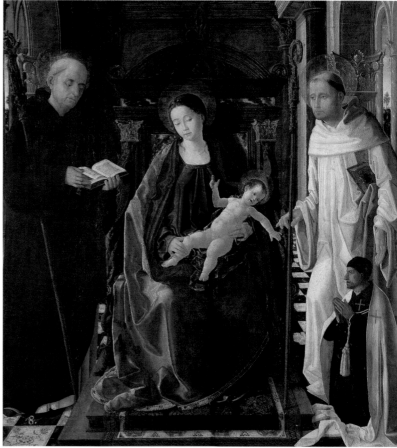

1

Fernando Yáñez de la Almedina
Active between 1501 and 1531 in
Valencia
St Catherine of Alexandria
Panel, 212 × 112 cm
From the collection of the
Marquis of Casa-Argudín
Acquired in 1946
Cat. no. 2902

2

Paolo de San Leocadio
(formerly known as the **Master of
the Knight of Montesa**)
Born in Italy; active between 1472
and 1514 in Valencia
*The Virgin and Child (The Virgin
of the Knight of Montesa)*
Panel, 102 × 96 cm
Acquired in 1919
Cat. no. 1335

3

Pedro Machuca
Toledo, late fifteenth century;
died in Granada, 1550
The Descent from the Cross
Panel, 141 × 128 cm
(including frame)
Acquired in 1961
Cat. no. 3017

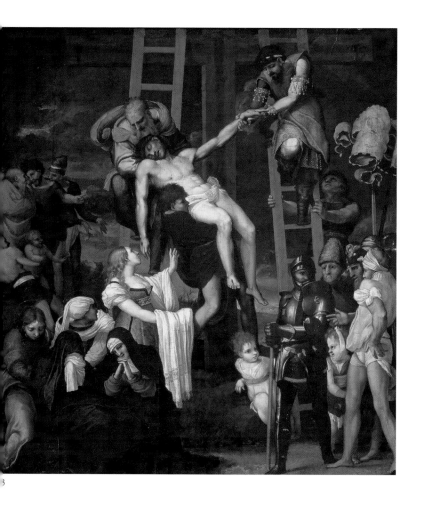

4
Luis de Morales,
known as **El Divino**
Badajoz, c.1500–86
St Stephen
Panel, 67 × 50 cm
Donated in 1915 by the
descendants of the Countess
of Castañeda
Cat. no. 948

5
Luis de Morales,
known as **El Divino**
Badajoz, c.1500–86
The Virgin and Child
Panel, 84 × 64 cm
Bequeathed by Don Pablo Bosch
in 1915
Cat. no. 2656

4

5

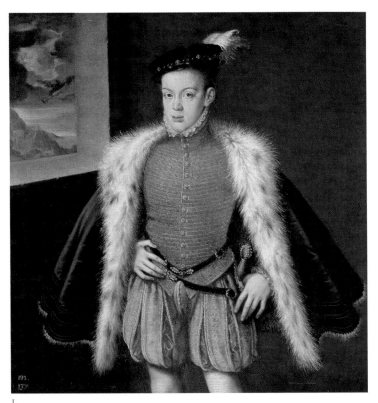

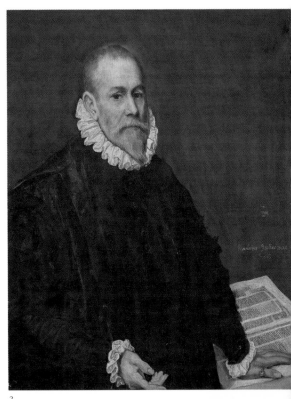

1

2

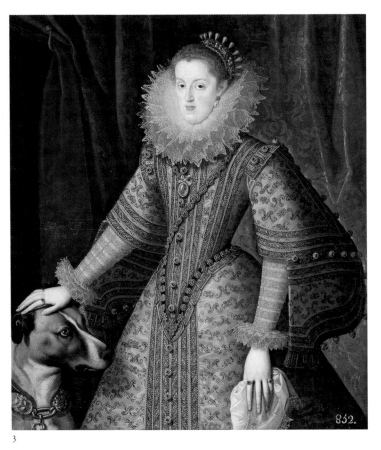

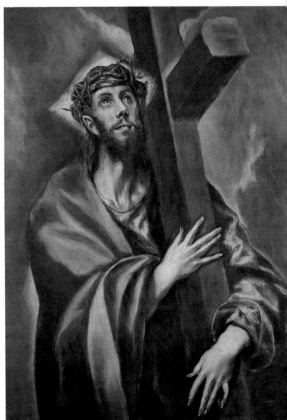

3

4

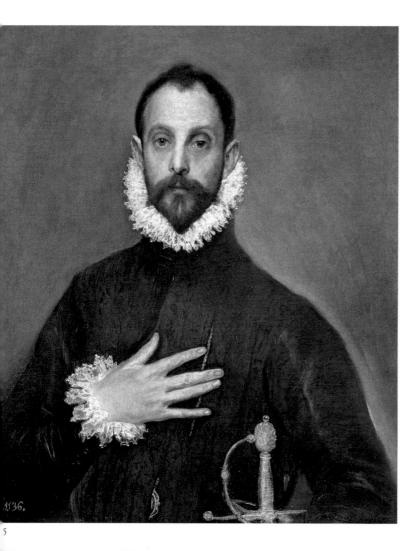

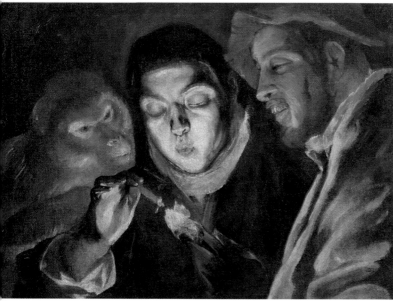

1
Alonso Sánchez Coello
Valencia, c.1531/32–Madrid, 1588
Prince Charles of Austria
Canvas, 109 × 95 cm
Philip II collection
Cat. no. 1136

2
Domenikos Theotokopoulos,
known as **El Greco**
Kameia, c.1540/1–Toledo, 1614
Doctor Rodrigo de la Fuente (?),
before 1598
Canvas, 93 × 82 cm
Philip IV collection
Cat. no. 807

3
Bartolomé González
Valladolid, 1564–Madrid, 1627
Queen Margarita of Austria, 1609
Canvas, 116 × 100 cm
Provenance unknown
Cat. no. 716

4
Domenikos Theotokopoulos,
known as **El Greco**
Kameia, c.1540/1–Toledo, 1614
Christ Carrying the Cross,
c.1600/10
Canvas, 108 × 78 cm
Entered the Prado in 1877
Cat. no. 822

5
Domenikos Theotokopoulos,
known as **El Greco**
Kameia, c.1540/1–Toledo, 1614
*Portrait of a Nobleman with his
Hand on his Chest*, c.1577/84
Canvas, 81 × 66 cm
Royal collection
Cat. no. 809

6
Domenikos Theotokopoulos,
known as **El Greco**
Kameia, c.1540/1–Toledo, 1614
Fable, c.1600
Canvas, 50 × 64 cm
Purchased in 1993
Cat. no. 7657

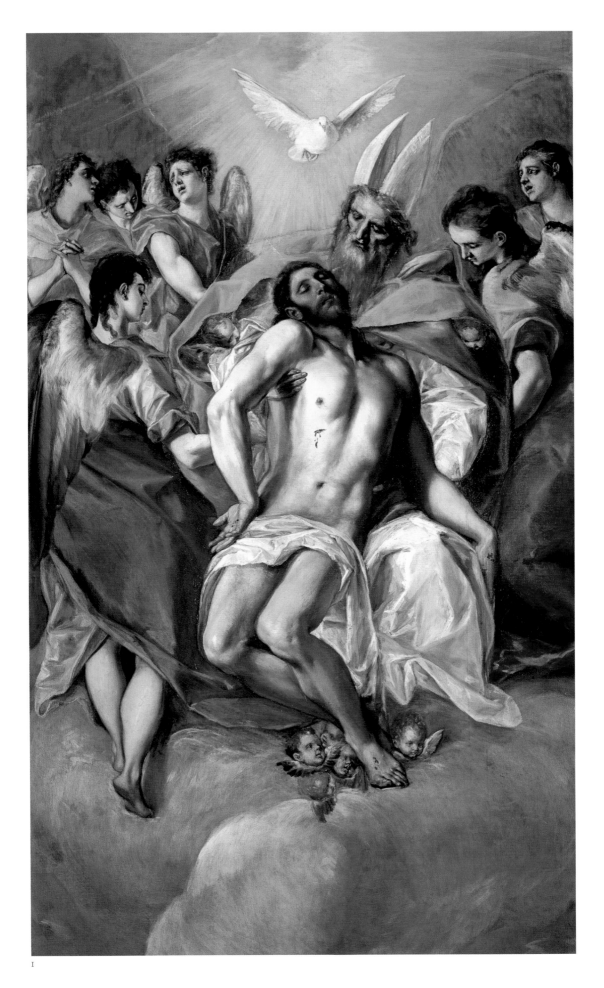

I

1

Domenikos Theotokopoulos,
known as **El Greco**
Kameia, *c.*1540/1–Toledo, 1614
*The Holy Trinity, c.*1577/9
Canvas, 300 × 179 cm
Acquired in 1827
Cat. no. 824

Designed for the church of Santo Domingo el Antiguo, this painting was part of El Greco's first commission on his arrival in Toledo in 1577. He earned a considerable name for himself in what was then an artistically backward city, which assured him a successful future. The general composition is based on an engraving by Dürer, and the artist probably drew inspiration from the figure of Christ in Michelangelo's *Pietà* for Vittoria Colonna. The accentuating of the grey tones of the dead body of Christ, together with the pale colours in the Mannerist style and the rather loosely composed figures, produces a feverish pathos.

2

Domenikos Theotokopoulos,
known as **El Greco**
Kameia, *c.*1540/1–Toledo, 1614
*The Resurrection, c.*1596/1610
Canvas, 275 × 127 cm
From the Colegio de Doña María de Aragón, Madrid
Cat. no. 825

page 30
Domenikos Theotokopoulos,
known as **El Greco**
Kameia, *c.*1540/1–Toledo, 1614
*The Adoration of the Shepherds,
c.*1614
Canvas, 319 × 180 cm
Entered the Prado in 1954
Cat. No. 2988

This *Nativity*, painted by El Greco for his own burial chapel in the church of Santo Dominigo El Antiguo in Toledo, provides an excellent example of the artist's late style. The elongated bodies seem almost without substance: the cold, vibrant colours are accentuated by a nervous brushwork; the exaggerated attitudes of the figures communicate a palpable spirituality.

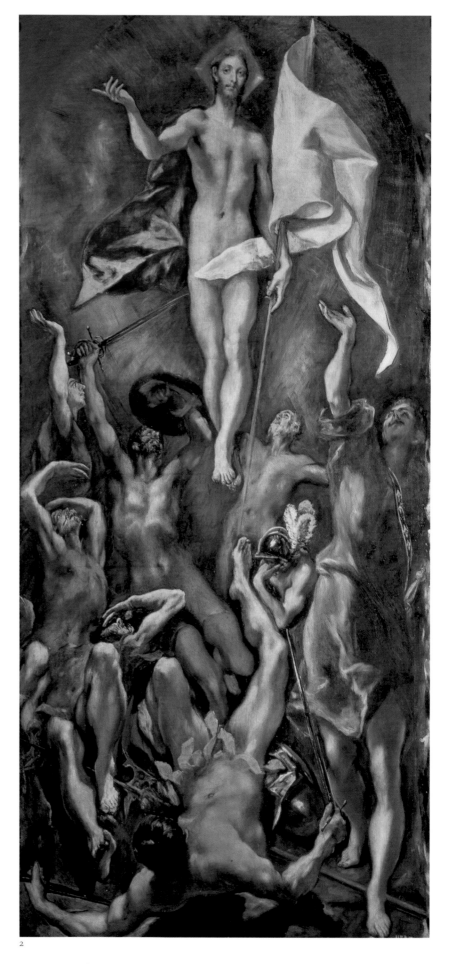

2

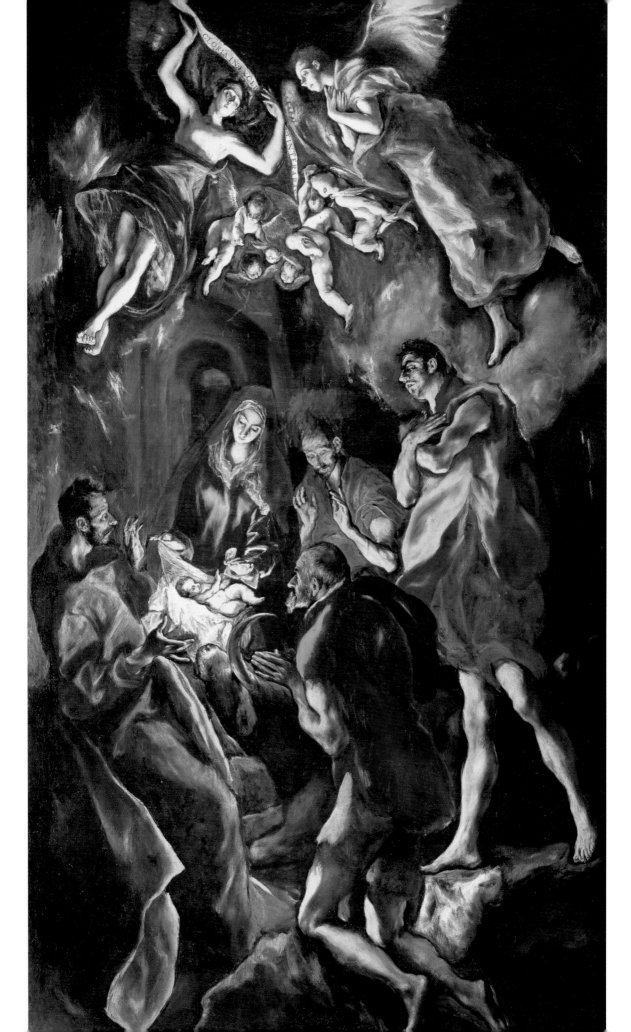

VELÁZQUEZ AND
THE SEVENTEENTH CENTURY

When El Greco died in 1614, the first signs were already appearing in Spain of the style known as 'naturalist tenebrism', which was to bring with it a new vision of pictorial reality. The technique consisted in emphasizing details such as folds, creases or subtle physical characteristics, in bright theatrical lighting almost like a spotlight, isolating and magnifying them under its glare in order to make the greatest impact on the viewer. This early naturalism owed much to Italian models and was perhaps already hinted at in the return to a sense of order, clarity and immediacy that gradually became apparent in the work of some of the artists employed at the Escorial, such as Federico Zuccaro, Luca Cambiaso, Bartolomé Carducho and Francisco Ribalta.

Ribalta, a Catalan from Solsona who trained in Castile but settled in Valencia, was receptive to the influence of naturalism without entirely renouncing the lucid forms of the Renaissance. The Prado possesses some of his most important works. Simultaneously, in Castile, several followers of artists brought to the Escorial by Philip II began to revert to forms of realism. The works of these painters, notably Vicente Carducho and Juan Bautista Maino, are well represented in the museum. In Seville, under the shadow of the timid naturalism of older artists such as Pacheco or Roelas, whose work is barely represented in The Prado, younger artists appeared, such as Cano, Velázquez and Zurbarán, who were to produce masterpieces within the limits of a stricter naturalism.

However, before describing the mature work of these artists, the Valencian painter José de Ribera must be mentioned. Although Ribera emigrated to Italy when still very young and never returned to Spain, he is considered as important a figure in the history of Spanish painting as in Italian painting. He settled in Naples in 1616 and created a style of his own, delighting in grandiose compositions and in a natural and sensual treatment of the human form that is regarded as one of the most powerful expressions of European Baroque. He was patronized enthusiastically by the Spanish viceroys of Naples, and a large part of his output ended up in the royal palaces in Madrid until it was eventually transferred to the Prado. With Ribera, the Golden Age of Spanish painting was firmly established.

Zurbarán, with the exception of one visit to court, divided his working life between his native Extremadura and Seville, and only spent his final years in Madrid. His main works are not in the Prado, though the museum does contain an important selection of his paintings. These may well be the most representative of the monastic world of the Spanish Counter-Reformation – a world of 'broken bread, wine and serge', as Rafael Alberti aptly described it, which is so perfectly depicted in Zurbarán's still lifes.

Velázquez, who was an entirely different character, established himself at court from 1623 onwards and was closely involved with all aspects of court life. In these surroundings, with access to the wonderful collections of Venetian and Flemish paintings housed in the Madrid palaces, it did not take him long to forget the dark tenebrist art of his young days in Seville. He was thus able to develop a mature personal style that is characterized by an inimitable light brushwork, a preference for cold colours – as can be seen in his use of greyish tones – and a supreme sensibility in relation to composition and the posing of his models. The major part of the work of Velázquez, the court painter *par excellence,* remained in the royal palaces, and the Prado is proud to possess over a third of his entire output, enabling visitors to make a comprehensive study of his work as a whole. Understandably, paintings from his naturalist period in Seville are missing from the collection, with the exception of *The Adoration of the Kings* and a few portraits that indicate his early style. All the later stages of his art are exhibited: his portraits of kings, princes, royal favourites, buffoons; his mythological themes; historical paintings such as *The Surrender of Breda,* with its immensely dignified composition; his religious works with their quiet elegance; landscapes such as the gardens of the Villa Medici in Rome, where a more melancholy, reticent side to the artist's sensibility can be perceived; and the famous picture of *Las Meninas,* that astonishing symbol of the relationship that exists in all paintings between appearance and reality and yet mysteriously withholds its significance.

The wave of High Baroque works in Madrid produced at that time was partly for the decoration of monasteries and churches. As a consequence of Mendizábal's disestablishment laws in the nineteenth century and the disappearance of the Museo de la Trinidad, many of these came to the Prado, and its collection has been augmented by subsequent purchases and donations. The following artists of the period are all well represented: Antonio de Pereda, still very close to naturalism in his best known works; Carreño de Miranda, whose portraits have inherited something of the distinction of Velázquez; Herrera the Younger, whose paintings contain both decorative and dynamic elements; Antolínez and Cerezo, delicate colourists who both died young; and Claudio Coello, with his large rhetorical images and his capacity to communicate immediacy and the sublime.

Around 1650 two artists of major importance appeared in Seville. The first, Murillo, enjoyed great popularity in his time and during the eighteenth and nineteenth centuries, although his reputation has somewhat unjustly diminished since then because modern taste considers his work to be too sentimental. This perception is partly due to the over-exploitation of his

originals by a vast number of followers and imitators and, more recently, to mass reproductions of poor quality. Murillo was a painter of great technical skill, a remarkable draughtsman and a refined colourist. He absorbed the realist tradition of the religious painting of the Counter-Reformation and transformed it by studying the Flemish artists, especially Van Dyck. The style in which he excelled was emotional and decorative, and though some consider it sugary and superficial, it reflected a genuine piety and exerted considerable popular appeal for over two centuries. Murillo developed a familiar, simple and tender manner of pictorial expression, and managed to evade all crude and distasteful elements, even in those paintings portraying beggars and ruffians. In this respect he might fairly be described as sentimentalist, yet despite his present-day

reputation, his works are of high quality and maintain their important position in the history of art. The Prado has a large collection of his paintings, mainly as a result of the pictures purchased by Queen Isabel Farnese in Seville, but also due to later acquisitions. Unfortunately there are no paintings of young ruffians and beggars, his most popular subject matter, and these can only be studied outside Spain.

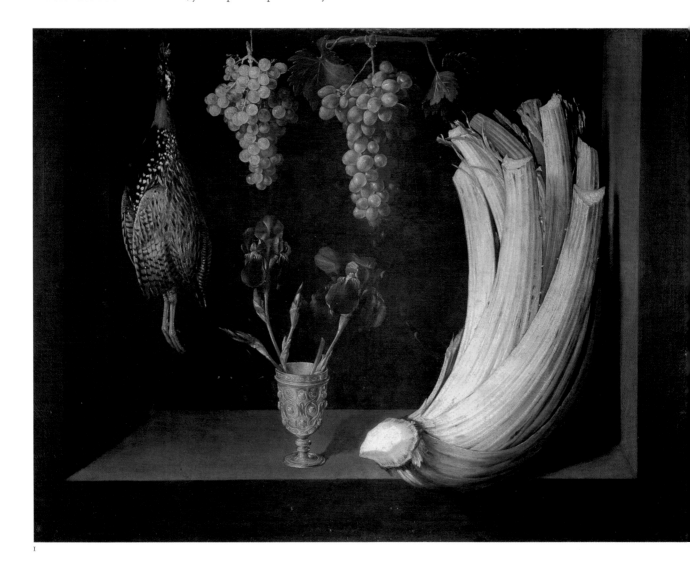

1

Felipe Ramírez
Probably active in Toledo
in the first quarter of the
seventeenth century
Still life
Canvas, 72 × 92 cm
Purchased in 1940 with a legacy
from the Count of Cartagena
Cat. no. 2802

2
Juan Sánchez Cotán
Orgaz, 1560–Granada, 1627
*Still life with Game, Vegetables
and Fruit*, 1602
Canvas, 69 × 88 cm
From the collection of the Infante
Sebastián Gabriel de Borbón
Later owned by the Dukes of
Hernani
Acquired in 1993
Cat. no. 7612

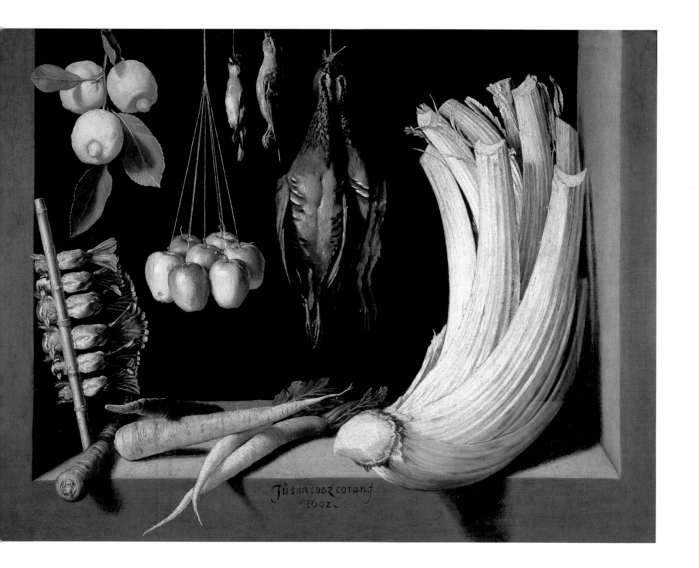

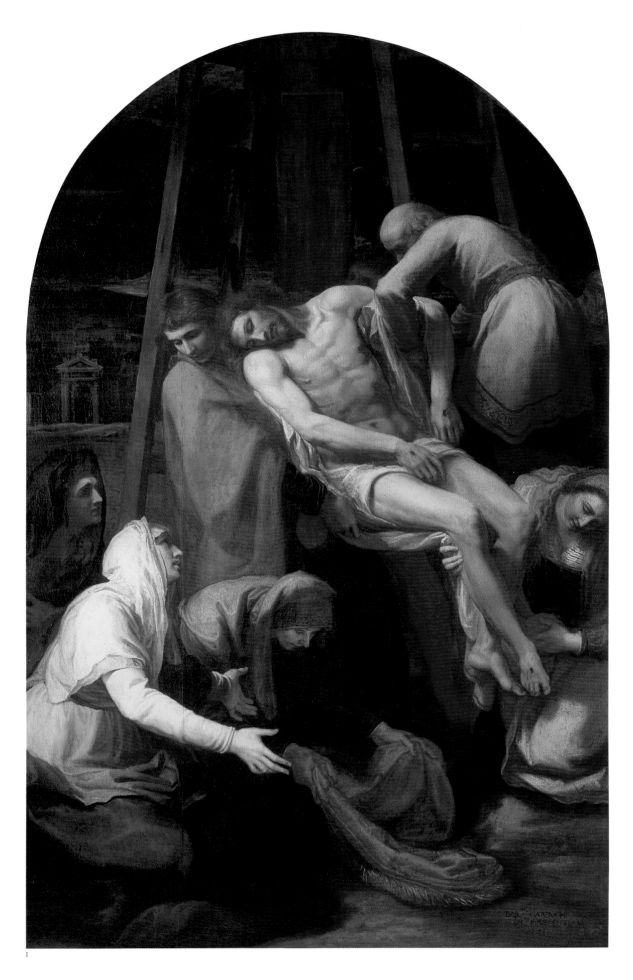

I

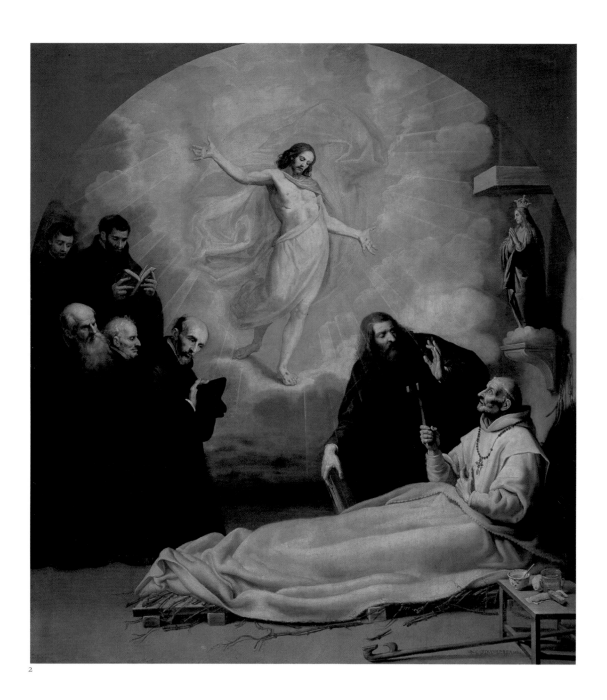

2

1

Bartolomé Carducho
Florence, 1554–Madrid, 1608
The Descent from the Cross, 1595
Canvas, 263 × 181 cm
Painted for the church of San
Felipe el Real, Madrid
Cat. no. 66

2

Vicente Carducho
Florence, 1576/8–Madrid, 1638
*The Death of the Venerable Odón
de Novara*, 1632
Canvas, 342 × 302 cm
From the Cartuja del Paular
Cat. no. 639

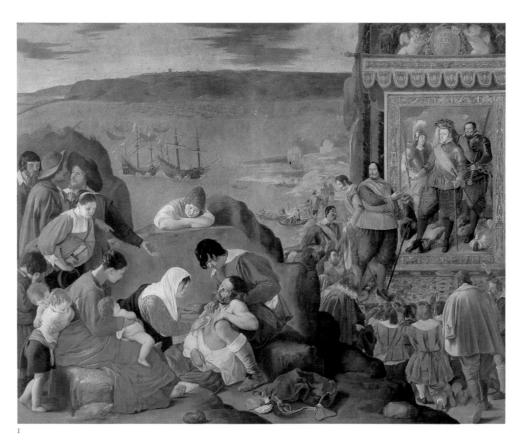

1

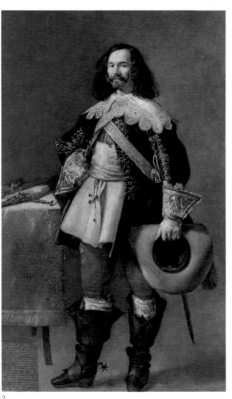

2

3

1
Fray Juan Bautista Maino
Pastrana, 1581–Madrid, 1649
The Recovery of Bahía, Brazil, in 1625, c.1634/5
Canvas, 309 × 381 cm
From the Hall of the Realms in the
Buen Retiro Palace
Entered the Prado in 1827
Cat. no. 885

2
Fray Juan Andrés Rizi
Madrid, 1600–Monte Casino, 1681
Don Tiburcio de Redín
Canvas, 203 × 124 cm
Charles IV collection
Cat. no. 887

3
Francisco Collantes
Madrid, 1559–1656
St Onuphrius
Canvas, 168 × 108 cm
Queen Isabel Farnese collection
Cat. no. 3027

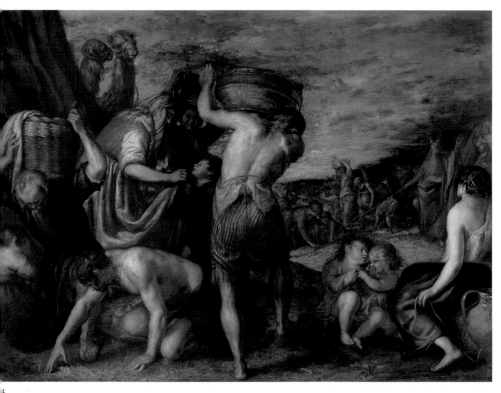

4

Diego Polo
Burgos, c.1610–Madrid, 1665
Collecting the Manna
Canvas, 187 × 238 cm
From the collection of the Infante
Sebastián Gabriel de Borbón
Entered the Prado in 1982
Cat. no. 6775

5

Francisco Collantes
Madrid, 1559–1656
The Vision of Ezekiel, 1630
Canvas, 177 × 205 cm
Philip IV collection
Entered the Prado in 1827
Cat. no. 666

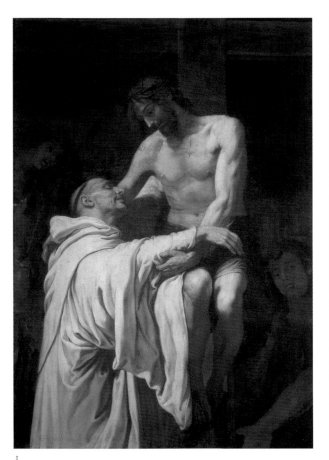

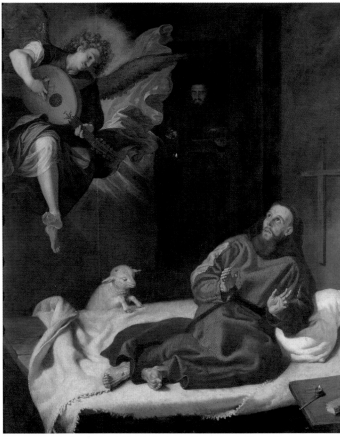

1

2

Francisco Ribalta
Solsona, 1565–Valencia, 1628
Christ embracing St Bernard
Canvas, 158 × 113 cm
Purchased in 1940 with a legacy
from the Count of Cartagena
Cat. no. 2804

Francisco Ribalta
Solsona, 1565–Valencia, 1628
St Francis consoled by an Angel
Canvas, 204 × 158 cm
Charles IV collection
Cat. no. 1062

3
José de Ribera
Játiva, 1591–Naples, 1652
Jacob's Dream, 1639
Canvas, 179 × 233 cm
In the collection of Queen Isabel
Farnese by 1746
Entered the Prado in 1827
Cat. no. 1117

This work by Ribera is particularly
interesting because it conspicu-
ously avoids the usual iconography
of Jacob's Dream involving the
traditional image of a ladder.
Here, the dream is suggested
merely by vaporous golden figures
that might almost be part of the
sky. But the dreamer's posture
and the play of light on his face
lend an air of mystery to the scene.

4
José de Ribera
Játiva, 1591–Naples, 1652
The Holy Trinity, c.1635/6
Canvas, 226 × 181 cm
Acquired in 1820
Cat. no. 1069

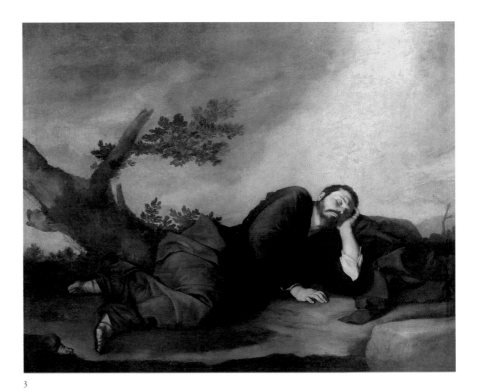

3

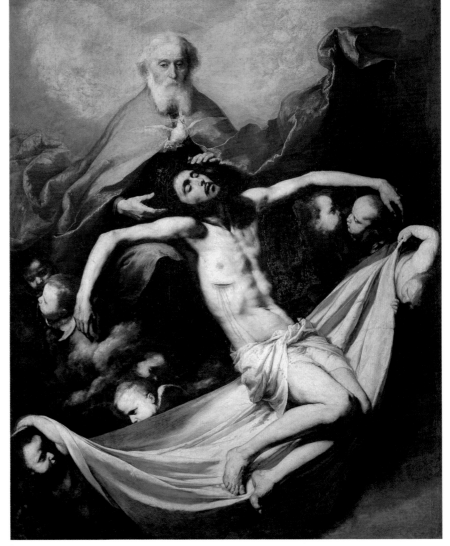

4

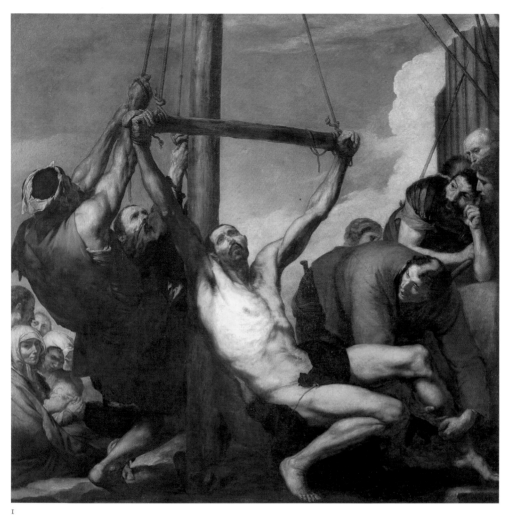

1

1
José de Ribera
Játiva, 1591–Naples, 1652
The Martyrdom of St Philip, 1639 (?)
Canvas, 234 × 234 cm
Philip IV collection
Cat. no. 1101

2
José de Ribera
Játiva, 1591–Naples, 1652
Jacob receiving Isaac's Blessing, 1637
Canvas, 129 × 289 cm
Charles II collection
Cat. no. 1118

3
José de Ribera
Játiva, 1591–Naples, 1652
*St Andrew, c.*1630/32
Canvas, 123 × 95 cm
Formerly in the Escorial
Entered the Prado in 1838
Cat. no. 1078

4
José de Ribera
Játiva, 1591–Naples, 1652
*Mary Magdalene (or St Thais?) in
the Desert, c.*1640/41
Canvas, 182 × 149 cm
From the collection of the
Marquis of Los Llanos
In the Royal Palace, Madrid, by 1772
Cat. no. 1103

2

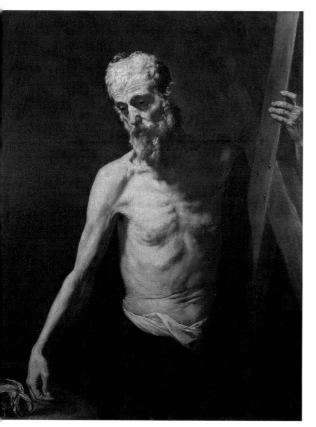

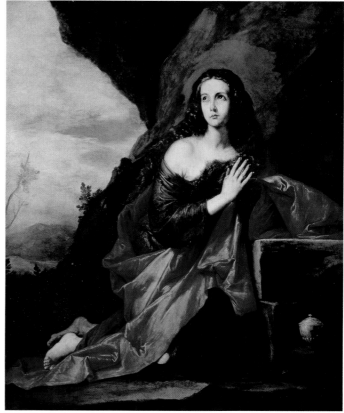

4

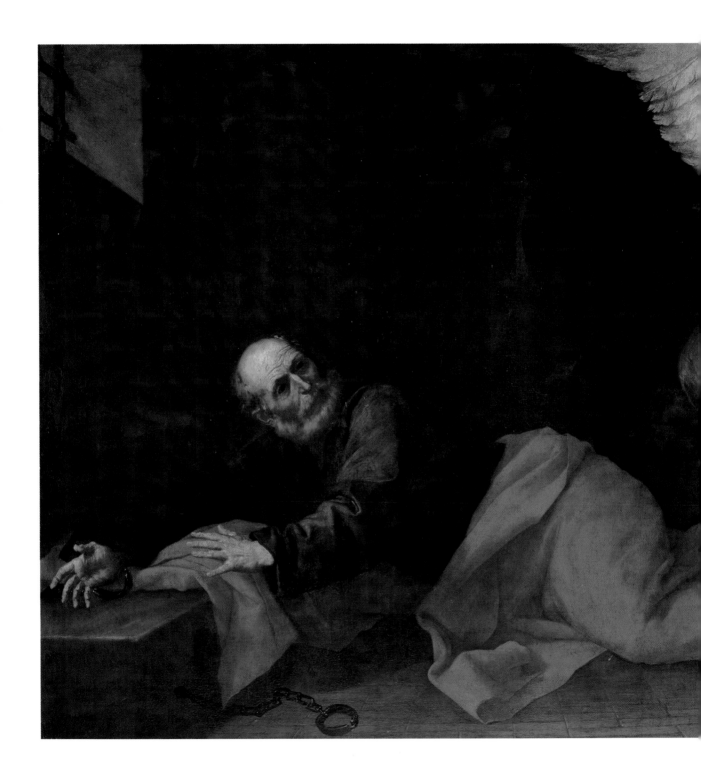

José de Ribera
Játiva, 1591–Naples, 1652
*St Peter freed from Prison by an
Angel*, 1639
Canvas, 177 × 232 cm
In the collection of Queen Isabel
Farnese by 1746
Cat. no. 1073

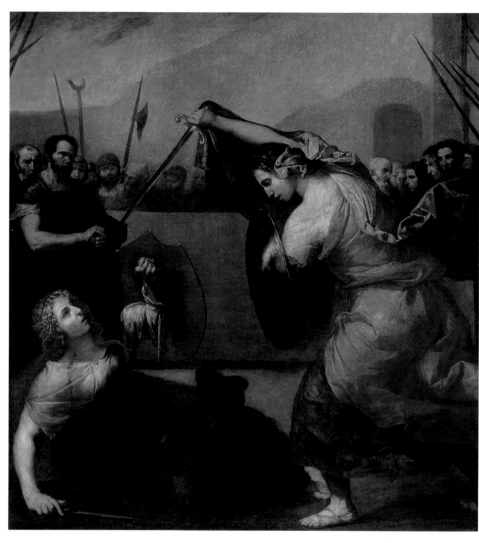

José de Ribera
Játiva, 1591–Naples, 1652
*The Duel between Isabella de Carazzi
and Diambra de Pettinella*, 1636
Canvas, 235 × 212 cm
Philip IV collection (?)
Cat. no. 1124

Ribera is known primarily for his
religious subjects, but he also
painted a number of mythological
and historical scenes. This painting
represents the true story of a duel
between two women, Isabella de
Carazzi and Diambra de Pettinella,
for the love of Fabio de Zeresola.
Ribera was most probably attracted
by the unusual or grotesque
nature of the story; he may also
have been motivated by a wish to
ridicule duels of honour, which
were a common event in Naples
at the time. The artist employs the
warm colouring typical of his
mature works.

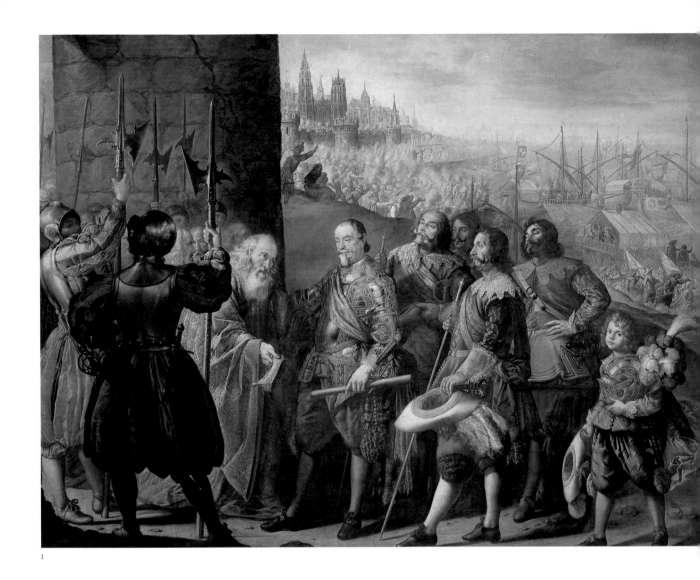

1

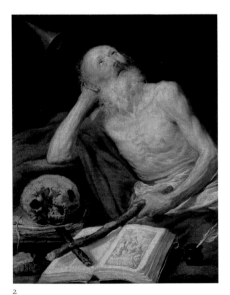

2

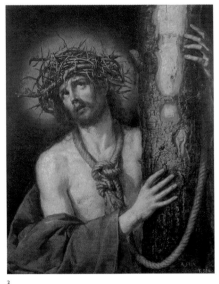

3

1

Antonio de Pereda
Valladolid, 1611–Madrid, 1678
The Relief of Genoa, c.1634/5
Canvas, 290 × 370 cm
From the Hall of the Realms in
the Buen Retiro Palace
Donated to the Prado in 1912 by
Marzel de Nemes
Cat. no. 1317

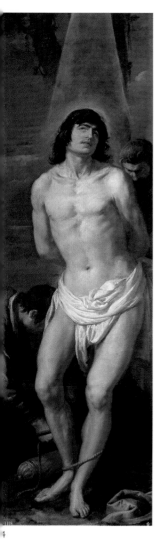

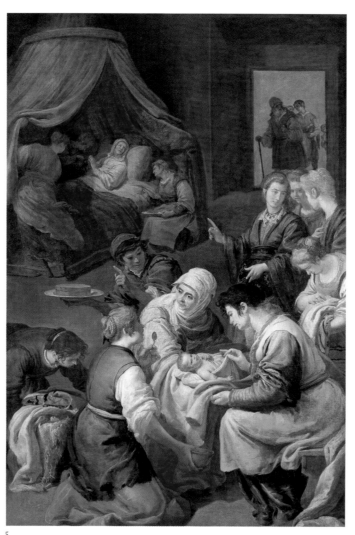

4 5

2
Antonio de Pereda
Valladolid, 1611–Madrid, 1678
St Jerome, 1643
Canvas, 105 × 84 cm
From the palace of Aranjuez
Cat. no. 1046

3
Antonio de Pereda
Valladolid, 1611–Madrid, 1678
Christ the Man of Sorrows, 1641
Canvas, 97 × 78 cm
From the Museo de la Trinidad
Cat. no. 1047

4
José Leonardo
Calatayud, 1601–Zaragoza,
before 1653
St Sebastian
Canvas, 192 × 58 cm
In the collection of Queen Isabel
Farnese by 1746
Cat. no. 67

5
José Leonardo
Calatayud, 1601–Zaragoza,
before 1653
The Birth of the Virgin Mary, 1640
Canvas, 180 × 122 cm
Entered the Museo de la
Trinidad in 1864
Cat. no. 860

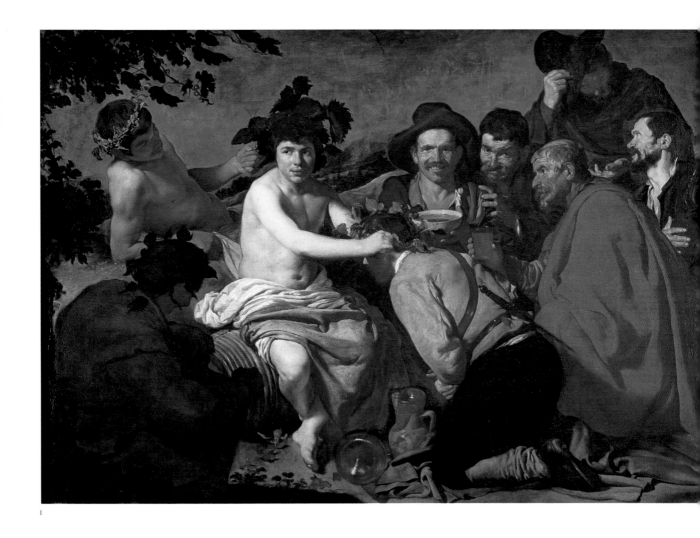

1

1
Diego Velázquez de Silva
Seville, 1599–Madrid, 1660
*'Los Borrachos' or the Triumph of
Bacchus*
Canvas, 165 × 225 cm
Philip IV collection
Cat. no. 1170

2
Diego Velázquez de Silva
Seville, 1599–Madrid, 1660
Apollo at the Forge of Vulcan, 1630
Canvas, 223 × 290 cm
Acquired for Philip IV in 1634
Cat. no. 1171

3
Diego Velázquez de Silva
Seville, 1599–Madrid, 1660
*The Gardens of the Villa Medici in
Rome*, c.1650/51
Canvas, 44 × 38 cm
Philip IV collection
Cat. no. 1211

4
Diego Velázquez de Silva
Seville, 1599–Madrid, 1660
*The Gardens of the Villa Medici in
Rome*, c.1650/51
Canvas, 48 × 42 cm
Philip IV collection
Cat. no. 1210

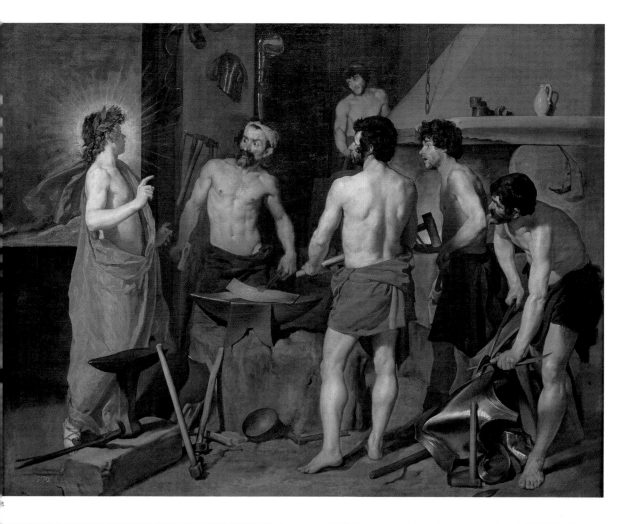

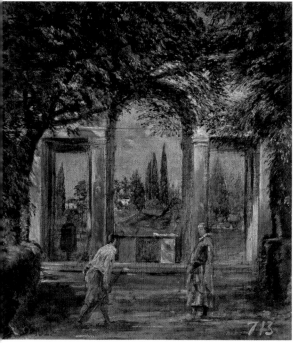

4

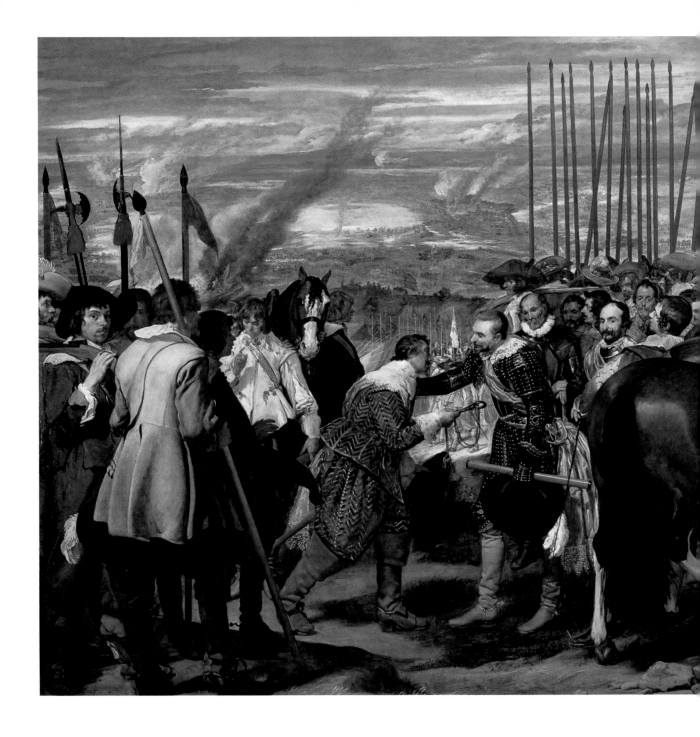

Diego Velázquez de Silva
Seville, 1599–Madrid, 1660
The Surrender of Breda, before 1635
Canvas, 307 × 367 cm From the
Hall of the Realms in the Buen
Retiro Palace
Cat. no. 1172

Velázquez was not present himself at the surrender of the town of Breda, but he had access to an engraving by Jacques Callot produced shortly after the siege (in 1625), and on his first visit to Italy in 1629 he also met the victorious General Spinola. The painting is noticeably free of the sensationalism and drama so typical of Baroque historical paintings of the era, in strong contrast to such pictures as the *Meeting between the Cardinal-Infante Don Fernando and the King of Hungary at*

Nördlingen by Rubens.

The device used to create the landscape, which is laid out like a map in the background, recalls the work of Peeter Snayers. Nevertheless, although recognizable, it lacks the topographical precision of some of the other paintings in the Hall of the Realms and in fact provides no more than a blurred backdrop for the figures. The clearing sky and trailing columns of smoke are perhaps intended to suggest the recent battle. The variety of figures and

the contrast between the two groups – the erect lances of the victors *vis-à-vis* the oblique lines of those of the defeated – recreate the scene with extraordinary conviction and give the impression that it is happening before our eyes, as if the viewer were actually there with the artist. To a certain extent it anticipates the subject matter of *Las Meninas*.

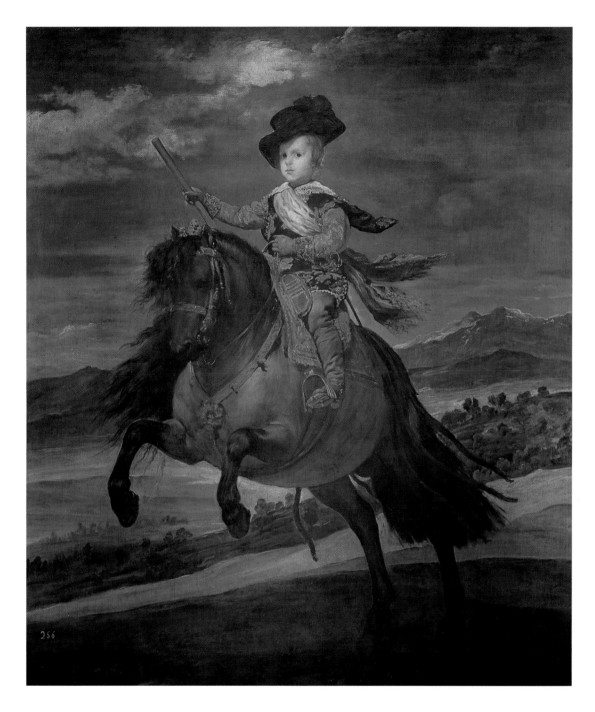

Diego Velázquez de Silva
Seville, 1599–Madrid, 1660
Prince Baltasar Carlos on Horse-back, c.1635/6
Canvas, 209 × 173 cm
From the Hall of the Realms in the Buen Retiro Palace
Cat. no. 1180

Together with four other equestrian portraits by Velázquez, a cycle of thirteen battle scenes by Cajés, Maino, Zurbarán, Carducho, Castello, Leonardo and Pereda, and a series on the Labours of Hercules by Zurbarán, this painting represents a human anecdote – the prince is the heir to the throne – among the immense decorative scheme of the Hall of the Realms in the Buen Retiro Palace. The project was organized by the Count-Duke of Olivares in order to reaffirm the glory of the Spanish monarchy during what was in fact the start of its decline. This portrait, though highly conventional, is painted by Velázquez with his usual conviction and with brilliant touches of impasto.

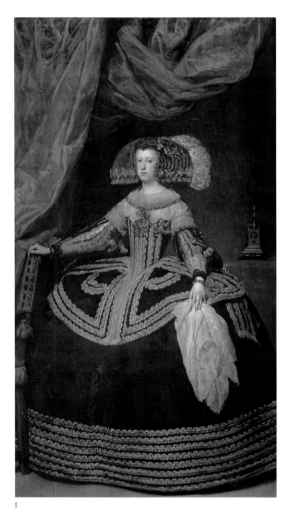

1

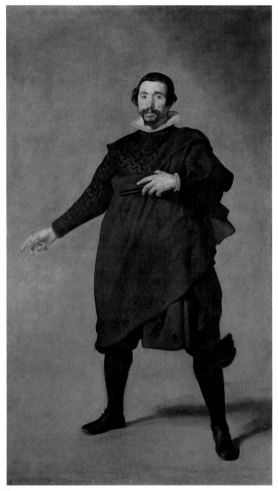

2

1
Diego Velázquez de Silva
Seville, 1599–Madrid, 1660
Queen Mariana de Austria,
*c.*1652/3
Canvas, 231 × 131 cm
Philip IV collection
Cat. no. 1191

2
Diego Velázquez de Silva
Seville, 1599–Madrid, 1660
*Pablo de Valladolid, c.*1632
Canvas, 209 × 123 cm
Philip IV collection (from the
Queen's apartments in the
Buen Retiro Palace)
Cat. no. 1198

3
Diego Velázquez de Silva
Seville, 1599–Madrid, 1660
Las Meninas, 1656
Canvas, 316 × 276 cm
Philip IV collection
Cat. no. 1174

Las Meninas (*The Maids of Honour*)
is more than a portrait, or even a
portrait of a portraitist at work. It
can be interpreted as a declaration
in paint of the intellectual dignity
of art. We know that Velázquez
was always concerned about his
status at court and that he must
have assimilated much of his
father-in-law Francisco Pacheco's
treatise on the nobility of painting
titled *El arte de la pintura*. He
therefore includes the king and
the queen – albeit by a somewhat
ambiguous method – who are
clearly present as witnesses to the
painter in full creative flow. The
artist shows himself pausing, in
order to demonstrate that paint-
ing requires not only action but
also reflection.

The figures in the picture seem
to be caught between one position
and the next, with the snapshot
effect that the Impressionists, and
particularly Degas, were to seek so
earnestly 200 years later. Other
painters were to try to equal or
better the extraordinary illusion
of space in the picture, but
Velázquez's skill in achieving this
was already apparent in earlier
works such as *The Surrender of*
Breda. Here, by having the king
and queen reflected in a mirror, he
extends the space of the picture to
include the viewer. The painting
is the consummation of Baroque
spatial fiction or illusionism, and
is a singular example of the power
of art both to communicate what
is real and to imagine what by
nature is unreal.

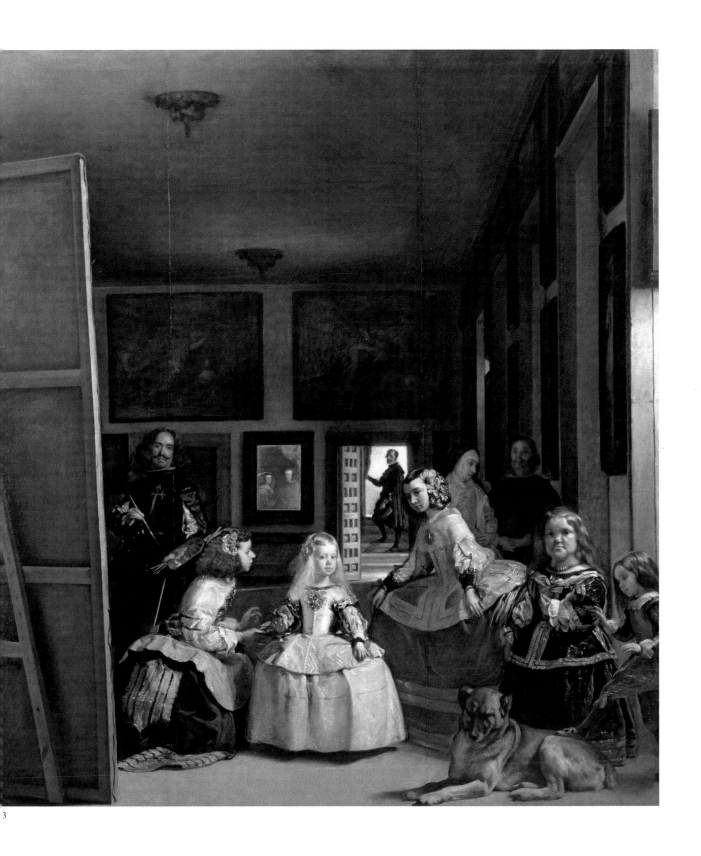

3

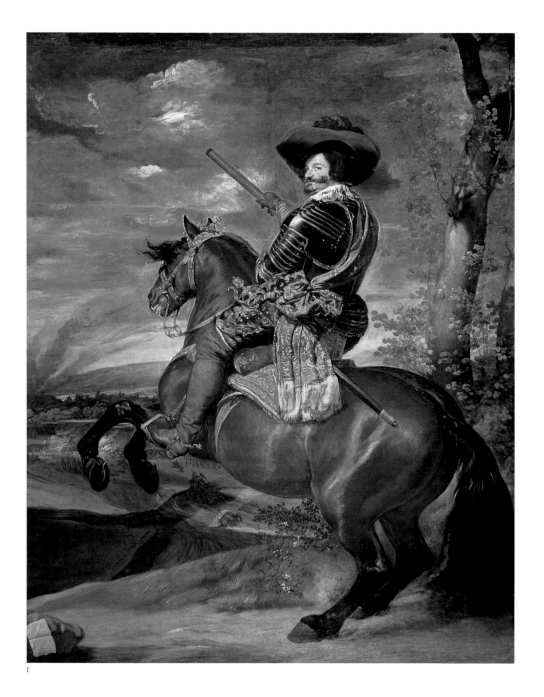

I

I

Diego Velázquez de Silva
Seville, 1599–Madrid, 1660
*The Count-Duke of Olivares on
Horseback, c.*1634
Canvas, 313 × 239 cm
Acquired by Charles III in 1769
from the collection of the Marquis
of La Ensenada
Cat. no. 1181

The part painted by Velázquez
was only small; the canvas was
restored and augmented in the
seventeenth century. Shown here
is what remains of the original.

There has been much discus-
sion about the meaning of *Las*

2

Diego Velázquez de Silva
Seville, 1599–Madrid, 1660
*Las Hilanderas, c.*1657
Canvas, 220 × 289 cm (original
dimensions 164 × 250 cm)
In the collection of Don Pedro de
Arce in 1664
Later in the royal collection
Cat. no. 1173

Hilanderas (The Spinners), but the
essence of the picture seems clear
enough. Just as Velázquez placed
country folk beside Bacchus in *Los
Borrachos*, here he sets Minerva
alongside Arachne, who dared to
challenge her, in the context of
actual tapestry-makers. The pic-
ture possibly reflects an everyday
scene at the Royal Tapestry Factory
of St Elizabeth in Madrid. Minerva,
disguised as an old woman,
competes with Arachne in the fore-
ground; the second scene is played
out in the background, when
Minerva punishes Arachne for
her audacity.

Velázquez conveys their indus-
triousness with astonishing
immediacy, seeming to mingle
the humming of the spinning
wheels with the shifts of colour in
the lighting. Nothing could be
further from the silent suspen-
sion and frozen movements of *Las
Meninas*. Nevertheless, what both
pictures – and certain earlier works
by the artist – have in common is
ambiguity in the handling of space,
with which Velázquez deliberately
fascinates the viewer.

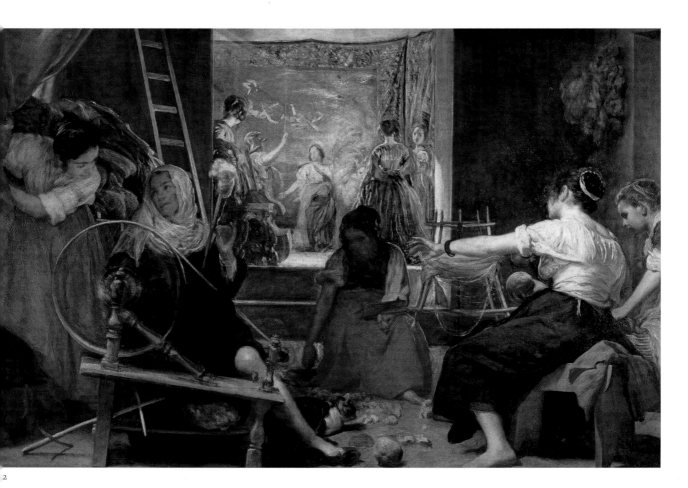

2

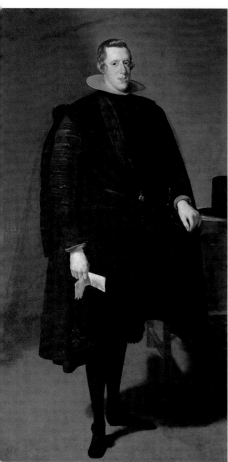

3
Diego Velázquez de Silva
Seville, 1599–Madrid, 1660
Philip IV of Spain, before 1628
Canvas, 201 × 102 cm
Philip IV collection
Cat. no. 1182

3

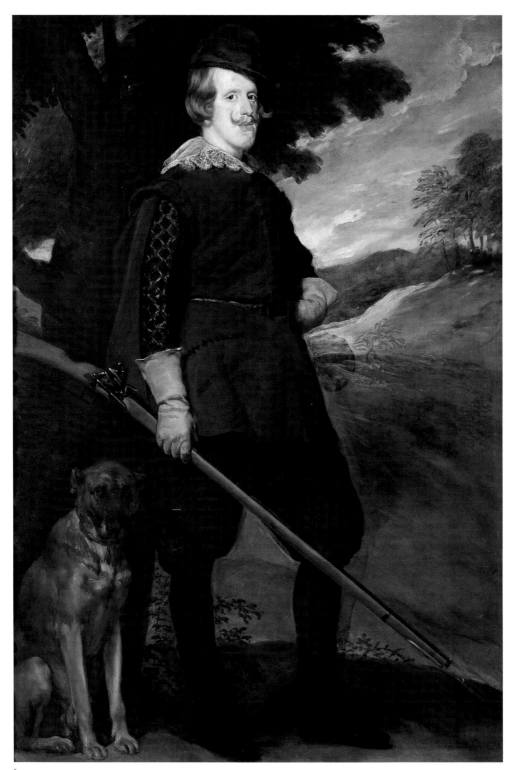

I

1
Diego Velázquez de Silva
Seville, 1599–Madrid, 1660
Philip IV as a Huntsman,
*c.*1634/5
Canvas, 191 × 126 cm
Commissioned by Philip IV
for the Torre de la Parada
Cat. no. 1184

2
Diego Velázquez de Silva
Seville, 1599–Madrid, 1660
and
Juan Bautista Martínez del Mazo
Beteta (?), 1615–Madrid, 1667
The Infanta Margarita de Austria,
*c.*1660
Canvas, 212 × 147 cm
Philip IV collection
Cat. no. 1192

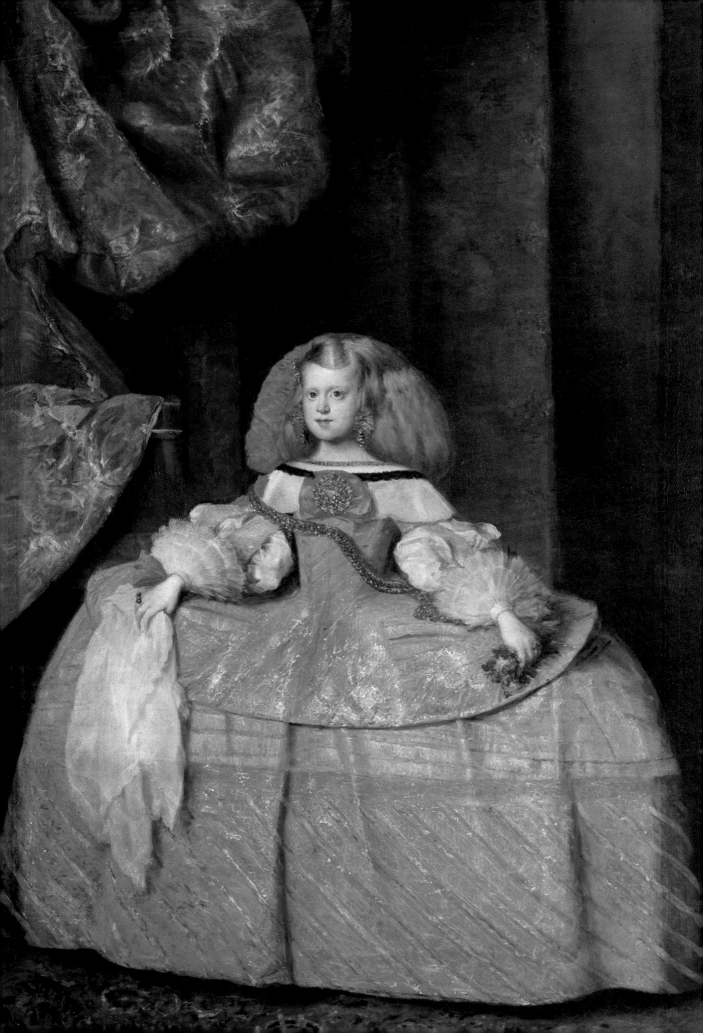

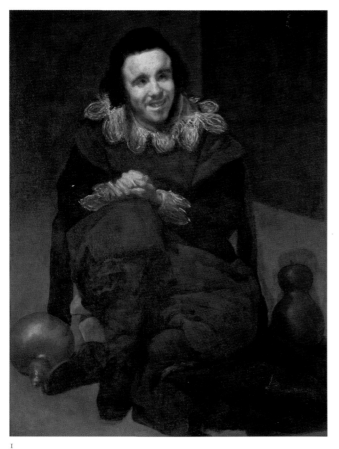

1

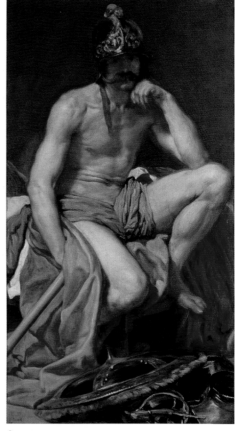

2

Diego Velázquez de Silva
Seville, 1599–Madrid, 1660
*The Dwarf Don Juan Calabazas,
known as Calabacillas,* c.1639
Canvas, 106 × 83 cm
Philip IV collection (from the
Queen's apartments in the
Buen Retiro Palace)
Cat. no. 1205

Dwarfs, fools and jesters abound-
ed at the court of Philip IV, who
maintained them in accordance
with an old tradition dating back
to the Middle Ages. The origins
of the tradition were charitable,
but many fools came to be appre-
ciated for their wit, arousing
affection and at times achieving
considerable fame. Because they
were not taken seriously they were
free to parody or mock the
etiquette by which the courtiers,
courtesans and royalty were bound,
and they were therefore very pop-
ular at the strict court of Philip IV.

 In portraying them, Velázquez
used a number of subtle devices,
and of particular interest is the
way in which the light plays
uncertainly over the face of
Calabacillas, revealing his defec-
tive eyesight. Here the artist
anticipated, or perhaps influ-
enced, certain techniques that
Goya was to employ a century
and a half later.

Diego Velázquez de Silva
Seville, 1599–Madrid, 1660
Mars, God of War, 1640
Canvas, 179 × 95 cm
Commissioned by Philip IV for
the Torre de la Parada, the hunt-
ing lodge at El Pardo
Entered the Prado after 1827
Cat. no. 1208

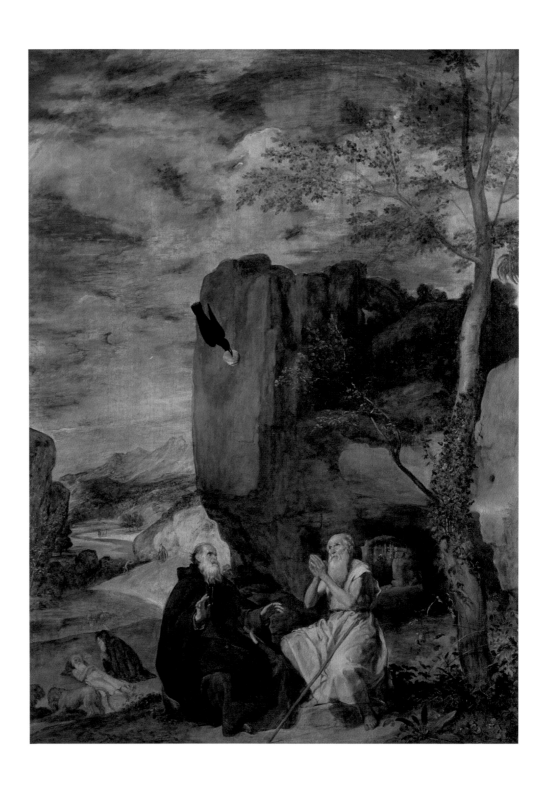

Diego Velázquez de Silva
Seville, 1599–Madrid, 1660
*St Anthony Abbot and St Paul the
Hermit*, c.1642
Canvas, 257 × 188 cm
Painted for the chapel of San
Pablo in the gardens of the Buen
Retiro Palace
Cat. no. 1169

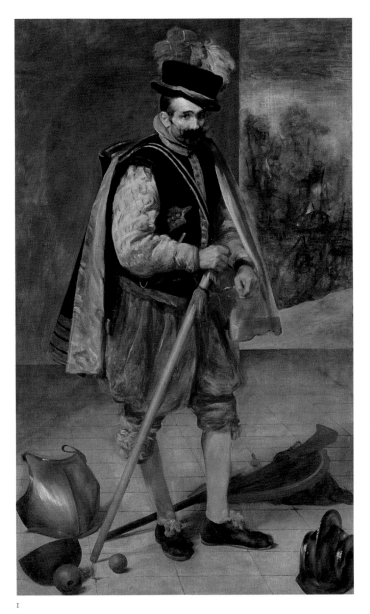

1

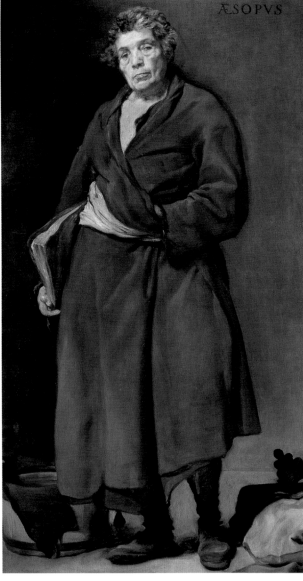

2

1
Diego Velázquez de Silva
Seville, 1599–Madrid, 1660
The Jester Don John of Austria,
*c.*1632/5
Canvas, 210 × 123 cm
Philip IV collection (from the
Queen's apartments in the
Buen Retiro Palace)
Cat. no. 1200

2
Diego Velázquez de Silva
Seville, 1599–Madrid, 1660
Aesop, 1640
Canvas, 179 × 94 cm
Commissioned by Philip IV
for the Torre de la Parada
Entered the Prado after 1827
Cat. no. 1206

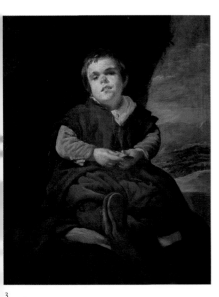

3

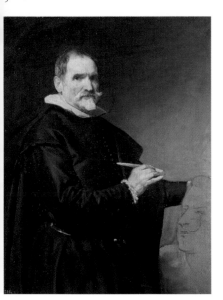

4

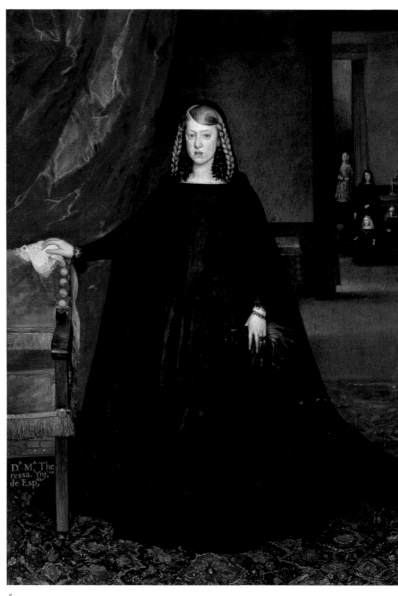

5

3
Diego Velázquez de Silva
Seville, 1599–Madrid, 1660
The Dwarf Francisco Lecano, known
as El Niño de Vallecas, c.1637
Canvas, 107 × 83 cm
Commissioned by Philip IV for
the Torre de la Parada
Entered the Prado after 1827
Cat. no. 1204

4
Diego Velázquez de Silva
Seville, 1599–Madrid, 1660
Juan Martínez Montañés, c.1635
Canvas, 109 × 107 cm
In the royal collection in the
eighteenth century
In the Quinta del Duque
del Arco in 1794
Cat. no. 1194

5
Juan Bautista Martínez del Mazo
Beteta (?), 1615–Madrid, 1667
The Empress Margarita de Austria
dressed in Mourning, 1666
Canvas, 209 × 147 cm
Entered the Prado in 1847
Cat. no. 888

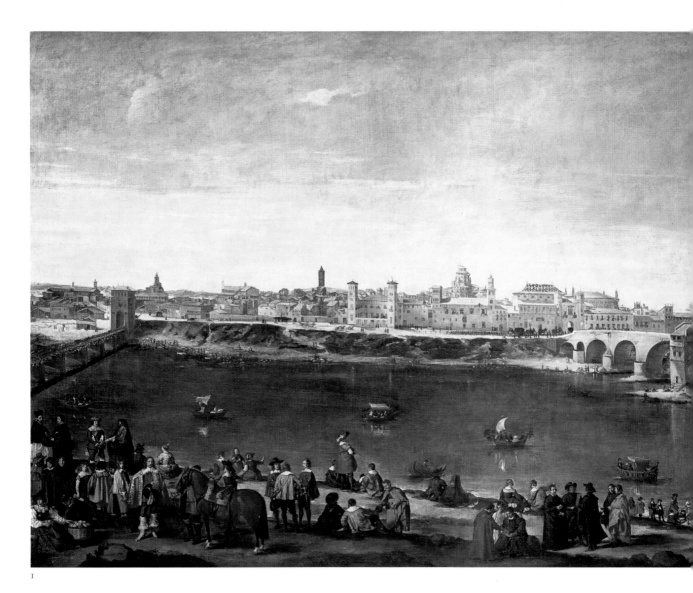

1

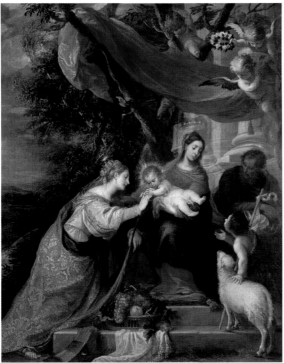

2

1

Juan Bautista Martínez del Mazo
Beteta (?), 1615–Madrid, 1667
View of Zaragoza, 1547 (?)
Canvas, 181 × 331 cm
Commissioned by Prince Baltasar
Carlos
Philip IV collection
Cat. no. 889

2

Mateo Cerezo
Burgos, c.1626–Madrid, 1666
The Mystic Marriage of
St Catherine, 1660
Canvas, 207 × 163 cm
Acquired by Ferdinand VII from
the collection of Don José
Antonio Ruiz
Cat. no. 659

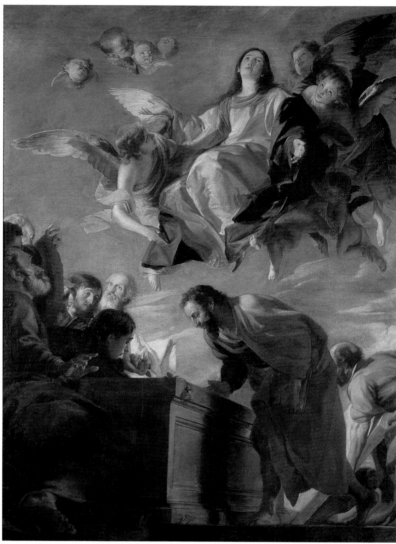

3

3
Juan Martín Cabezalero
Almadén (Ciudad Real),
1633–Madrid, 1673
The Assumption of the Virgin Mary
Canvas, 237 × 169 cm
From the palace of Aranjuez
Cat. no. 658

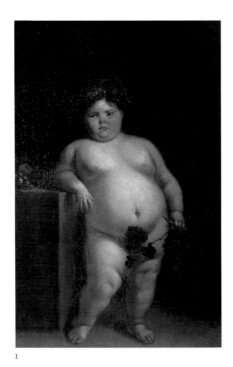

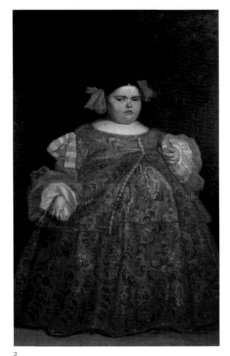

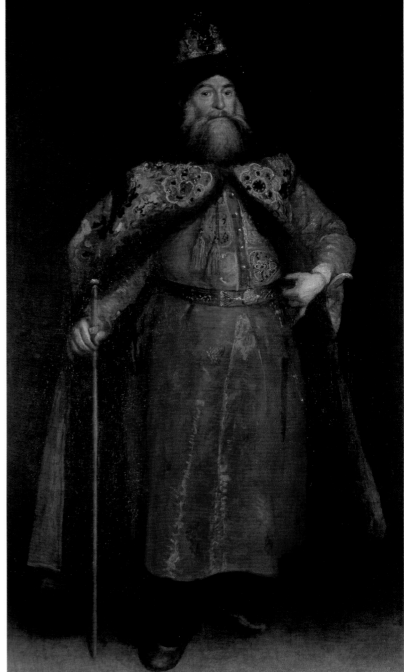

1

1

Juan Carreño de Miranda
Avilés, 1614–Madrid, 1685
The Naked Monster (Eugenia Martínez Vallejo unclothed)
Canvas, 165 × 198 cm
Charles II collection
Cat. no. 2800

2

Juan Carreño de Miranda
Avilés, 1614–Madrid, 1685
Eugenia Martínez Vallejo, known as The Monster
Canvas, 165 × 107 cm
Charles II collection
Cat. no. 646

3

Juan Carreño de Miranda
Avilés, 1614–Madrid, 1685
The Russian Ambassador Piotr Ivanowitz Potemkin, 1681
Canvas, 204 × 120 cm
Charles II collection
Cat. no. 645

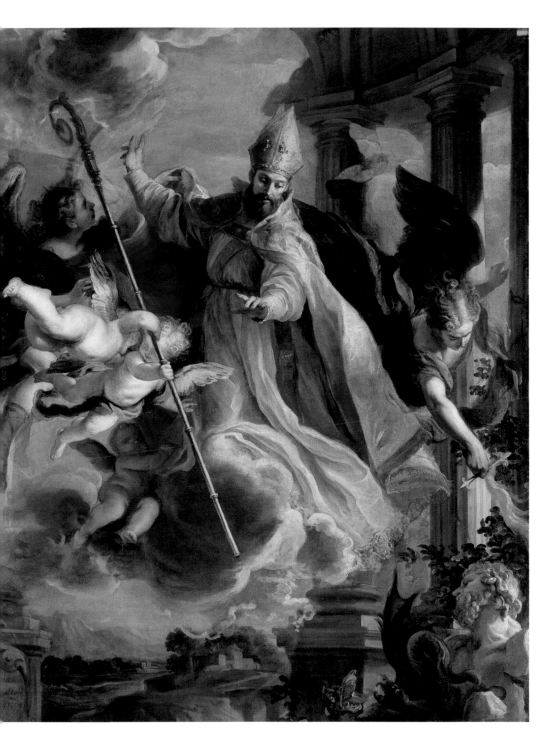

Claudio Coello
Madrid, 1642–93
The Triumph of St Augustine, 1664
Canvas, 271 × 203 cm
From the convent of the Agustinos
Recoletos, Alcalá de Henares
Entered the Museo de la
Trinidad in 1836
Cat. no. 664

Coello, of Portuguese origin, became one of the leading exponents of the seventeenth-century Madrid Baroque school, having absorbed the influence of Carreño and Flemish painting. This large-format work exhibits a number of typical characteristics of the artist, such as the diagonal line of the

figures, emphasizing the impression of dynamic movement by the saint, and the setting formed of elements of classical architecture. The sumptuous, sensual colours are reminiscent of Rubens, and Coello was undoubtedly influenced by the latter's numerous works in the royal collection.

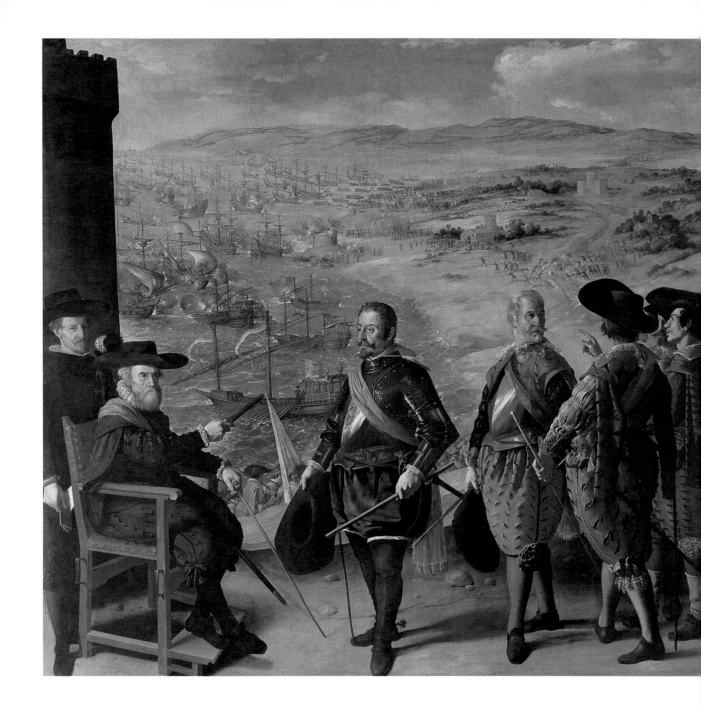

Francisco de Zurbarán
Fuente de Cantos,
1598–Madrid, 1664
The Defence of Cadiz against the
English, 1634
Canvas, 302 × 323 cm
From the Hall of the Realms in
the Buen Retiro Palace
Cat. no. 656

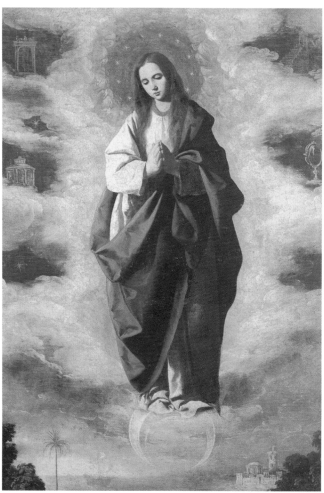

2

1	2	3
Francisco de Zurbarán	**Francisco de Zurbarán**	**Francisco de Zurbarán**
Fuente de Cantos,	Fuente de Cantos,	Fuente de Cantos,
1598–Madrid, 1664	1598–Madrid, 1664	1598–Madrid, 1664
St Elizabeth, 1640	*Our Lady of Immaculate*	*Still life*
Canvas, 184 × 90 cm	*Conception, c.*1630/35	Canvas, 46 × 84 cm
In the royal collection by the end	Canvas, 139 × 104 cm	Donated in 1940 by Don
of the eighteenth century	Acquired in 1956	Francisco Cambó
Cat. no. 1239	Cat. no. 2992	Cat. no. 2803

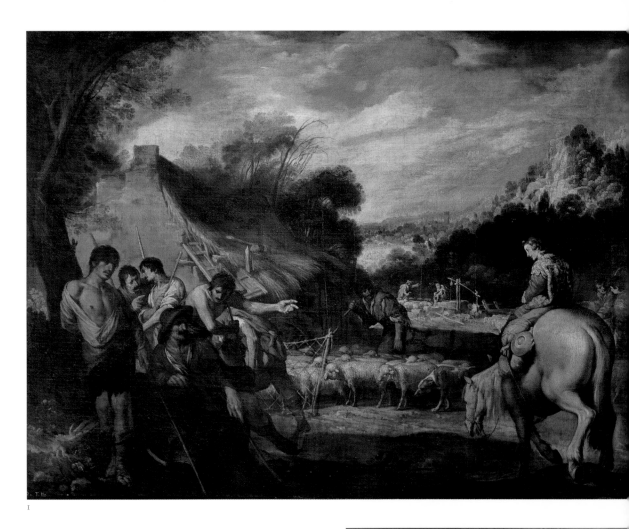

1

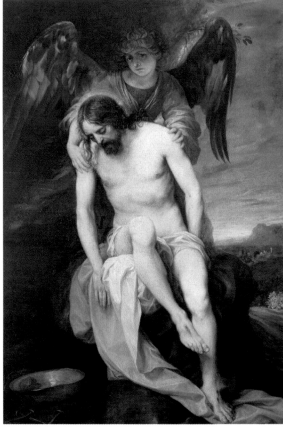

2

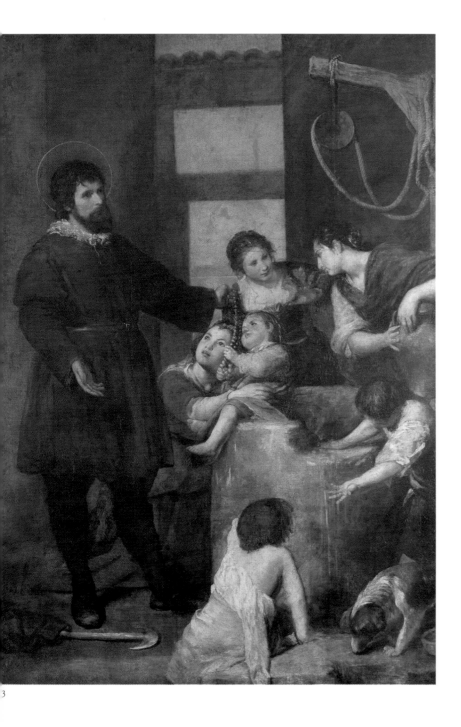

3

1
Antonio del Castillo
Córdoba, 1616–68
Joseph and his Brethren
Canvas, 109 × 145 cm
Entered the Museo de la
Trinidad in 1863
Cat. no. 951

2
Alonso Cano
Granada, 1601–67
*The Dead Christ supported by an
Angel, c.1646/52*
Canvas, 178 × 121 cm
Acquired for Charles III in 1769
from the collection of the
Marquis of La Ensenada
Cat. no. 629

3
Alonso Cano
Granada, 1601–67
*The Miracle of the Well (St Isidro
saves a Child fallen into a Well),
c.1646/8*
Canvas 216 × 149 cm
Entered the Prado in 1941
Cat. no. 2806

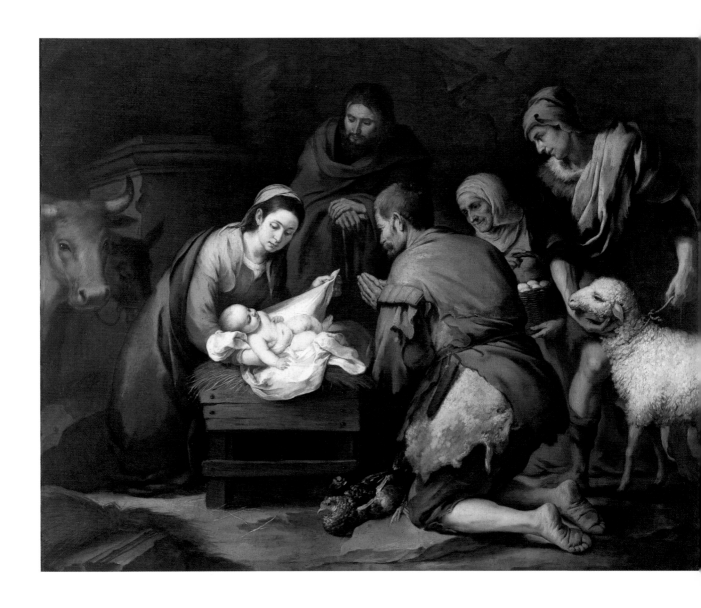

Bartolomé Esteban Murillo
Seville, 1618–82
The Adoration of the Shepherds,
*c.*1650/55
Canvas, 187 × 228 cm
Acquired for Charles III in 1764
from the Kelly collection
Entered the Prado in 1819
Cat. no. 961

Murillo, like Velázquez and
Ribera, is one of the few Spanish
artists with an international repu-
tation. Even during his own
lifetime, his genre paintings were
exported to Flanders. However,
his work aroused much greater
interest in the early nineteenth

century when, as a consequence
of the Peninsular Wars, the agents
of French and other collectors
were able to acquire and export
other types of paintings by him.

This early picture reflects the
typical features of the Seville
School that were the basis of his
development as an artist. There
is an accent on clear detail,
emphasized by contrasts of light
and shade, and the high view-
point gives the impression that
the viewer has just burst upon
the scene. These intimate, imme-
diate effects were typical of the
late-Baroque style of the Counter-
Reformation.

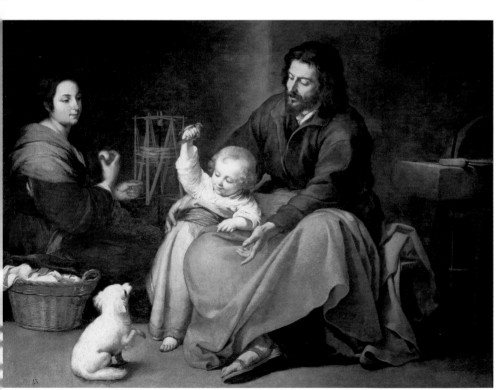

1

Bartolomé Esteban Murillo
Seville, 1618–82
The Martyrdom of St Andrew,
c.1675/82
Canvas, 123 × 162 cm
Collection of Charles IV
Cat. no. 982

2

Bartolomé Esteban Murillo
Seville, 1618–82
Christ the Good Shepherd, c.1660
Canvas, 123 × 161 cm
In the collection of Queen Isabel
Farnese by 1746
Cat. no. 962

3

Bartolomé Esteban Murillo
Seville, 1618–82
The Holy Family, before 1650
Canvas, 144 × 188 cm
In the collection of Queen Isabel
Farnese by 1746
Cat. no. 960

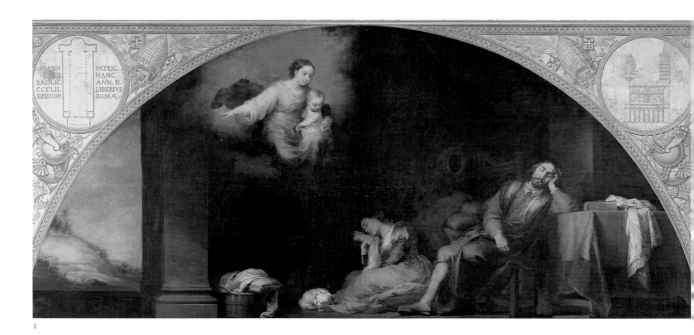

1

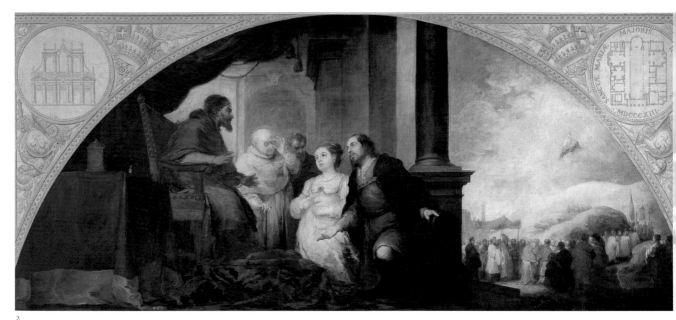

2

1

Bartolomé Esteban Murillo
Seville, 1618–82
*The Founding of Santa Maria
Maggiore in Rome: The Patrician's
Dream*, c.1662/5
Canvas, 232 × 522 cm
Entered the Prado in 1901
Cat. no. 994

2

Bartolomé Esteban Murillo
Seville, 1618–82
*The Founding of Santa Maria
Maggiore in Rome: The Patrician
reveals his Dream to the Pope*,
c.1662/5
Canvas, 232 × 522 cm
Entered the Prado in 1901
Cat. no. 995

Both paintings are from the
church of Santa Maria la Blanca
in Seville. Stolen by Marshal
Soult, they were returned to
Spain and deposited at the Real
Academia de San Fernando.

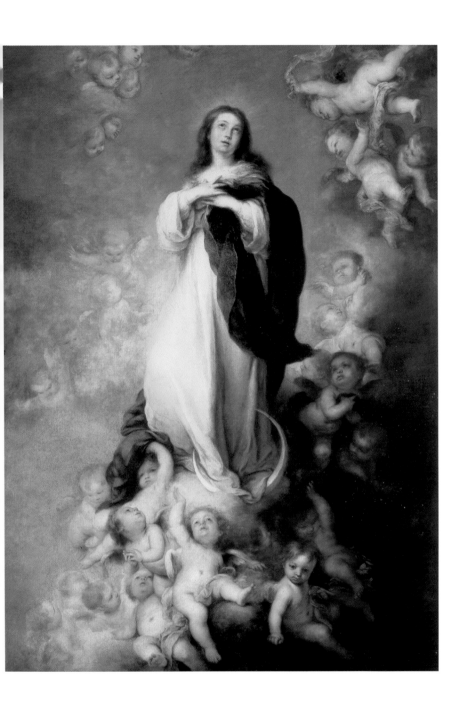

Bartolomé Esteban Murillo
Seville, 1618–82
*The Soult Immaculate Conception, c.*1678
Canvas, 274 × 190 cm
Painted for the church of the Hospital de Venerables Sacerdotes, Seville
Taken to France in 1813 by Marshal Soult
Returned to the Prado in 1941
Cat. no. 2809

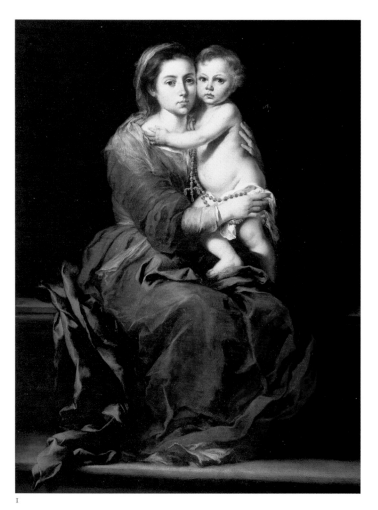

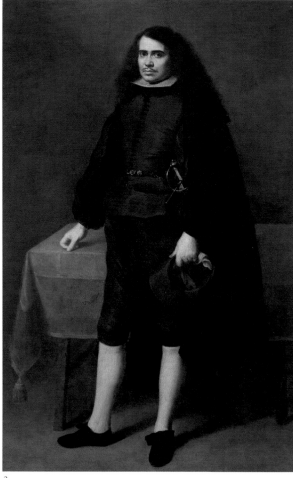

1	2	3	4
Bartolomé Esteban Murillo	**Bartolomé Esteban Murillo**	**Francisco de Herrera the Younger**	**Ignacio Iriarte**
Seville, 1618–82	Seville, 1618–82	Seville, 1622–Madrid, 1685	Santa María de Azcoitia,
The Virgin and Child with Rosary,	*Portrait of a Gentleman in a Ruff,*	*The Triumph of St Hermengild*	1621–Seville, 1685
*c.*1650/55	*c.*1670	Canvas, 328 × 229 cm	*Landscape with a Torrent,* 1665
Canvas, 164 × 110 cm	Canvas, 198 × 127 cm	From the convent of the	Canvas, 112 × 198 cm
Charles IV collection	Acquired in 1941	Carmelitas Descalzos, Madrid	Donated in 1952 by
Cat. no. 975	Cat. no. 2845	Entered the Prado in 1832	Mr Frederick Mont
		Cat. no. 833	Cat. no. 836

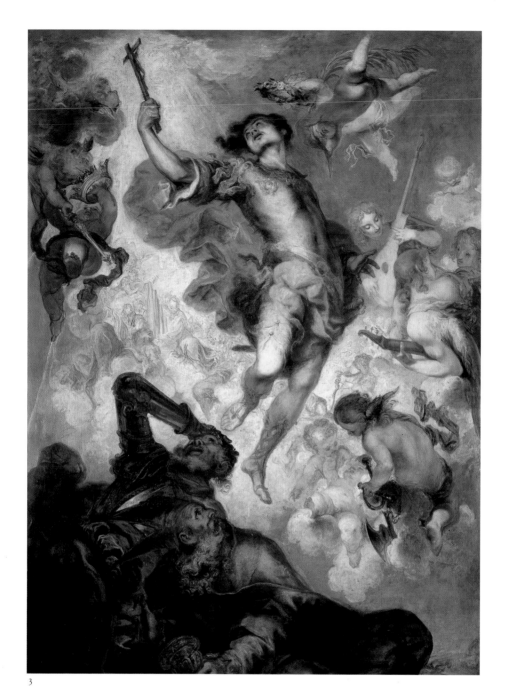

3

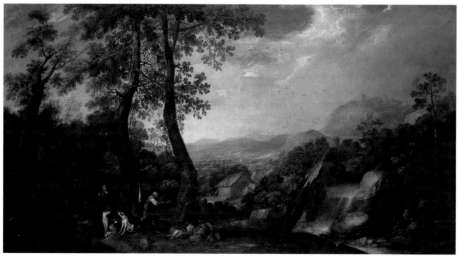

4

GOYA AND THE
EIGHTEENTH CENTURY

The eighteenth century has until recently been considered a period of lesser interest as far as Spanish painting is concerned. It began with artists still working in the decorative Baroque style of the previous century. The paintings by Palomino, better known as the great biographer of Spanish artists, follow the style of Coello and reflect the influence of Luca Giordano; they represent the work of the Madrid School of the time. The century continued with the strong growth of the French and Italian artistic influences introduced by the Bourbon monarchs. This influence was originally limited to the court, but later spread throughout Spain as a consequence of the foundation of the academies, the first of which was the Real Academia de San Fernando, founded in 1752. The academies institutionalized the visit to Rome and unified the output of contemporary artists, who, it must be confessed, did not show any great creative promise.

Before passing on to the phenomenon that was Goya, who brings the century to a close in such an extraordinary manner, mention should be made of two other artists whose work stands out from the modest accomplishments of their contemporaries. The first of these is the still life painter Meléndez, whose excellent representations of domestic utensils, created in meticulous and almost obsessive detail, reflect the naturalist legacy of the previous century. The second is Luis Paret, son of a Frenchman, whose works have a porcelain-like fragility interpreted in a lively, almost miniaturist, manner that combines the best of French and Italian Rococo. The work of Peret, who was a close contemporary of Goya, consists of cabinet paintings, local themes and court scenes, all in all reflecting a delightful and varied sensibility. Both these artists are well represented in the museum.

The emergence of Francisco José de Goya not only entirely redeems Spanish painting of the eighteenth century, but also anticipates some of the most interesting forms of modern art, such as Surrealism and Expressionism. Although his training and early artistic development took place outside Madrid, his marriage to the sister of Francisco Bayeu, an artist much in favour at court, and his subsequent appointment in 1785 as painter to the king gave him the position of official court portraitist. Goya's privileged position at court meant that the Prado automatically inherited a large number of his works, including official portraits and historical paintings. The latter are based on his personal experience of war and go beyond heroic and patriotic representations to produce a savage indictment of human cruelty.

The Prado also possesses Goya's beautiful tapestry cartoons that reflect the more enjoyable and popular side of his work and display great energy and charm in their colouring and composition. This lightness of tone is sometimes combined with a mordant sense of humour, acute observation of the outside world and occasional touches of irony. Lastly, the Prado owns the famous 'Black Paintings', in which, at the age of 74, the deaf and lonely Goya expressed his bitter pessimism through his remorseless depiction of the futility of human existence. Taken as a whole, Goya's works constitute the largest and most varied collection in the entire museum; a study of this collection is crucial to any understanding of the artist's genius.

1

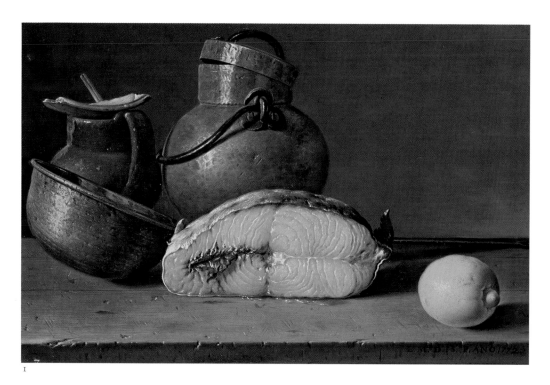

2

Luis Egidio Meléndez
Naples, 1716–Madrid, 1780
Still life, 1772
Canvas, 42 × 62 cm
Charles III collection
Cat. no. 902

2
Luis Paret y Alcázar
Madrid, 1746–98 or 99
Still life of Flowers
Canvas, 39 × 37 cm
Charles IV collection
Cat. no. 1043

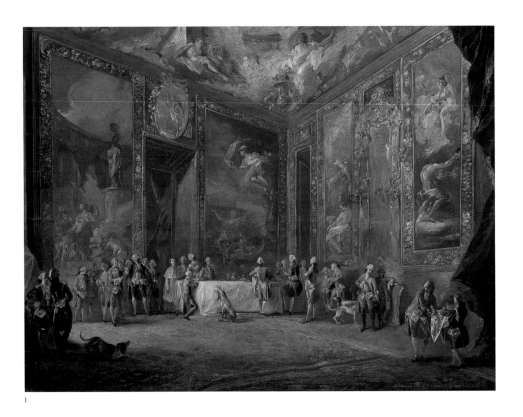

I

1

Luis Paret y Alcázar
Madrid, 1746–98 or 99
*Charles III lunching in the presence
of his Court, c.*1770
Panel, 50 × 64 cm
Supposedly from the Gatchina
Palace in Russia
Acquired with a legacy from the
Count of Cartagena
Cat. no. 2422

Paret is the most distinguished
representative of the Spanish
Rococo. He portrayed aristocrats
and members of the *haute bour-
geoisie* of his day with a studied
elegance. Influenced by the
eighteenth-century Venetian and
French Schools, he developed a
personal technique, combining
transparent textures, achieved by
judicious and somewhat free
brushwork, with light, vaporous
colouring. His scenes and land-
scapes have a dreamy atmosphere
and a slight touch of irony.

2

Francisco Bayeu
Zaragoza, 1734–Madrid, 1795
*The Fall of the Giants besieging
Olympus,* 1764
Canvas, 68 × 123 cm
Acquired by Ferdinand VII for
the Prado
Cat. no. 604

3

Luis Paret y Alcázar
Madrid, 1746–98 or 99
*María Nieves Micaela Fourdinier,
Wife of the Artist, c.*1780
Copper, 37 × 28 cm
Acquired in 1974
Cat. no. 3250

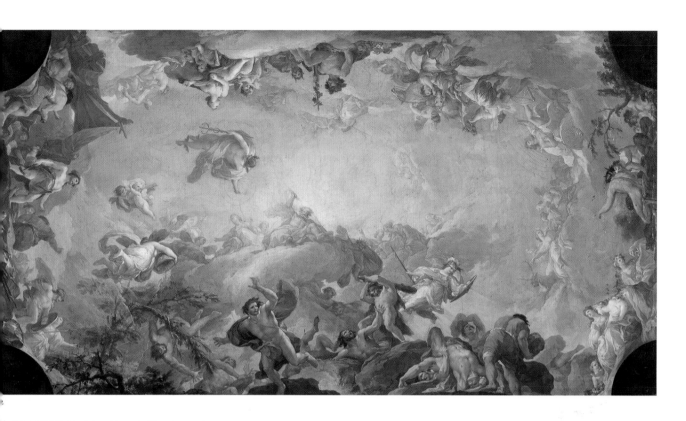

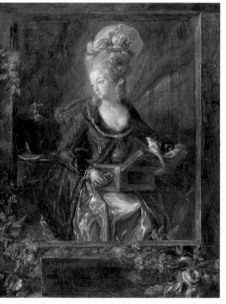

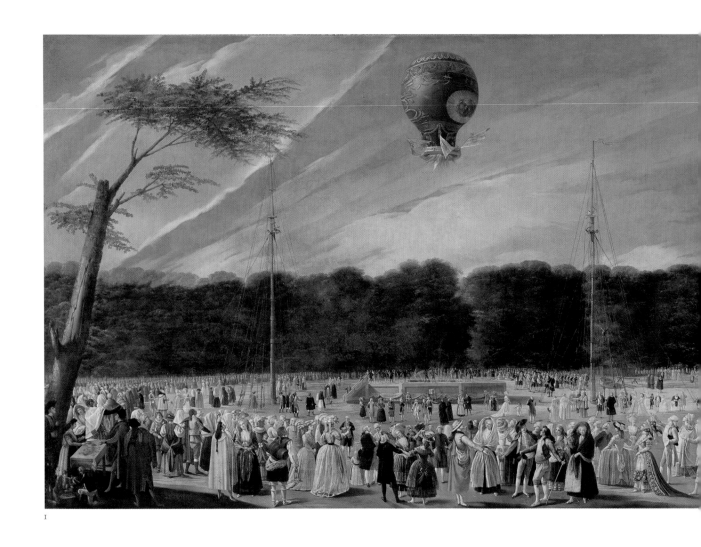

1

1
Antonio Carnicero
Salamanca, 1748–Madrid, 1814
A Montgolfier Balloon at
*Aranjuez, c.*1764
Canvas, 170 × 284 cm
Acquired from the collection of
the Duke of Osuna in 1896
Cat. no. 641

2
José Camarón
Segorbe, 1730–Valencia, 1802
Dancing the 'Bolero', 1790
Canvas, 83 × 108 cm
Acquired in 1980 from the collec-
tion of the Prince of Hohenlohe at
El Quexigal, Madrid
Cat. no. 6732

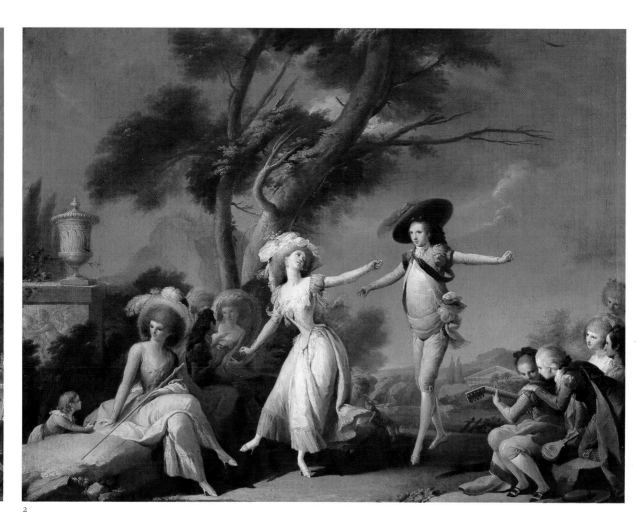

2

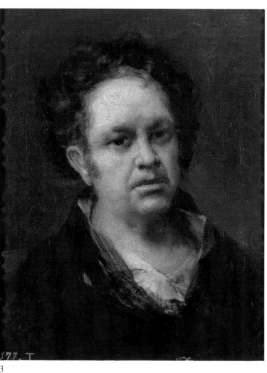

3

3
Francisco José de Goya
Fuendetodos, 1746–
Bordeaux, 1828
Self-portrait, 1815
Canvas, 46 × 35 cm
Acquired for the Museo de la
Trinidad in 1866
Entered the Prado in 1872
Cat. no. 723

In this rigorous, melancholy vision
of himself, Goya seems to be trying
to express his patience in the face of
suffering and disillusionment.

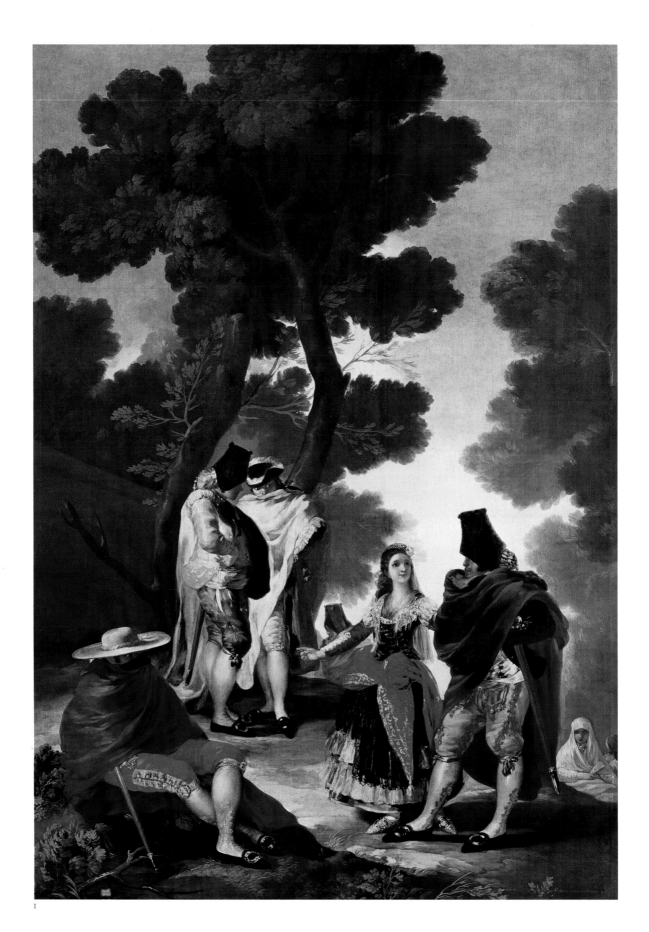

1

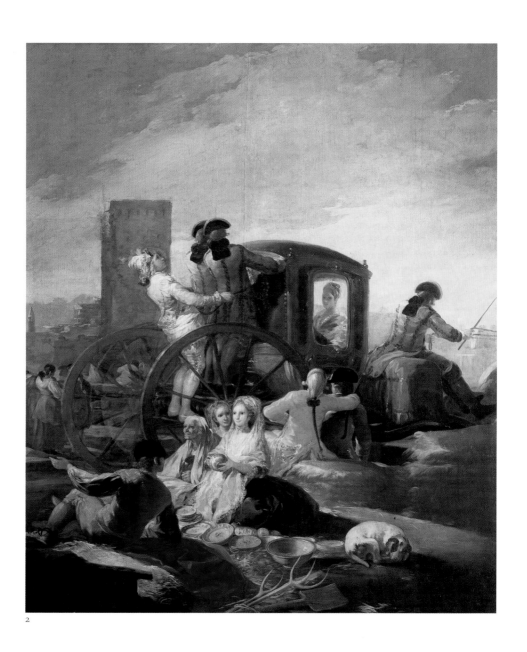

2

Francisco José de Goya
Fuendetodos, 1746–
Bordeaux, 1828
The 'Maja' and Gallants, 1777
Canvas, 275 × 190 cm
From the Royal Palace, Madrid
Entered the Prado in 1870
Cat. no. 771

Francisco José de Goya
Fuendetodos, 1746–
Bordeaux, 1828
The Pottery Vendor, 1779
Canvas, 259 × 220 cm
From the Royal Palace, Madrid
Entered the Prado in 1870
Cat. no. 780

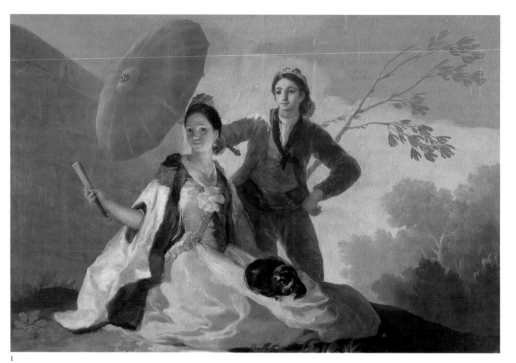

1

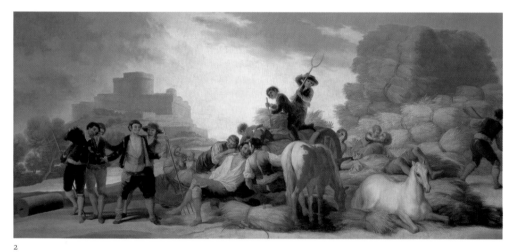

2

1

Francisco José de Goya
Fuendetodos, 1746–
Bordeaux, 1828
The Parasol, 1777
Canvas, 104 × 152 cm
From the Royal Palace, Madrid
Entered the Prado in 1870
Cat. no. 773

This canvas was painted as a car-
toon for a tapestry to hang over
one of the doors in the Prince of
Asturias's dining room in El
Pardo. Goya worked on many
such royal commissions for the
Santa Barbara Tapestry Factory
between 1775 and 1792. The series
of cartoons he produced show the
development of his art from
orthodox court paintings for
decorating the palaces to a more
individual form of expression. It
was a process whereby the artist
moved gradually and subtly from
delicate, mannered anecdote to an
overt facetiousness laced with
crude irony.

2

Francisco José de Goya
Fuendetodos, 1746–
Bordeaux, 1828
Summer, or the Harvest, 1786
Canvas, 276 × 641 cm
From the Royal Palace, Madrid
Entered the Prado in 1870
Cat. no. 794

3

Francisco José de Goya
Fuendetodos, 1746–
Bordeaux, 1828
Autumn, or the Grape Harvest
Canvas, 275 × 190 cm
From the Royal Palace, Madrid
Entered the Prado in 1870
Cat. no. 795

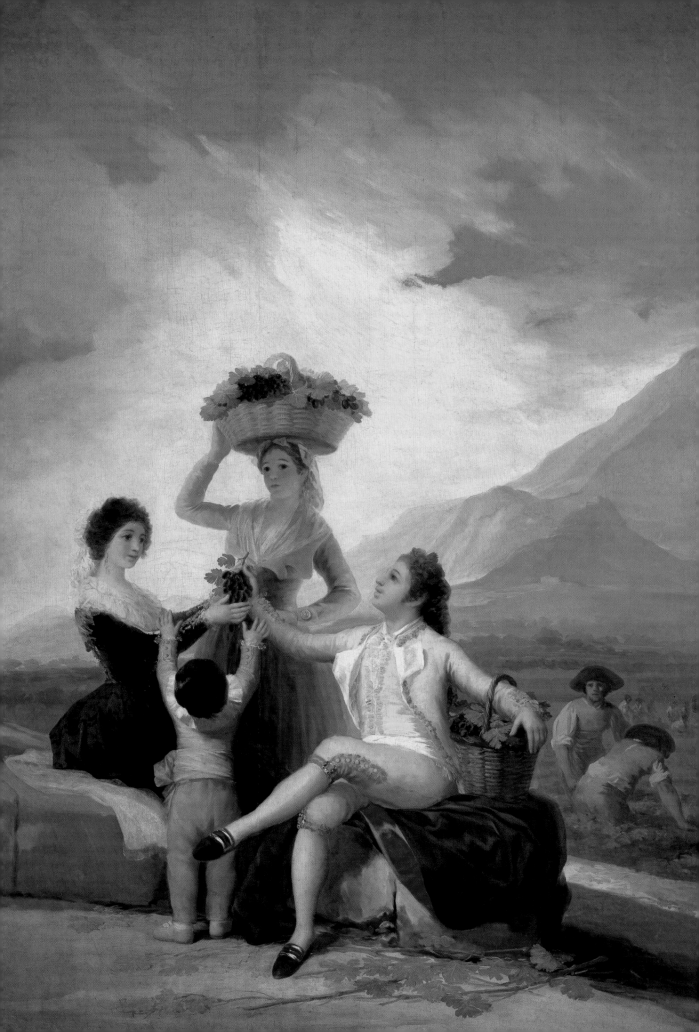

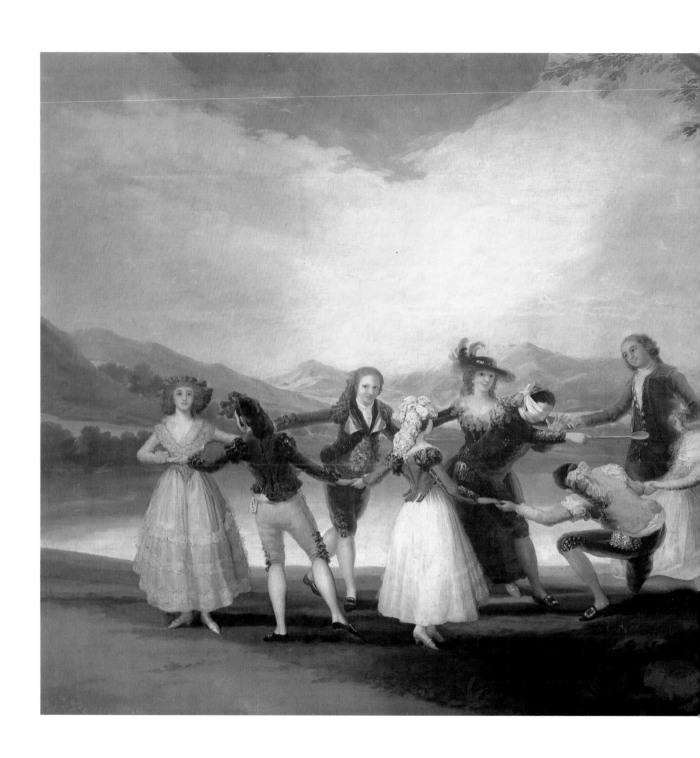

Francisco José de Goya
Fuendetodos, 1746–
Bordeaux, 1828
Blind Man's Buff, 1789
Canvas, 269 × 350 cm
From the Royal Palace, Madrid
Entered the Prado in 1870
Cat. no. 804

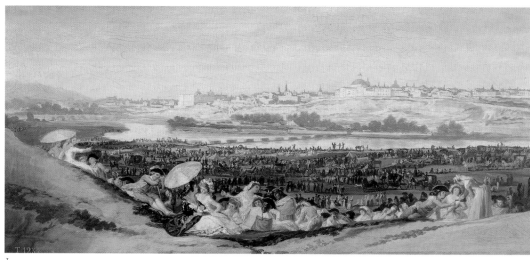

1

2

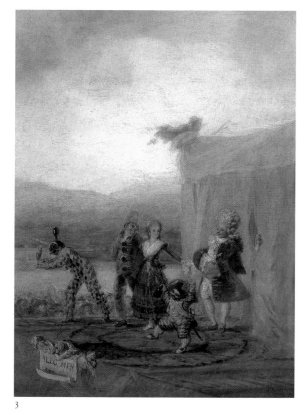

3

1
Francisco José de Goya
Fuendetodos, 1746–
Bordeaux, 1828
The Meadow at St Isidro, 1788
Canvas, 44 × 94 cm
Acquired from the collection of
the Duke of Osuna in 1896
Cat. no. 750

2
Francisco José de Goya
Fuendetodos, 1746–
Bordeaux, 1828
Christ's Arrest in the Garden,
c.1788/98
Canvas, 40 × 23 cm
Acquired in 1966
Cat. no. 3113

3
Francisco José de Goya
Fuendetodos, 1746–
Bordeaux, 1828
The Travelling Players, 1793 (?)
Tin-plate, 43 × 32 cm
Acquired in 1962
Cat. no. 3045

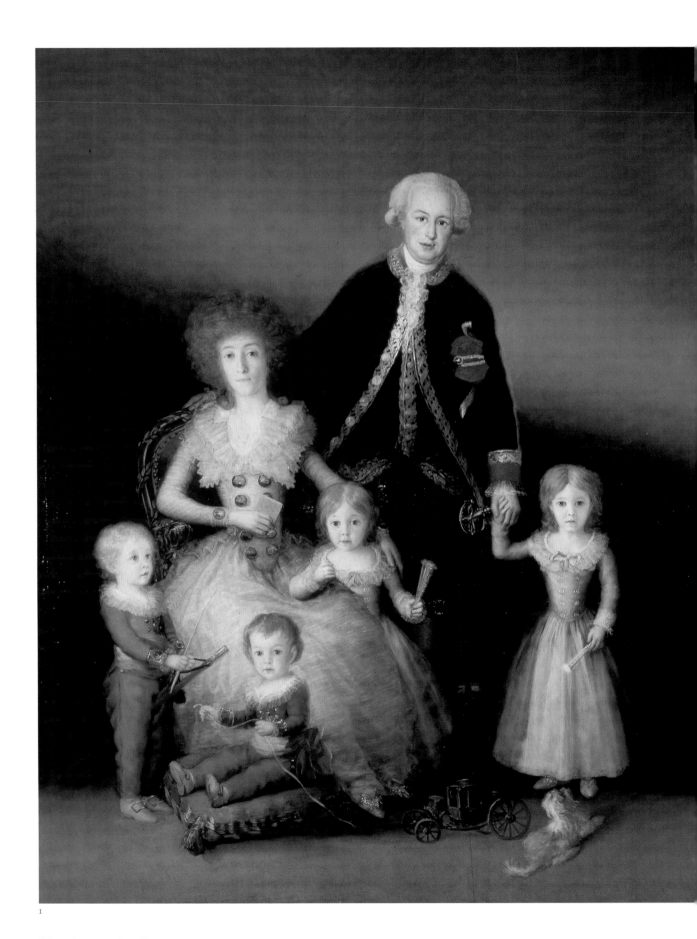

I

1

Francisco José de Goya
Fuendetodos, 1746–
Bordeaux, 1828
*The Duke of Osuna and his
Family*, 1788
Canvas, 225 × 174 cm
Donated to the Prado in 1897
by the descendants of the
Duke of Osuna
Cat. no. 739

Several great Spanish families
commissioned works from Goya,
among them the Osunas. This
excellent group portrait shows
remarkable sensitivity, and the
children, with their small, fragile
bodies and innocent expressions,
are particularly memorable (it is
interesting to note that the seated
child later became Director of the
Prado). The simple composition
and the neutral background
heighten the sense of intimacy,
which is also enhanced by the
silvery grey lighting.

2

Francisco José de Goya
Fuendetodos, 1746–
Bordeaux, 1828
Charles III, as a Huntsman,
c.1786/8
Canvas, 210 × 127 cm
Charles III collection
Cat. no. 737

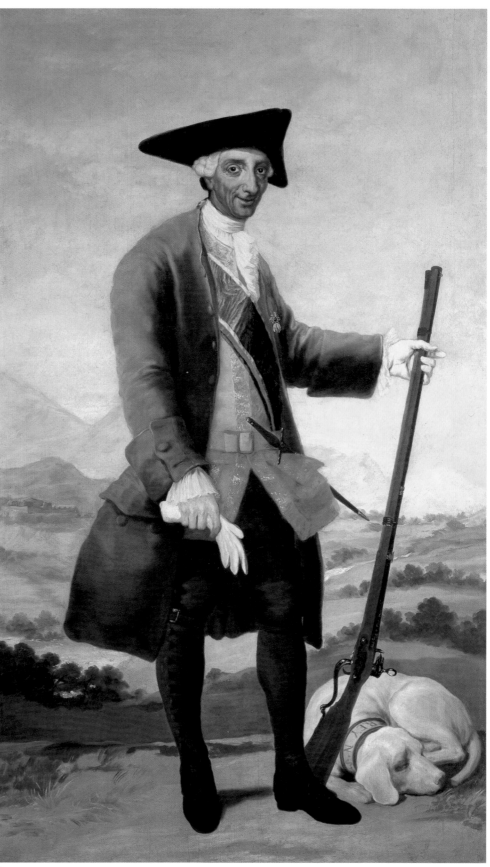

2

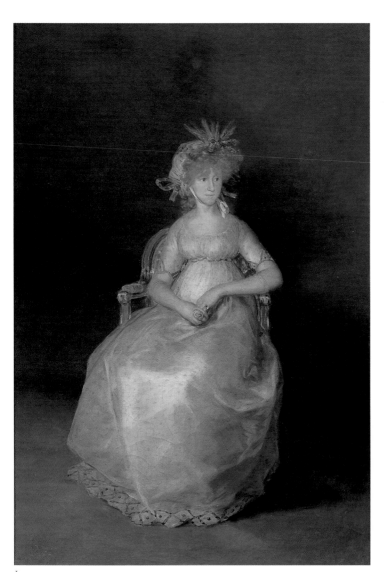

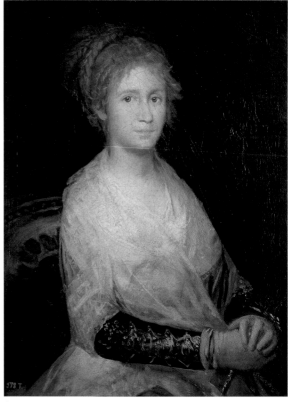

1
Francisco José de Goya
Fuendetodos, 1746–
Bordeaux, 1828
*María Teresa de Borbón y
Vallabriga, Countess of Chincon,*
1800
Canvas, 216 × 144 cm
Acquired in 2000

Daughter of the Infante Luis de
Borbón, brother of Charles III, in
1797 she married Manuel Godoy,
Príncipe de la Paz and a minister
of Charles IV. Goya portrays the
Countess when she was expecting
her first child, the Infanta Carlota.
Shy, exquisite and elegant, she
offers an unforgettable image that
raises this painting to the category
of a masterpiece.

2
Francisco José de Goya
Fuendetodos, 1746–
Bordeaux, 1828
*Doña Josefa Bayeu de Goya, Wife
of the Artist* (?), c.1790/98
Canvas, 81 × 56 cm
Acquired in 1866 for the Museo
de la Trinidad
Entered the Prado in 1872
Cat. no. 722

3
Francisco José de Goya
Fuendetodos, 1746–
Bordeaux, 1828
The Marquis of Villafranca, 1795
Canvas, 195 × 126 cm
Bequeathed in 1926 by the Count
of Niebla
Cat. no. 2449

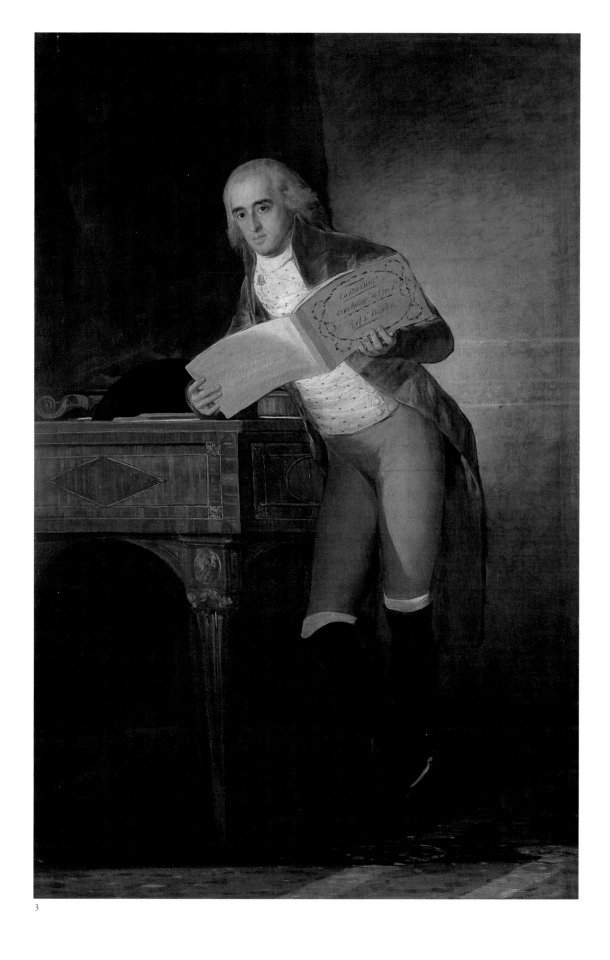

3

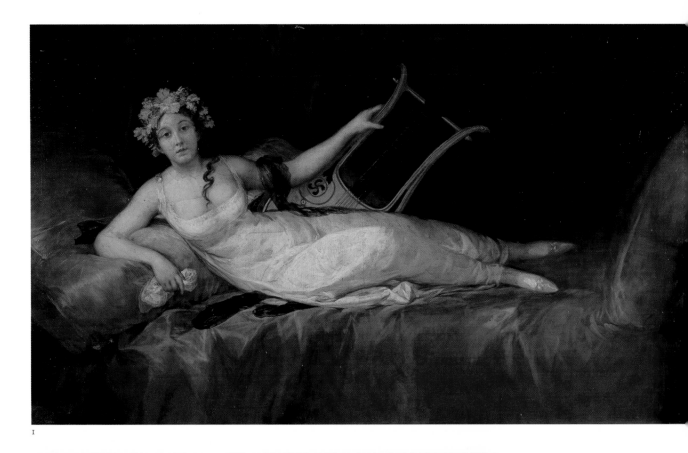

1

2

1
Francisco José de Goya
Fuendetodos, 1746–
Bordeaux, 1828
The Marquesa de Santa Cruz, 1805
Canvas, 125 × 207 cm
Acquired in 1986
Cat. no. 7070

2
Francisco José de Goya
Fuendetodos, 1746–
Bordeaux, 1828
Still life, c.1808/12
Canvas, 45 × 63 cm
Acquired in 1900
Cat. no. 751

3
Francisco José de Goya
Fuendetodos, 1746–
Bordeaux, 1828
*Queen María Luisa wearing a
Mantilla*, 1799
Canvas, 209 × 125 cm
In the royal collection by the
early nineteenth century
Cat. no. 728

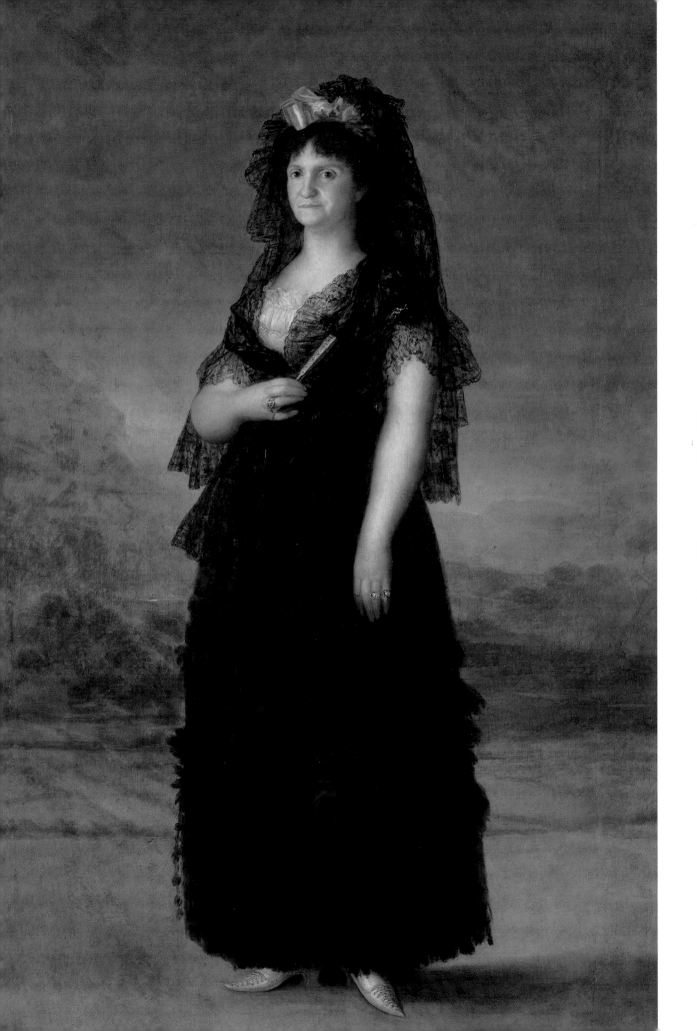

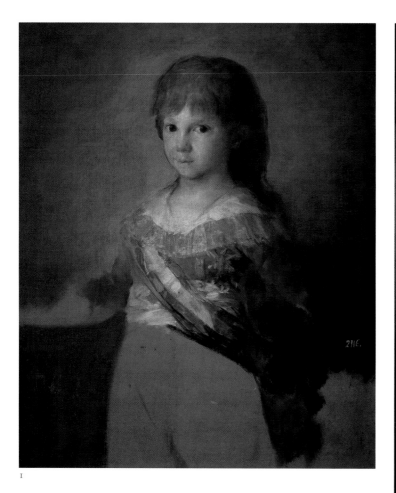

1

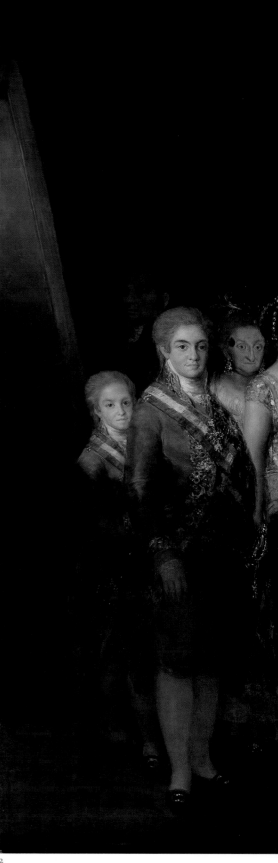

1
Francisco José de Goya
Fuendetodos, 1746–
Bordeaux, 1828
*The Infante Don Francisco de
Paula Antonio,* 1800
Canvas, 74 × 60 cm
Charles IV collection
Cat. no. 730

2
Francisco José de Goya
Fuendetodos, 1746–
Bordeaux, 1828
Charles IV with his Family, 1800
Canvas, 280 × 336 cm
Charles IV collection
Cat. no. 726

2

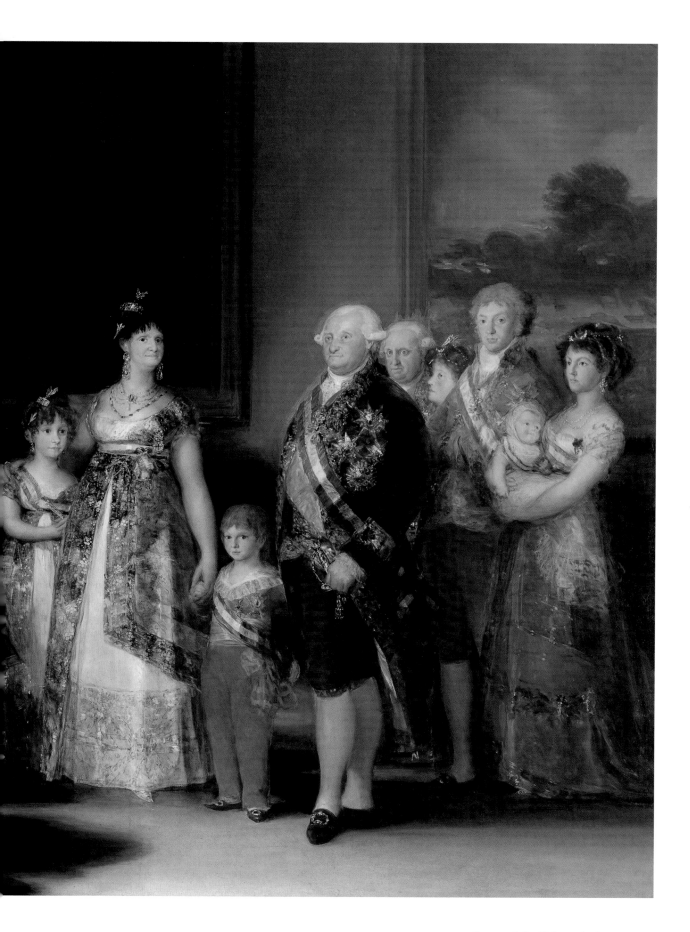

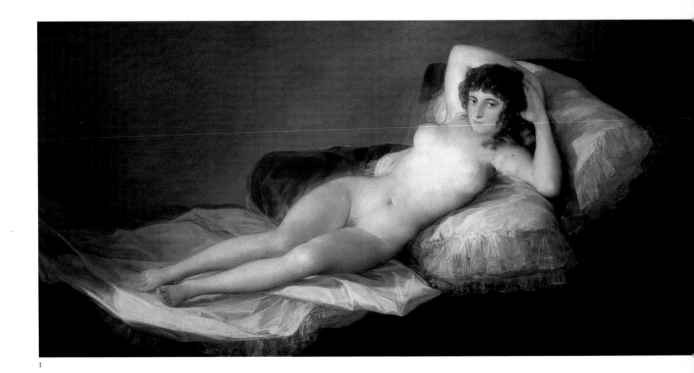

1

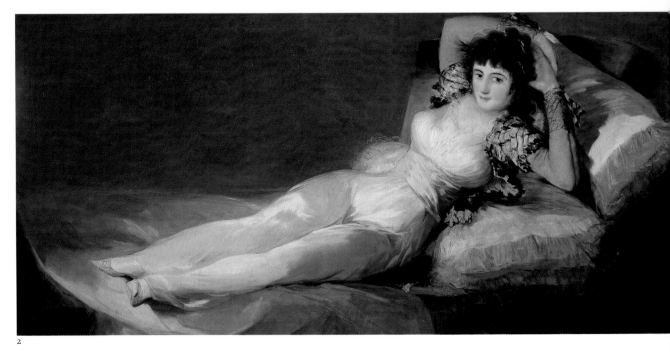

2

1
Francisco José de Goya
Fuendetodos, 1746–
Bordeaux, 1828
The Naked 'Maja', c.1800/03
Canvas 97 × 190 cm
From the collection at the Real
Academia de San Fernando
Entered the Prado in 1901
Cat. no. 742

2
Francisco José de Goya
Fuendetodos, 1746–
Bordeaux, 1828
The Clothed 'Maja', c.1800/03
Canvas, 95 × 190 cm
From the collection at the Real
Academia de San Fernando
Entered the Prado in 1901
Cat. no. 741

3
Francisco José de Goya
Fuendetodos, 1746–
Bordeaux, 1828
The Naked 'Maja' (detail)

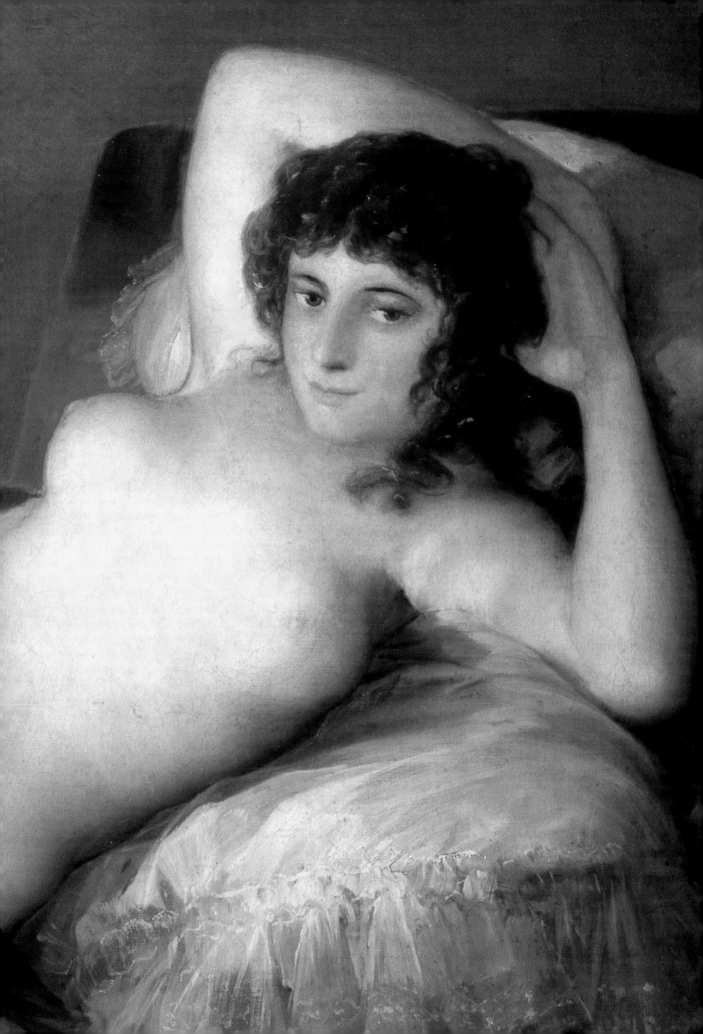

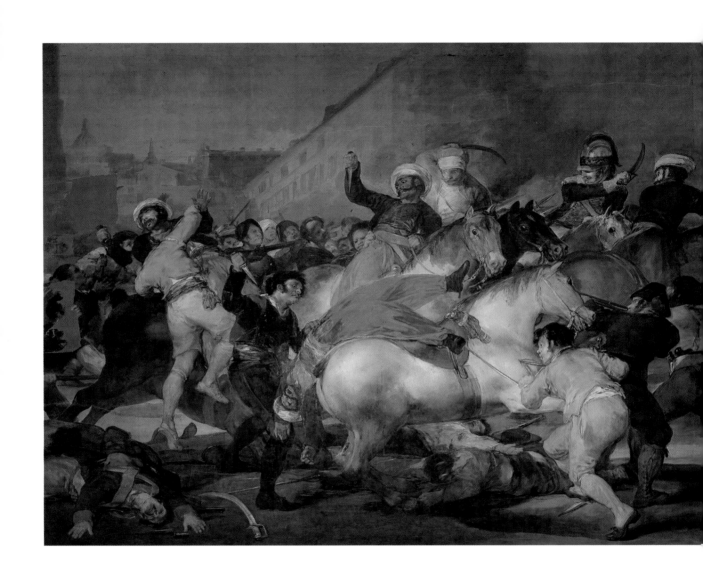

Francisco José de Goya
Fuendetodos, 1746–
Bordeaux, 1828
*The Second of May 1808: The Charge
of the Mamelukes,* 1814
Canvas, 266 × 345 cm
Ferdinand VII collection
Cat. no. 748

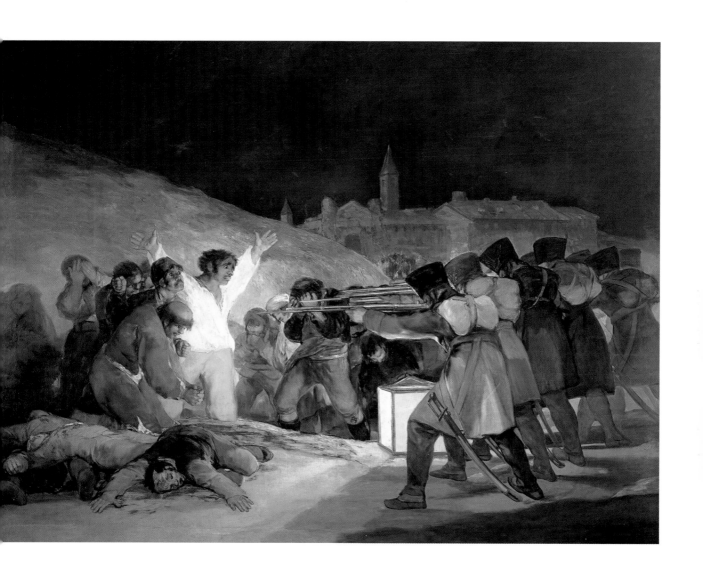

Francisco José de Goya
Fuendetodos, 1746–
Bordeaux, 1828
*The Third of May 1808:
The Execution of the Defenders
of Madrid*, 1814
Canvas, 266 × 345 cm
Ferdinand VII collection
Cat. no. 749

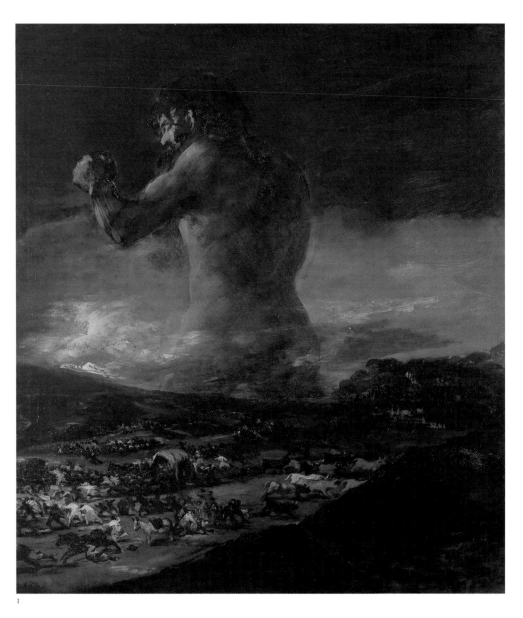

1

Francisco José de Goya
Fuendetodos, 1746–
Bordeaux, 1828
The Colossus, 1808/12
Canvas, 116 × 105 cm
Bequeathed in 1930 by Don
Pedro Fernández Durán
Cat. no. 2785

Goya's famous 'Black Paintings'
received their name as a result of
their horrifying contents rather
than their colouring. He painted
them on the inside walls of his
house, La Quinta del Sordo, on
the banks of the River
Manzanares; they were removed
and transferred to canvas in 1873.
 They are highly personal and
overwhelmingly pessimistic.
There are many different ways of
interpreting them in detail, but
the idea of futile conflict, and of
man's evil and stupid ways,
emerges frequently. The ageing
artist revealed a constant preoccu-
pation with despair, horror and
the grotesque.

2

Francisco José de Goya
Fuendetodos, 1746–
Bordeaux, 1828
*La Leocadia (Doña Leocadia
Zorrilla, the Artist's Housekeeper)*
*c.*1821/3
Mural transferred to canvas,
147 × 132 cm
Donated in 1881 by
Baron Emile d'Erlanger
Cat. no. 754

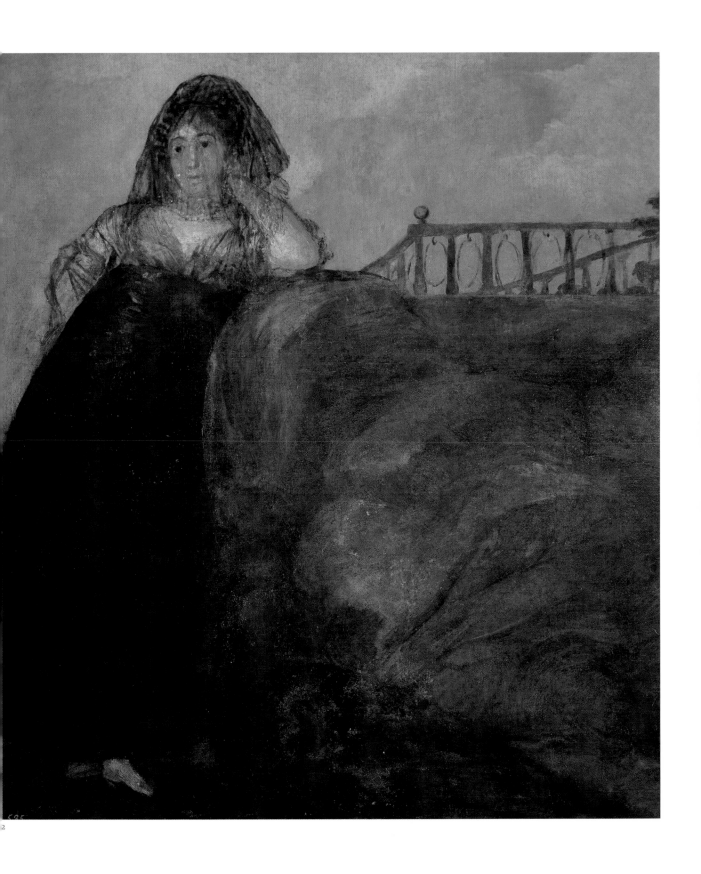

585
2

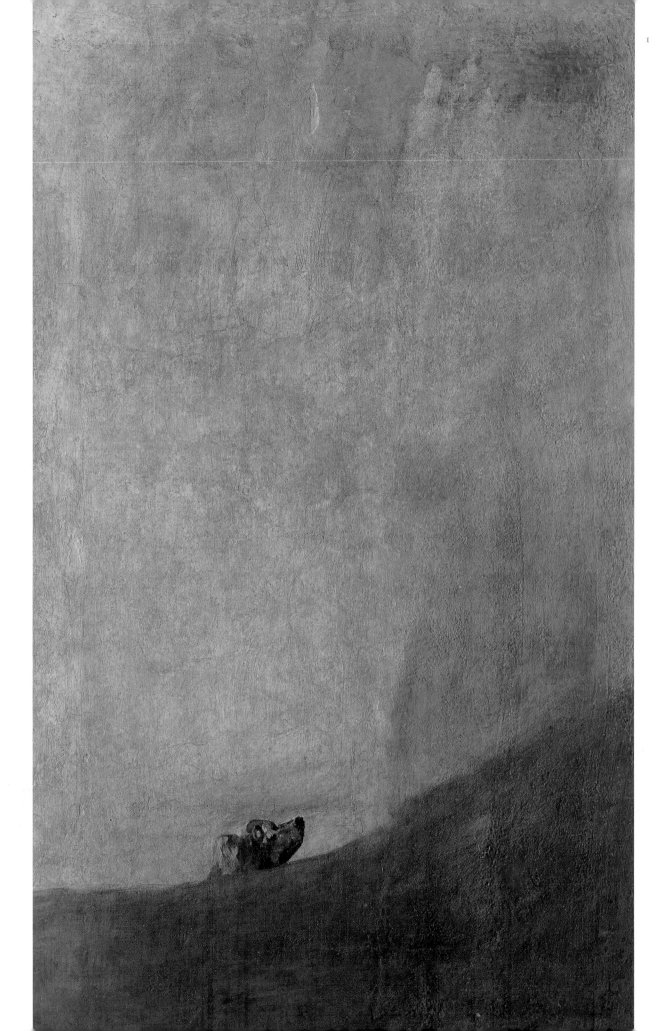

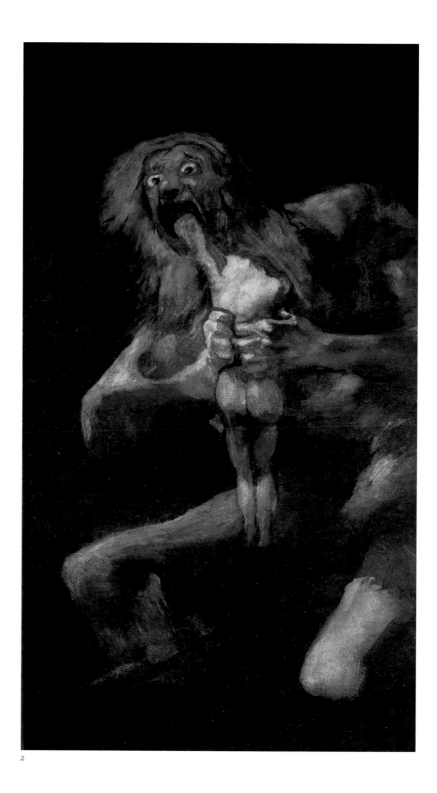

Francisco José de Goya
Fuendetodos, 1746–
Bordeaux, 1828
The Dog, c.1821/3
Mural transferred to canvas,
134 × 80 cm
Donated in 1881 by
Baron Emile d'Erlanger
Cat. no. 767

Francisco José de Goya
Fuendetodos, 1746–
Bordeaux, 1828
Saturn devouring one of his Sons
c.1821/3
Mural transferred to canvas,
146 × 83 cm
Donated in 1881 by
Baron Emile d'Erlanger
Cat. no. 763

2

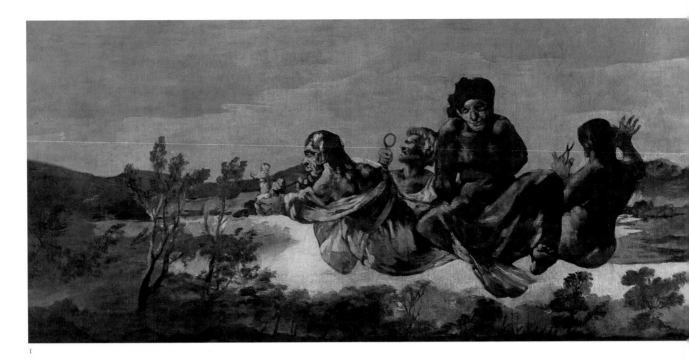

1

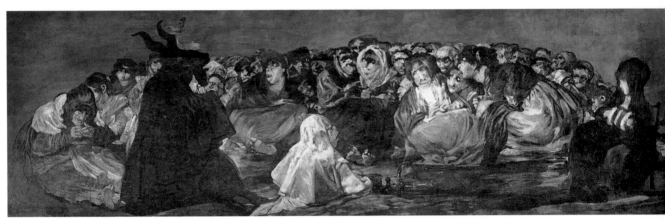

2

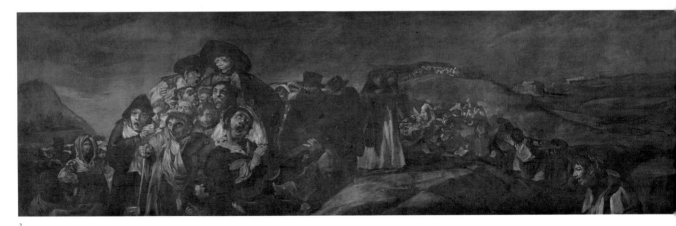

3

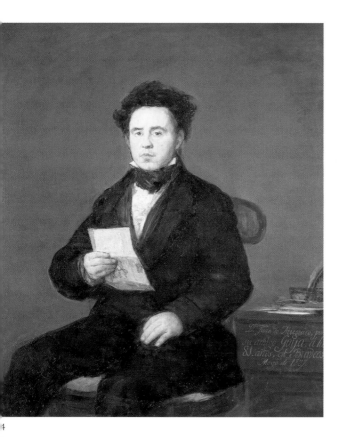

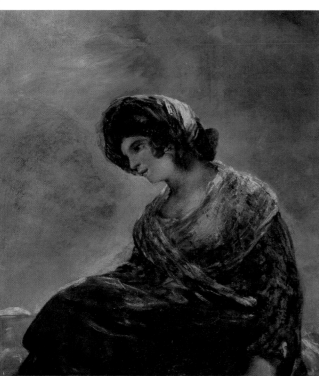

1
Francisco José de Goya
Fuendetodos, 1746–
Bordeaux, 1828
The Fates (Atropos), c.1821/3
Mural transferred to canvas,
123 × 266 cm
Donated in 1881 by Baron Emile
d'Erlanger
Cat. no. 757

2
Francisco José de Goya
Fuendetodos, 1746–
Bordeaux, 1828
The Witches' Sabbath, c.1821/3
Mural transferred to canvas,
140 × 438 cm
Donated in 1881 by Baron Emile
d'Erlanger
Cat. no. 761

3
Francisco José de Goya
Fuendetodos, 1746–
Bordeaux, 1828
San Isidro Pilgrimage, c.1821/3
Mural transferred to canvas,
146 × 438 cm
Donated in 1881 by Baron Emile
d'Erlanger
Cat. no. 766

4
Francisco José de Goya
Fuendetodos, 1746–
Bordeaux, 1828
Don Juan Bautista de Muguiro,
1827
Canvas, 74 × 68 cm
Bequeathed by the 2nd Count of
Muguiro
Cat. no. 2898

5
Francisco José de Goya
Fuendetodos, 1746–
Bordeaux, 1828
The Milkmaid from Bordeaux,
c.1825/7
Canvas, 74 × 68 cm
Bequeathed in 1946 by the
Count of Muguiro
Cat. no. 2899

Painted two or three years before
the artist's death, this work is a
tribute to Goya's vitality despite
his age. Continuing to experiment
with new techniques, he adopted
freer, more luminous colours,
using shorter brush strokes and
applying the paint in a style that
anticipated the Impressionists.

THE NINETEENTH CENTURY

Most of the romantic art of the nineteenth century is to be found in the Casón del Buen Retiro (the annex to the Prado), which also houses a fine selection of portraits by Federico de Madrazo, who succeeded Vicente López as the most distinguished portrait painter in Madrid. The Buen Retiro also contains the works by Antonio María Esquivel, with examples of his historical pictures, religious compositions, genre paintings and portraits, including his *Gathering of the Poets*, which is of particular interest.

The work of three of the artists from this period – Lucas, Alenza and Lameyer – are examples of what the historian Elías Torno termed the 'the bold vein', a recurring feature of Spanish painting from El Greco, through Goya, to Picasso. These artists might be described as 'romantic colourists', very much in the style of Delacroix, the spirit of French Romanticism, as distinct from the classicism of his compatriot, Ingres. It would be quite unfair to classify Eugenio Lucas as simply an imitator of Goya (though he certainly shows talent in assimilating Goya's 'Black' style) since he displays a much greater degree of intelligence and creative capacity in his less derivative works. The Buen Retiro possesses an extensive collection of paintings by Lucas, with works on many of his favourite subjects, among which are to be found scenes of the Inquisition, witchcraft, bull-fighting and *majas* on balconies. Leonardo Alenza, a more important artist than Lucas, was also influenced by Goya's style, as can be seen in works such as the portrait of Pasutti and *The Beating*, which is a version of one of the *Caprichos* titled *If you break the jug...* However, before encountering Goya's painting, Alenza absorbed the influence of Teniers through works at present in the Prado, and his *costumbrista* style can be attributed to this pictorial context as much as to the later influence of Goya. Among this group of 'romantic colourists' Francisco Lameyer stands out as a painter captivated by African and oriental themes, a predilection that earned him the rather incongruous title of the 'Spanish Delacroix'.

Spanish *costumbrismo* – art depicting local customs and manners – was made up of a number of varied and individual styles that were appreciated both in Spain and abroad. The four main exponents of this genre in the Casón del Buen Retiro are the delicate purist, Valeriano Bécquer; the quasi-naïve Manuel Cabral y Aguado Bejarano; the realist Manuel Castellano; and Manuel Rodríguez de Guzmán. Under the influence of David Roberts (1796–1864), such artists as Genaro Pérez Villaamil and Luis Rigalt established a new form of landscape painting, sometimes filled with fantasy, from which the immediate realist current was to develop. Its most significant representative in Spain was Carlos de Haes, who although Belgian by birth was brought up in Málaga and was undoubtedly more Spanish than Flemish.

Among the artists active at the start of realist landscape painting in Spain was Martín Rico. Born in Madrid, Rico eventually settled in Venice and his later style shows a luminosity and precise draughtsmanship partly influenced by Mariano Fortuny. Yet another contemporary, Ramon Martí i Alsina, was highly influential in his native Catalonia. Among the collection of realist landscapes to be seen in the Buen Retiro, the works of the following artists are also represented: Jaime Morera, one of the closest followers of Haes; Antonio Muñoz Degrain, who did not limit himself exclusively to landscapes; and José Jiménez Aranda, well known as a painter of anecdotal genre paintings but who also produced landscapes that appear to anticipate the super-realism of the twentieth century.

Mariano Fortuny was a painter who enjoyed a considerable reputation during his short but brilliant career. Although the critics of the first wave of French Impressionism reproached him for his association with the new style, he was not in any real sense an Impressionist. However, his work has many fascinating characteristics, including a delight in the effects of sunlight and an easy, fluent technique; on the other hand, he is noted for his rigorous draughtsmanship as well as a palette that is always in keeping with the subject matter, be it light or dark. Of the many examples of Fortuny's varied oeuvre which are displayed in the Buen Retiro, certain parts of the picture of his own sons in the Japanese Room perhaps best illustrate the modernity and virtuosity of this artist's work. Raimundo de Madrazo, a brother-in-law of Fortuny and son of the painter Federico de Madrazo, is also an artist who painted with pleasant effects, despite of his extreme realism.

For most Spaniards, the quality of Eduardo Rosales's work is comparable to that of Fortuny. Unlike Fortuny's uninhibited style, however, Rosales's paintings are of a stately gravity that reflects something of the humanity and creativity that are so characteristic of the Spanish spirit. Rosales placed himself in the historical Spanish tradition, as can be seen in his monumental composition *The Testament of Queen Isabella the Catholic*.

Two interesting artists that were close contemporaries of Rosales and Fortuny are Vicente Palmaroli and José Casado del Alisal. Palmaroli is an ambivalent painter. On the one hand he produced work displaying scrupulous draughtsmanship and modelling, whilst on the other he cultivated a very fluid style using an uneven palette in which dark and sombre tones predominate.

Francisco Domingo Marqués, Ignacio Pinazo and Joaquín Sorolla are three Valencian artists who became highly significant Spanish painters of the late nineteenth and early twentieth centuries. All three, with their rich and fluent styles, developed nineteenth-century realism in a dramatic form. In the case of

Marqués and Pinazo this was done without departing from their uneven and often dark colour range; they showed a lively interest in the material quality of the paint itself and portrayed the natural world with great skill. However, although Sorolla did not entirely abandon the dark palette, which seems to have such an affinity with the Spanish temperament, he succeeded in becoming a remarkable luminarist.

The last section in the Buen Retiro contains landscapes of the late nineteenth and early twentieth centuries. There is an extensive selection of paintings by Aureliano de Beruete, which clearly demonstrates his impressionistic work with its keen perception of light, atmosphere and form. There are also several works by Agustín Riancho who, like Beruete, was a follower of Carlos de Haes. Riancho ended his career as a realist painter, when his work underwent a sudden transformation that resulted in an intense, almost Fauvist style of pictorial expression.

It should finally be mentioned, at the end of this brief description of nineteenth-century art owned by the Prado, that since the holding is very extensive, much of it has been distributed among other Spanish museums. The collection consists mainly of paintings that have won awards at the National Fine Arts Exhibitions, the first of which was held in 1856. A considerable number of excellent pictures come from donations and legacies. The paintings that had formerly belonged to the Prado and the Museo de la Trinidad were kept at the Museo de Arte Moderno in Madrid from 1894 to 1968. When the latter closed, they were transferred to the Museo Español de Arte Contemporáneo, also in Madrid, where they remained until 1971, when they were returned to the Prado.

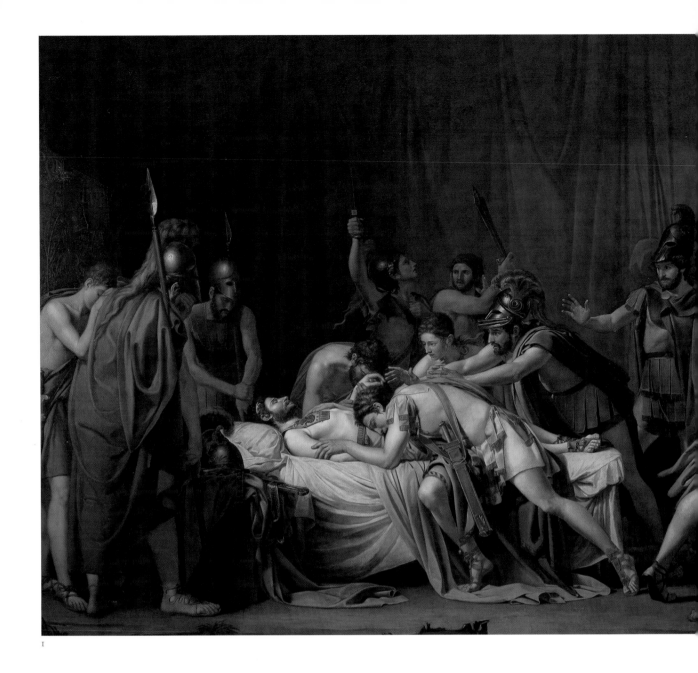

1

1
José de Madrazo
Santander, 1781–Madrid, 1859
*The Death of Viriatus, c.*1808/18
Canvas, 307 × 462 cm
In the royal collection by the
nineteenth century
Cat. no. 4469

2
Vicente López
Valencia, 1772–Madrid, 1850
Francisco José de Goya, 1826
Canvas, 93 × 77 cm
In the royal collection by the
nineteenth century
Cat. no. 864

3
Vicente López
Valencia, 1772–Madrid, 1850
Sketch for a ceiling painting,
*The Institution of the Order of
Charles III*
Canvas, 113 × 106 cm
Acquired in 1879
Cat. no. 3804

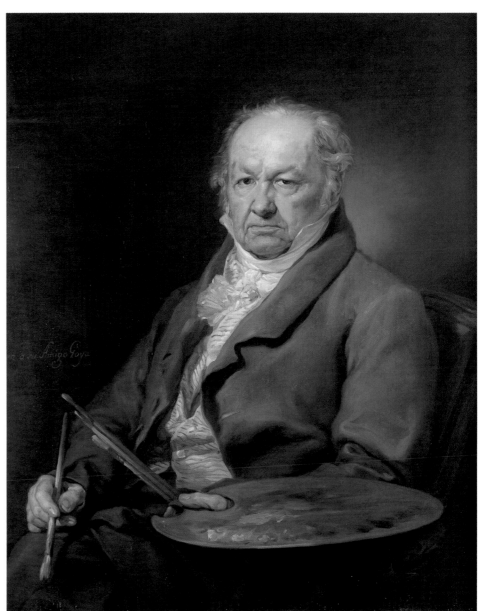

2

3

1

1
Bernardo López
Valencia, 1800–Madrid, 1874
Queen María Isabel de Braganza, 1829
Canvas, 254 × 172 cm
In the royal collection by the nineteenth century
Cat. no. 863

Bernardo López, son of the more famous Vicente López, never developed his own style in any significant way but remained a close follower of his father. The subject of the portrait, who was born in 1797 and died in 1818, was the second wife of Ferdinand VII of Spain and the daughter of John VI of Portugal and Queen Carlota Joaquina de Borbón. The picture commemorates her as co-founder of the Prado.

2
Eugenio Lucas
Alcalá de Henares, 1824–Madrid, 1870
A Huntsman
Canvas, 216 × 153 cm
Acquired in 1931
Cat. no. 4424

3
Eugenio Lucas
Alcalá de Henares, 1824–Madrid, 1870
'Majas' on a Balcony, 1862
Canvas, 107 × 81 cm
From the Victórica bequest in 1969
Cat. no. 4427

4
Ascensió Juliá
Valencia, 1767–Madrid, *c.*1830
Scene from a Comedy
Canvas, 42 × 56 cm
Acquired in 1934
Cat. no. 2573

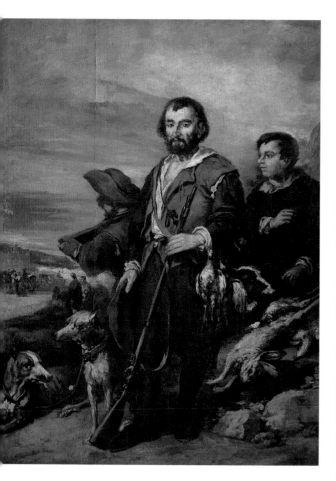

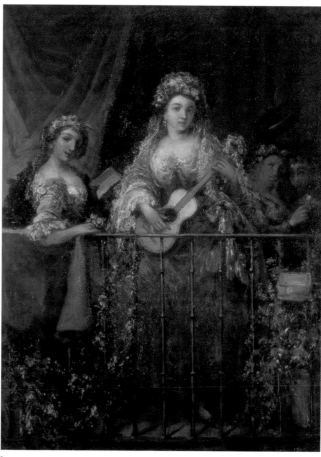

3

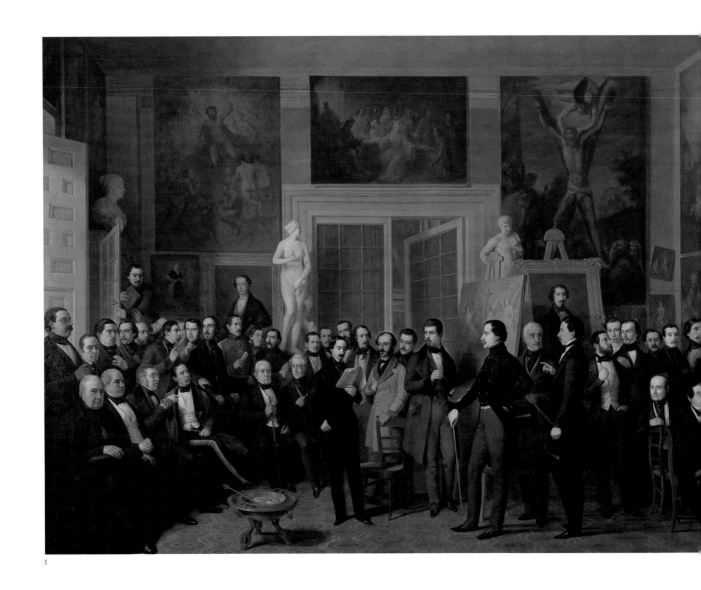

1

1
Antonio María Esquivel
Seville, 1806–Madrid, 1857
The Gathering of the Poets, 1846
Canvas, 144 × 217 cm
Donated in 1866 by the Ministry
for Development
Cat. no. 4299

2
Valeriano Domínguez Bécquer
Seville, 1834–Madrid, 1870
Sorian Peasants dancing, 1866
Canvas, 65 × 101 cm
Donated by the artist on receiving
a government pension
Cat. no. 4324

3
Leonardo Alenza
Madrid, 1807-45
'El gallego de los curritos'
Canvas, 35 × 25 cm
From the Museo de Arte
Moderno
Cat. no. 4205

4
Francisco Lameyer
Puerto de Santa María,
1825–Madrid, 1877
A Group of Moors
Panel, 38 × 54 cm
From the Laffitte bequest in 194
Cat. no. 4394

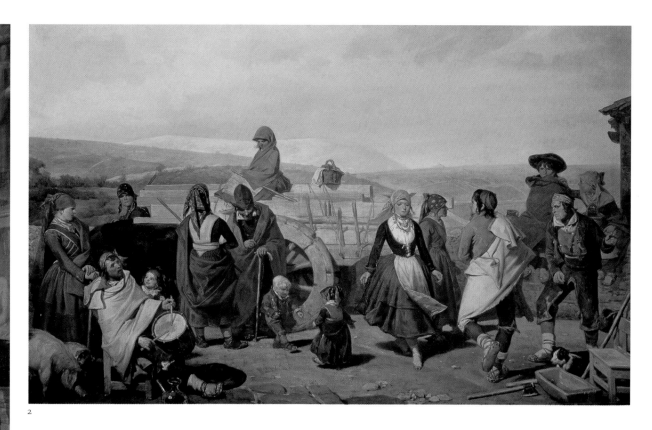

2

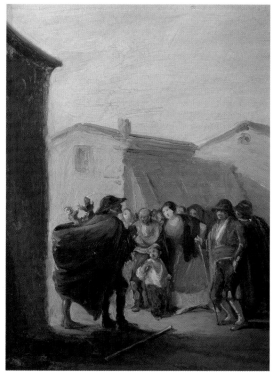

3

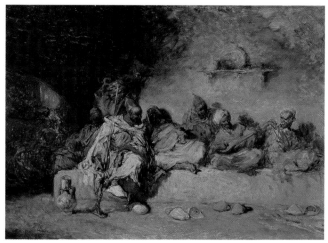

4

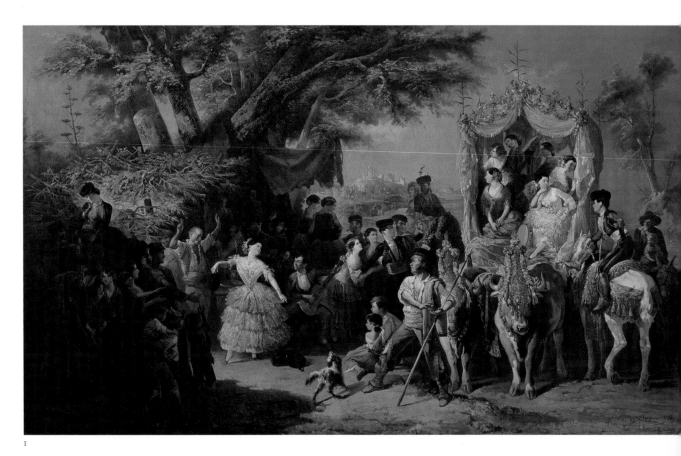

1

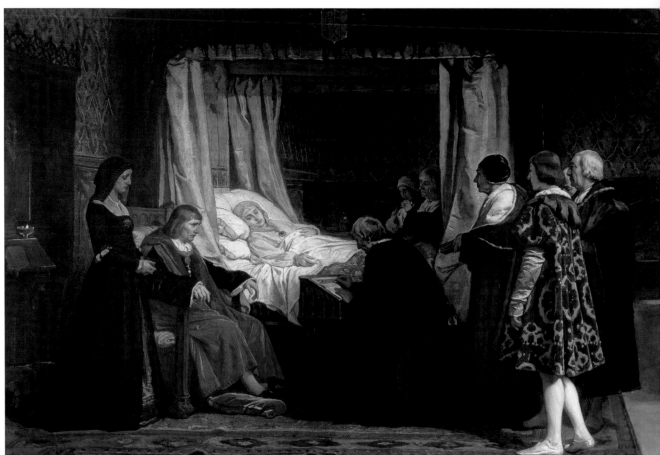

2

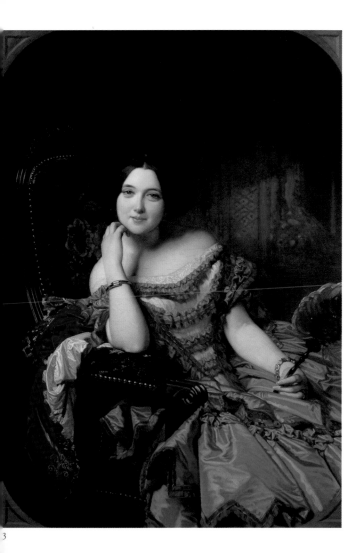

3

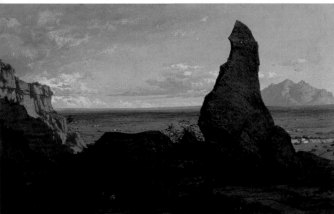

4

1

Manuel Rodríguez de Guzmán
Madrid, 1818–Madrid, c.1866/7
The Santiponce Fair, 1855
Canvas, 125 × 196 cm
Acquired in 1856
Cat. no. 4604

2

Eduardo Rosales
Madrid, 1837–73
*The Testament of Queen Isabella
the Catholic*, 1864
Canvas, 287 × 398 cm
Acquired in 1865
Cat. no. 4625

3

Federico de Madrazo
Rome, 1815–Madrid, 1894
The Countess of Vilches, 1853
Canvas, 126 × 89 cm
Bequeathed in 1944 by the
Count of La Cimera
Cat. no. 2878

Federico de Madrazo was twice appointed Director of the Prado – from 1860 to 1868 and from 1881 to his death. He was the son of the painter José de Madrazo, who had also been a Director of the Prado. His portraits show a special refinement and sensitivity, a delicate harmony of colour and texture, and the clear influence of the French painter Ingres. The subject of this painting, with its appealing aristocratic and yet informal air, is the Countess of Vilches (1821-74), an eminent writer and frequenter of the literary salons of her day.

4

Luis Rigalt
Barcelona, 1814–94
Landscape with Large Rock
Canvas, 62 × 98 cm
Acquired in 1974
Cat. no. 4601

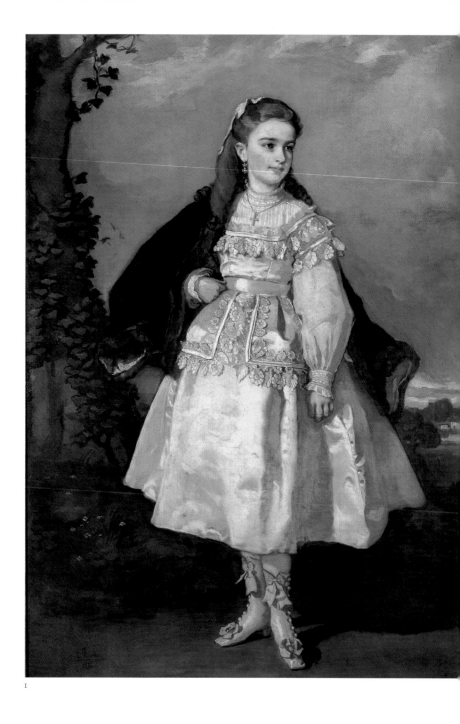

1

1
Eduardo Rosales
Madrid, 1837–73
The Countess of Santovenia, 1871
Canvas, 163 × 106 cm
Donated in 1982 by the Friends
of the Prado Museum
Cat. no. 6711

2
Vicente Palmaroli
Zarzalejo, 1834–Madrid, 1896
Confidences on the Beach, c.1883
Panel, 137 × 63 cm
In the Bauer collection until 1930
Bequeathed by the artist's daughter
Cat. no. 4537

3
Eduardo Rosales
Madrid, 1837–73
After the Bath
Canvas, 185 × 90 cm
Acquired in 1878
Cat. no. 4616

4
Mariano Fortuny
Reus, 1838–Rome, 1874
Nude on the Beach at Portici
Canvas, 13 × 19 cm
Bequeathed in 1904 by
Don Ramón de Errazu
Cat. no. 2606

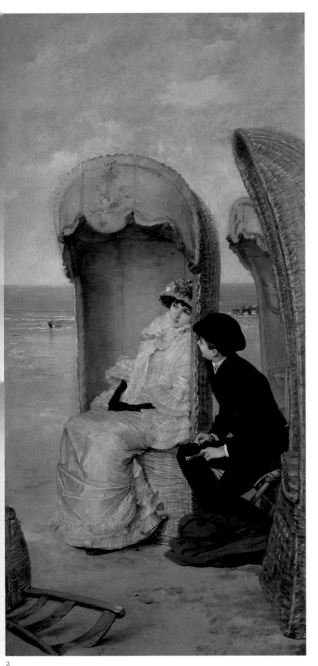

2

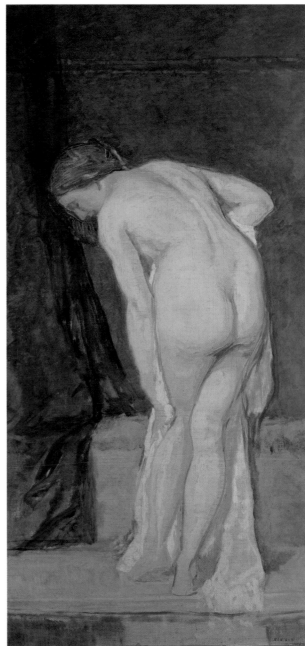

3

4

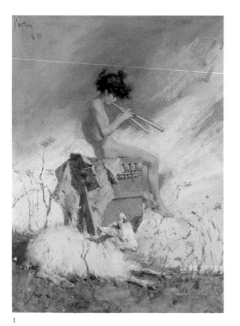

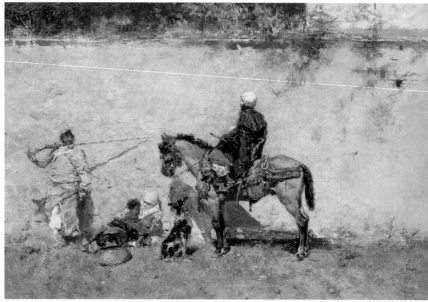

1

2

1
Mariano Fortuny
Reus, 1838–Rome, 1874
Moroccans
Panel, 13 × 19 cm
Bequeathed in 1904 by
Don Ramón de Errazu
Cat. no. 2607

2
Mariano Fortuny
Reus, 1838–Rome, 1874
Idyll, 1868
Paper, 31 × 22 cm
Bequeathed in 1904 by
Don Ramón de Errazu
Cat. no. 2609

3
Raimundo de Madrazo
Rome, 1841–Versailles, 1920
Aline Masson, the Artist's Model
Panel, 60 × 47 cm
Bequeathed in 1904 by
Don Ramón de Errazu
Cat. no. 2622

4
Francisco Domingo Marqués
Valencia, 1842–Madrid, 1920
*The Studio of Antonio Muñoz
Degrain in Valencia*, 1867
Canvas, 38 × 50 cm
Acquired in 1904
Cat. no. 4484

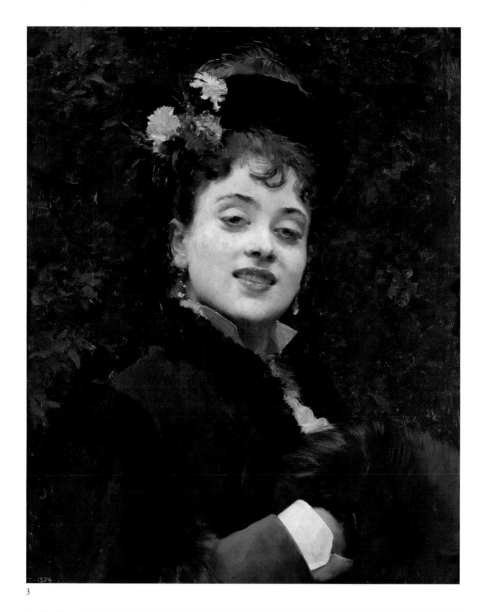

3

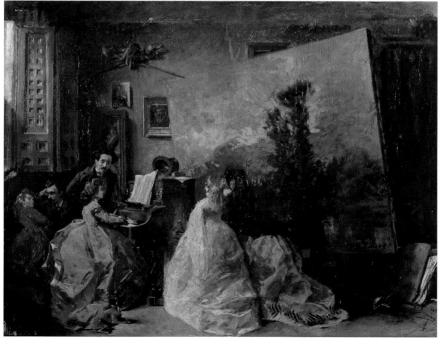

4

1

1
Aureliano de Beruete
Madrid, 1845–1912
*The Banks of the River
Manzanares*
Canvas, 57 × 81 cm
Provenance unknown
Cat. no. 4252

2
Ignacio Pinazo
Valencia, 1849–Godella, 1916
Study of a Nude, 1888
Panel, 10 × 18 cm
Provenance unknown
Cat. no. 4578

3
Carlos de Haes
Brussels, 1826–Madrid, 1898
Los Picos de Europa, 1876
Canvas, 167 × 123 cm
Acquired in 1876
Cat. no. 4391

2

3

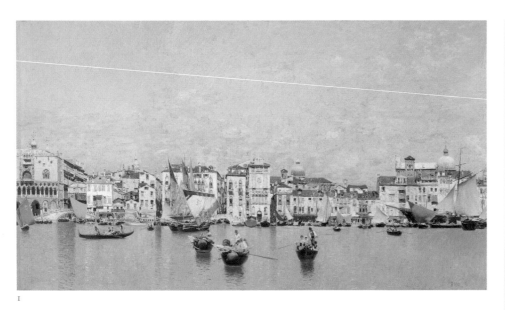

1

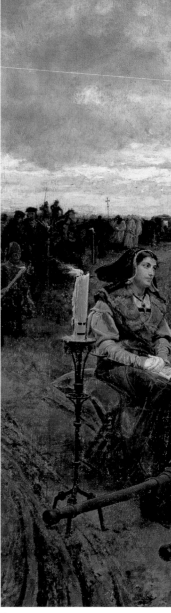

2

1
Martín Rico
Madrid, 1835–Venice, 1908
The Doge's Palace and the Riva
degli Schiavoni, Venice
Canvas, 41 × 71 cm
Bequeathed in 1904 by
Don Ramón de Errazu
Cat. no. 2625

2
Francisco Pradilla Ortiz
Villanueva de Gállego,
1848–Madrid, 1921
Joanna the Mad, 1877
Canvas, 340 × 500 cm
Acquired in 1878
Cat. no. 4584

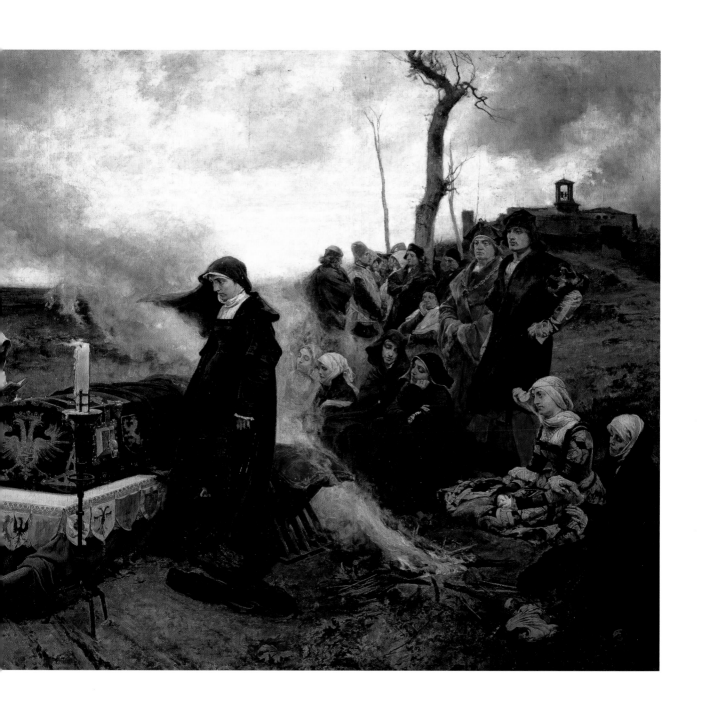

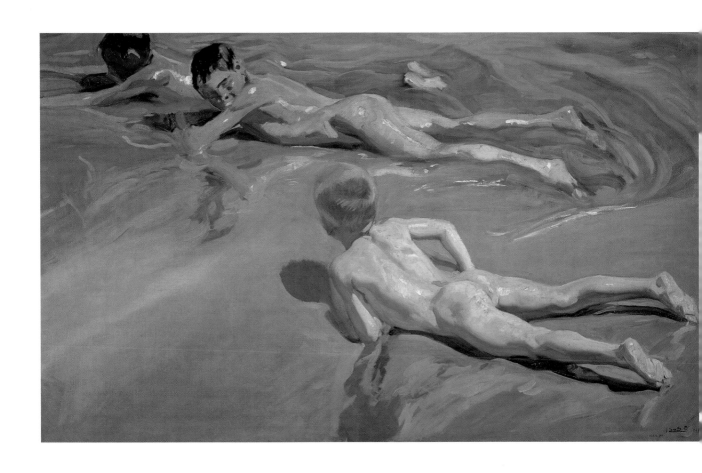

Joaquín Sorolla
Valencia, 1863–Carcadilla, 1923
Children at the Beach, 1910
Canvas, 118 × 185 cm
Presented by the artist in 1919
Cat. no. 4648

Trained in the nineteenth-century
realist tradition, Sorolla moved
towards a more luminous and
colourist style that enabled him
to express his feel for the vitality
and freshness of nature.
Through contact with the French
Impressionists, he developed a
technique involving long, confi-
dent brush strokes and a wide
range of colours.

THE FOREIGN COLLECTIONS

INTRODUCTION

Walking through the galleries of the Prado and surveying the magnificent pictures they contain, one cannot fail to be struck by the universal and individual quality of the museum. The various collections clearly reflect the tastes and political leanings of the kings and queens, courtiers and counsellors who assembled them, rather than the informed choice of art historians and scholars.

After close trading links had been established between Castile and the Low Countries during the Middle Ages, and following a succession of royal marriages and deaths, Charles I became king of Spain and also of Flanders in 1517 and two years later was elected Holy Roman Emperor as Charles V. These circumstances made it easy for Spain to import many works by Flemish artists from the fifteenth century onwards, a large number of which were added to the royal collections.

The Italian collection in the Prado is one of the most representative, and is considered by many to be a key to a full understanding of the development of Italian art. Most of the pictures were purchased direct from Madrid. The Venetian School was traditionally the one most favoured by the Spanish monarchy, no doubt partly due to the fact that Titian was official portrait painter not only to Charles I but also to Philip II. The latter, in particular, assembled an impressive collection of Italian paintings, including works by Correggio and Raphael, with which he decorated the Alcázar in Madrid and the palaces of El Pardo, El Escorial and Aranjuez. Although Philip III was not himself a great collector, the Duke of Urbino presented him with two magnificent paintings by Barocci, and it was during his reign that Rubens first visited the court in Madrid when in 1603 he accompanied an embassy from Vicenzo Gonzaga, Duke of Mantua.

Philip IV, however, was a great patron of the arts. During his reign, Spanish painters of the calibre of Velázquez, Zurbarán and Ribera were at the height of their careers, yet large numbers of Flemish paintings still continued to be imported to complete the decoration of the royal palaces. When Rubens died and his studio was sold, Philip IV acquired many of his pictures, and after the execution of Charles I of England in 1648, royal agents bought paintings from his collection by Mantegna, Raphael, Veronese, Andrea del Sarto, Tintoretto and Dürer. When the Buen Retiro Palace in Madrid was built in 1630, a number of works were commissioned and purchased in Italy, and Spanish ambassadors in Rome and viceroys of Naples vied with each other to send the finest pictures to decorate the new royal residence and the old Alcázar. Queen Christina of Sweden presented Philip IV with two pictures by Dürer, and many Spanish and Italian aristocrats also donated works, while Velázquez was ordered to purchase pictures for the king in Italy.

By the time Philip died in 1665, the collection was a magnificent one by any standards. His successor, Charles II, did not enlarge it significantly – though works by Rubens and a number of Italian still lifes by Recco, Nuzzi and Belvedere were added during his reign. In 1692, Luca Giordano arrived at court and dominated artistic circles in Spain for ten years. He renewed interest in large-scale decorative schemes, and his presence coincided with the final splendours of what is known as the Golden Age of Spanish painting.

With the establishment of the Bourbon dynasty in Spain in 1700, Philip V, grandson of Louis XIV of France, ascended the throne. He and his second wife, the Italian Isabel Farnese, commissioned French artists such as Houasse and Ranc to produce genre paintings and portraits, but chose Italian artists like Procaccini and Vaccaro for religious or historical works. The refurbishment of old palaces and the building of new ones such as La Granja called for new decorations. Accordingly, family portraits by Rigaud, Largillièrre, De Troy, Santerre and Gobert arrived, while royal agents acquired pictures in Italy, France and the Low Countries.

Ferdinand VI contributed very little to Spanish patronage of the arts, although during his reign several Italian painters produced mural paintings and minor pieces. Charles III, who reigned for 29 years, completed the construction of the new Royal Palace in Madrid and commissioned Tiepolo and Mengs to decorate it. During this period many very famous paintings were acquired from a number of artists including Rembrandt and Tintoretto. The Prince of Asturias, later to become Charles IV, started his own collection, and by the time he lost the throne in 1808 he had formed a highly sophisticated collection that included works by contemporary artists such as Pillement and Vernet, as well as earlier paintings by Andrea del Sarto, Robert Campin, Raphael, Domenichino, Turchi and Cavedone, which are now exhibited in the Prado.

After the upheaval caused by the Peninsula Wars and Napoleon's invasion of Spain in 1808, the House of Bourbon was duly restored in 1814 in the person of Ferdinand VII, and the Prado Museum was finally inaugurated in 1819. Its Director, Federico de Madrazo, obtained the beautiful altarpiece of the Annunciation by Fra Angelico in 1860, and five years later the exquisite polyptych of 40 animal subjects in gold leaf by Van Kessel the Elder was donated to the museum.

In 1872 numerous religious paintings from the Museo de la Trinidad were transferred to the Prado, including works by Van der Weyden and Barocci. The flow of donations continued until the end of the nineteenth century, the most remarkable being the extraordinary gift of almost 200 pictures from the Duchess of Pastrana.

Antonio Allegri, known as **Correggio**
Noli me tangere, c.1534 (detail)

The period between 1914 and 1936 was extremely rewarding for the Prado, and works by Andrea del Sarto, Van der Weyden, Van Kessel, Bernini, Tiepolo and Van Scorel were acquired. Since the end of World War II the collections have been enlarged in a more systematic way. An example of this is the collection of British paintings, which was non-existent at the beginning of the century but now boasts works by Reynolds, Gainsborough, Lawrence and Romney among others. The British section brings to a close this description of the Prado's collections of foreign paintings.

Italian painting forms the third largest collection in the Prado and includes much of the Italian art purchased or commissioned by the Spanish crown between the sixteenth and nineteenth centuries. Political relations between Spain and Italy played an important part in the formation of collections of Italian paintings in Spain during this period. The royal collection was assembled as a result of just such links, as were the private collections of the nobility, whose tastes usually followed those imposed by the court and whose visits to Italy as ambassadors enabled them to acquire notable works of art.

The personal tastes of the Spanish sovereigns naturally dictated the composition of the royal collection. They account for the presence of many paintings of the sixteenth-century Venetian School as well as others by the most important artists working in Rome in the middle of the seventeenth century. However, they equally explain the existence of large gaps in other periods: for instance, the marked absence of works from the Italian Quattrocento, due to the fact that, during the time of Ferdinand and Isabella political and trading links with Flanders resulted in a concentration on Flemish works of art. Similarly, in the eighteenth century the establishment of the Bourbon dynasty in Spain meant that artistic interests inclined more towards French painting than to the active Italian schools of the period.

Among the earliest works in the Italian collection are two small panels from the fourteenth century which probably formed part of the predella to an altarpiece. These are attributed to the 'Master of the Madonna della Misericordia', a Florentine artist from Giotto's circle of followers. The gilded backgrounds serve to frame and highlight the figures, and yet the elegance and richness of their garments do not detract from the monumental sense of form and individual expressiveness derived from Giotto. Also exhibited is a panel by Giovanni dal Ponte, an artist who might be considered somewhat archaic. Although this panel, which formed the front of a linen chest and represents the seven liberal arts, has been dated around 1435, the lack of geometrical perspective, the gilded background, and the elegant, affected attitudes of the figures suggest close contact with the International Gothic style of an earlier period and make this work an interesting example of the state of painting immediately prior to the innovations of the first Florentine Renaissance.

The Prado's collection of paintings from the Quattrocento proper begins with the exquisite *Annunciation* by Fra Angelico, which comes from one of the altars in the convent of San Domenico in Fiesole, near Florence and was sold by the Dominican friars in 1611 to pay for the restoration of the bell tower. The picture was purchased by the Duke of Lerma, a

great favourite of Philip III, and was donated in the same year to the convent of the Reales Descalzas in Madrid, where it adorned one of the cloister altars. In 1861, Federico de Madrazo, then Director of the Prado, discovered this magnificent painting in perfect condition and had it transferred to the museum, replacing it with one of his own works on the same subject.

Florentine painting of the second half of the fifteenth century is represented by three panels by Botticelli illustrating a story taken from Boccaccio's *Decameron*. Although very typical of Botticelli's early style, they display many of the features of his later painting.

One of the finest pieces in the Prado is undoubtedly *The Death of the Virgin Mary* by the Paduan artist Andrea Mantegna. It reflects well on the judgement of Philip IV and his artistic advisers that they should show an interest in the early Renaissance at a time when the prevailing taste was for Raphael and the contemporary Baroque masters.

The Quattrocento Venetian paintings in the Prado are at the threshold of the outstanding achievements of the art of sixteenth-century Venice. *The Dead Christ supported by an Angel*, by Antonello da Messina, is one of the artist's most beautiful works, and reveals the typically Venetian blend of atmosphere and light with elements of northern realism.

Melozzo da Forli, a follower of Piero della Francesca, is represented by a small detail in a fresco depicting an angel playing an instrument. Together with Antoniazzo Romano, Melozzo is an example of the Umbrian School of the late fifteenth century – the school from which Perugino was to emerge and in which the young Raphael was to be trained. The relative dearth of pictures from the fifteenth century in the Prado is offset by the magnificent collection of sixteenth-century paintings from practically all the various artistic centres in Italy.

The full development of Italian classicism at the beginning of the sixteenth century is best represented in the Prado by the works of Raphael. *The Holy Family with a Lamb*, painted in 1507 during his youth, belongs to the artist's Florentine period, during which he came in contact with the ideas of Leonardo and Fra Bartolommeo. The composition which shows Raphael's classicism at its most rigorous is *The Madonna of the Fish* painted around 1514. In this work, pictorial space is determined by geometrical relations, and the figures have a solid, monumental character. Raphael's profound psychological insight is clearly revealed in the impressive *Portrait of a Cardinal*, which embodies in the severe figure of the sitter all the refinement, intelligence and indifference of the princes of the Church during that period that was to culminate in bitter conflict with Lutheranism.

Of Andrea del Sarto's work, the Prado possess an enigmatic portrait of a woman whom critics recognize as Lucrezia di Baccio del Fede, the artist's wife, and also *The Virgin with a Saint and an Angel*, the museum's most grandiose painting by this artist. This scene, composed in a rigid pyramidal structure, is executed in a style that clearly recalls Leonardo's use of chiaroscuro, while the skilful blending of rich warm colours – pure reds, greens and yellows – with more roseate and iridescent tones anticipates the bold colouring of the Florentine Mannerists such as Pontormo and Bronzino.

Some of the best examples of the art of Niccolò dell'Abate and Parmigianino, working during the height of Mannerism in the sixteenth century, are also to be found in the Prado, while the works of Sebastiano del Piombo, Correggio and Barocci show the independent, individualistic tendencies of another group of painters who also formed part of the broad Mannerist panorama. Correggio was one of the most innovative and independent artistic figures of the first part of the century, and the Prado possesses one of his best known pictures, *Noli me tangere*.

Few other collections include so many works by the great Venetian masters of the sixteenth century, Titian, Tintoretto and Veronese, as well as paintings by other important Venetian artists such as Lotto, Bassano and Moroni. Almost all the Venetian paintings in the Prado come from the royal collections, and while some were acquired in the eighteenth century most of them arrived in Spain during the sixteenth and seventeenth centuries. Among the latter is Veronese's *Venus and Adonis*, purchased in Italy by Velázquez, who was expressly instructed by Philip IV to buy all works he considered suitable for the royal collections.

The Prado also has *The Worship of Venus* and *The Bacchanal* by Titian, which together with another two works, *Bacchus and Ariadne*, at present in the National Gallery in London, and *The Banquet of the Gods*, in the National Gallery in Washington, form a series produced between 1519 and 1525 for Alfonso d'Este, Duke of Ferrara. These pictures are the first of Titian's great mythological paintings. The Prado collection includes important examples of the artist's later religious themes as well as several portraits that had a major influence on Spanish portraiture during the sixteenth and seventeenth century. Among the magnificent portraits of leading figures of the period is the one of the Duke of Mantua, Federigo de Gonzaga, with its exquisite colouring and vague sense of melancholy. Titian's self-portrait, too, is a masterpiece of its kind. This picture, mentioned by Vasari, belonged to Rubens and was purchased by Philip IV on the sale of the latter's possessions after his death in 1640, probably on the advice of Velázquez.

Almost all the paintings by Veronese in the Prado were acquired during the reign of Philip IV. The work of Veronese,

with its wealth of colour and form and its power of expression, might be considered to represent the culmination of the Venetian Renaissance. The sensual beauty of his female figures is comparable only to Titian's, and this quality in his work is exemplified in the exquisite *Venus and Adonis*. Similarly, features such as the almost Rococo delicacy of the small version of *The Finding of Moses*, and the superb use of luminous landscapes, show Veronese's highly refined aesthetic.

The work of Tintoretto reflects an important change of direction in Venetian art, away from the sense of harmony so evident in Titian and Veronese and towards a new expressiveness that could well be described as 'Venetian Mannerism'. The dramatic tension in his compositions – achieved through the elongation of the figures, the use of bright colours and violent splashes of light that cut across the canvas like cold flashes of lightning – marked Tintoretto as one of the most original Venetian painters of this period. The Prado has a fine selection of his works, among them *Christ washing the Feet of His Disciples* and *The Battle between Turks and Christians*, together with a splendid series of portraits.

The sixteenth-century Venetian school in the Prado ends with a large number of paintings by the Bassano family and their workshop. The founder of this dynasty of painters was Jacopo Bassano, who used biblical themes as a pretext for genre scenes and animal paintings. Most of them are lively, decorative works in which the artist develops the naturalism, sense of space and colour, and vibrant brushwork of the Venetian masters. Francesco Bassano, whose most important picture is perhaps *The Last Supper*, painted in a very similar way to his father, and the work of his brother Leandro is also based on related themes.

The core of the seventeenth-century collection is formed of the works commissioned by Philip IV for the decoration of the new Buen Retiro Palace, to which some of the most famous painters of the time contributed. The two main trends in Italy at the beginning of the seventeenth century – classicism and 'tenebrist naturalism' – are moderately well represented in the museum. Pictures by the revolutionary Caravaggio do not, however, appear to have attracted the attention of the monarchy, though *David and Goliath* is the one outstanding exception. Nevertheless, the Prado does have some fine examples of the works of Caravaggio's followers, including *The beheading of St John the Baptist* by the Neapolitan artist Massimo Stanzione.

The classicist movement, which originated in Bologna at the beginning of the seventeenth century, as a result of the activities of Annibale Carracci and several of his followers, is also represented in the Prado. The most significant works in this style are those by Carracci himself, such as *Venus and Adonis*

and *The Assumption of the Virgin*, in which classicist elements are blended with the artist's knowledge of sixteenth-century Venetian painting. His immediate followers are also well represented with works such as *Venus attended by Nymphs and Cupids* by Francesco Albani and *Hippomenes and Atalanta* by Guido Reni. Domenichino, one of the most refined classicists of the first part of the century, is represented by various paintings, including the small *Triumphal Arch*, dated between 1607 and 1610, produced in honour of Giovanni Battista Agucchi, an art theorist and friend of the classicist painters. A contrast with the highly intellectual painting of Domenichino is the fine selection of pieces in the museum by his contemporary, Guercino. Another follower of Carracci, Giovanni Lanfranco, may be considered the forerunner of the grandiose paintings of the full Baroque; the figures in *The Banquet of the Gladiators* are arranged in the form of a classical frieze and are thrown into relief by the use of light against such a dark background.

The Neapolitan School also became active in the middle of the seventeenth century. Originating as a consequence of the creative work of Caravaggio in the city, Neapolitan art followed its individual path with the Spanish painter José de Ribera, who settled in Naples as a young man and founded a tradition that was to culminate towards the end of the century with the art of Luca Giordano. The Prado has an excellent selection of works by the principal Neapolitan artists, including a very delicate composition by Bernardo Cavallino; some exceptional pictures by Stanzione, whose personal style developed over the century, shifting from Carravaggio's tenebrism to a more luminous form; several paintings by Aniello Falcone, a pupil of Ribera's, among which is the beautiful composition entitled *The Concert*; Mattia Preti's *Christ in Glory*; and a splendid landscape titled *View of the Gulf of Salerno*, by Salvatore Rosa. Finally, of the many paintings by Luca Giordano, his *Dream of Solomon* is specially noteworthy for its wonderful colouring and bold contrasts of brilliant, metallic light.

Amongst the paintings of the Genoese School, mention should be made of *Moses drawing Water from the Rock* by Gioacchino Assereto, who had a great influence on Spanish painting, particularly the work of Murillo. *St Veronica* by Bernardo Strozzi and a fascinating *The Fable of Diogenes searching with a Lantern for a Good Man* by Giovanni Benedetto Castiglione are also worthy of note.

The seventeenth-century collection includes other works of great quality such as *The Finding of Moses* from Orazio Gentileschi's English period, and a *Pietà* by the Lombard painter Daniele Crespi. The flower paintings by the Neapolitan Andrea Belvedere are excellent examples of the style of still life paintings of the period. Among the works of the Florentine

chool, so closely connected with Spain towards the end of the sixteenth century, there is the magnificent *Lot and his Daughters* by Francesco Furini, a present to Philip IV from the Duke of Tuscany, who chose it from his own collection in order to delight the refined taste of the Spanish king.

In spite of Philip V's interest in French art and the consequent influx of French painters to the Spanish court in the eighteenth century, artistic relations with Italy were not entirely cut off. There were still visits by Italian artists such as Corrado Giaquinto and Giambattista Tiepolo, and the Prado also has works by some of the late followers of the classicist Carlo Maratta, who worked in Rome during the first part of the eighteenth century. The best example of this school is perhaps the portrait of *Cardinal Borja* by Andrea Procaccini, who was appointed court painter by Philip V.

The Prado possesses paintings by two notable Neapolitan artists of the eighteenth century, Francesco Solimena and Sebastiano Conca, from whom works were commissioned for the decoration of the royal palaces, though they themselves never came to Spain. The Neapolitan Corrado Giaquinto, who collaborated with Conca, was called to Madrid in 1753 by Ferdinand VI to execute mural decorations in the new Royal Palace and stayed to become Director of the Real Academia de San Fernando. The Prado has a number of his works, among which are some beautiful sketches for frescos, such as *Apollo and Bacchus* (a preliminary sketch for the grandiose decorative scheme for the staircase in the Royal Palace in Madrid). The delicate Rococo style of the figures by Giaquinto, together with their clear tones and the technical freedom of his work, had an important influence on the development of the Madrid School in the second half of the eighteenth century, especially Antonio González Velázquez, Francisco Bayeu and Maella; and Giaquinto's influence is even reflected in Goya's early paintings.

Next to Rome, Venice was the most active centre of Italian art during the eighteenth century. The Prado does not possess works by either Canaletto or Guardi, the main exponents of *veduta* or urban landscape painting: this facet of Italian art is represented instead by the views of Rome by Giovanni Paolo Panini and a view of Venice by Vanvitelli the Elder. The museum has recently added several interesting pictures of the palace of Aranjuez by Francesco Battaglioli, who studied in Venice and worked at the Spanish court from 1754. Another recent acquisition is the landscape entitled *Angels ministering to Christ*, by the eighteenth-century Genoese painter Alessandro Magnasco (in collaboration with Peruzzini).

However, the outstanding figures of Venetian art in the eighteenth century are without doubt the Tiepolos. Both the father, Giambattista, and his eldest son, Gian Domenico, travelled widely, executing a prodigious quantity of decorations in their native Venice and also in various other European towns, such as those to be found in the Kaisersaal, the residence of the bishop of Wurzburg. He arrived in Madrid with his two sons in 1762, already an old man. At the court he painted one of his most beautiful works, the frescoes in the Throne Room of the Royal Palace. The Prado also has the very fine collection of canvases that he painted for the church of San Pascual in Aranjuez in 1769.

The Prado's collection of eighteenth-century Italian painting concludes with two magnificent portraits by Pompeo Batoni, one of which is the imposing figure of the Duke of Gloucester, dated 1778.

1

1
Attributed to the '**Master of the Madonna della Misericordia**'
Florence, second half of the fourteenth century
St Eligius in the presence of King Chlotar, *c*.1365
Panel, 35 × 39 cm
Donated by Don Francisco Cambó in 1940
Cat. no. 2841

2
Giovanni dal Ponte
Florence, before 1376–*c*.1437
The Seven Liberal Arts, *c*.1427/35
Panel, 56 × 155 cm
Donated by Don Francisco Cambó in 1940
Cat. no. 2844

3
Fra Giovanni da Fiesole, known as **Fra Angelico**
Vicchio di Mugello (?), *c*.1400–Rome, 1455
The Annunciation, *c*.1430
Panel, 194 × 194 cm
From the convent of San Domenico in Fiesole; sold and brought to Spain in 1611
Entered the Prado in 1861
Cat. no. 15

This magnificent altarpiece, with its central image of the Annunciation and the predella with other scenes from the life of the Virgin Mary, is considered to have been produced with a considerable amount of collaboration from the artist's workshop. The central image repeats a design used by Fra Angelico in the Cortona *Annunciation* and also on the head of the staircase leading to the dormitory in his monastery of San Marco in Florence. The new Renaissance understanding of architectural perspective is combined with the continuing medieval delight in the lavish use of gilding.

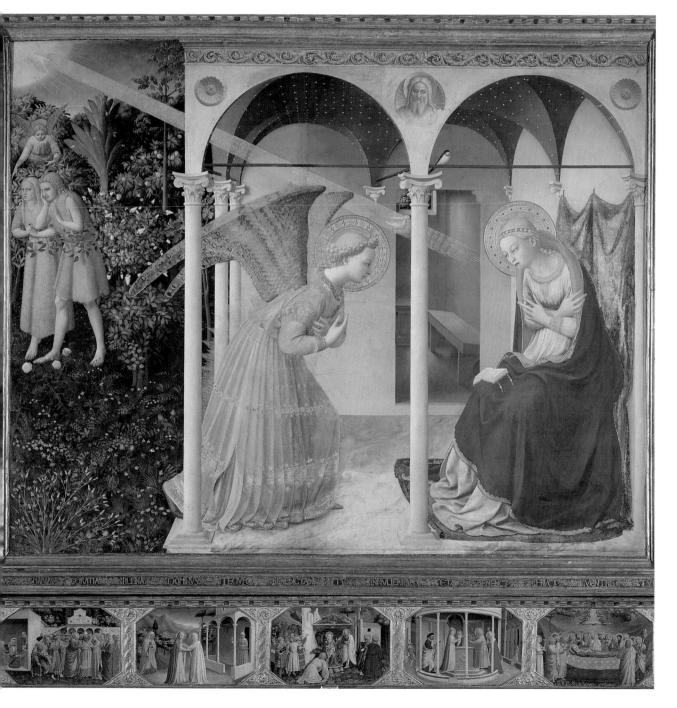

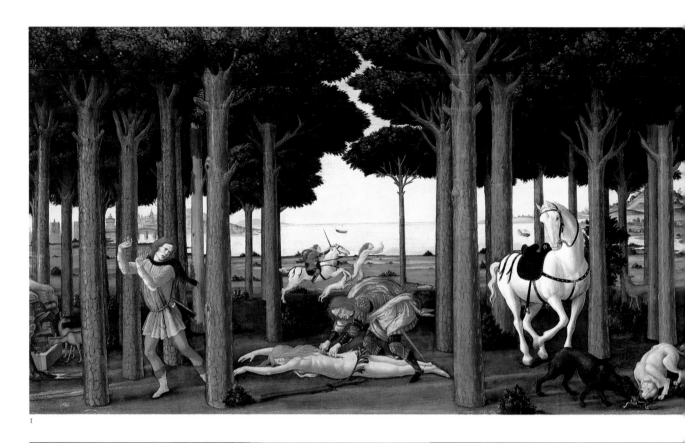

I

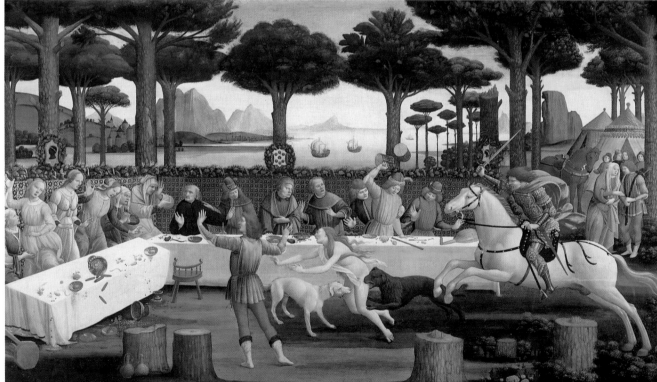

2

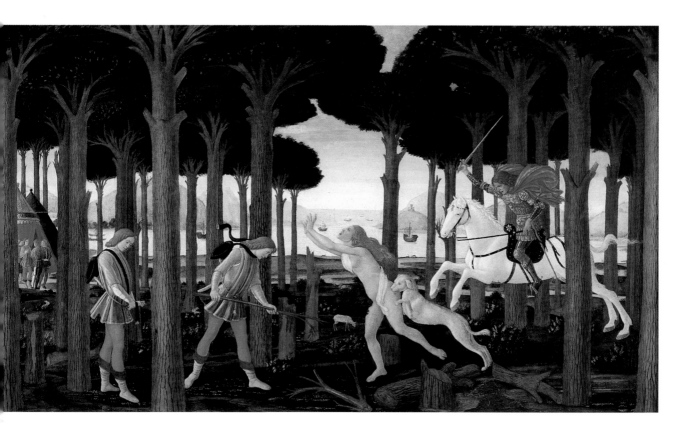

Alessandro Filipepi,
known as **Botticelli**
Florence, 1445–1510
The Story of Nastagio degli Onesti:
The Disembowelling of the Pursued
Woman, 1483
Panel, 138 × 83 cm
Donated by Don Francisco Cambó
in 1940
Cat. no. 2839

2
Alessandro Filipepi,
known as **Botticelli**
Florence, 1445–1510
The Story of Nastagio degli Onesti:
Nastagio arranges a Feast at which
the Ghosts reappear, 1483
Panel, 138 × 83 cm
Donated by Don Francisco
Cambó in 1940
Cat. no. 2840

3
Alessandro Filipepi,
known as **Botticelli**
Florence, 1445–1510
The Story of Nastagio degli Onesti:
Nastagio's Vision of the Ghostly
Pursuit in the Forest, 1483
Panel, 138 × 83 cm
Donated by Don Francisco Cambó
in 1940
Cat. no. 2838

These three panels, excellent
examples of the elegant, refined
style of the mature Botticelli aided
by his assistants, illustrate a story
from Boccaccio's *Decameron*.
Nastagio, rejected by his beloved
Paola Traversari, wanders alone in
the forest and comes upon the
terrible scene of a knight and his
dogs chasing and eventually
catching and disembowelling a
naked woman. He can do nothing
to stop them. When they have
finished disembowelling her, the
woman rises again and the chase
continues. The knight explains
that he committed suicide for love
and this is his punishment, and
also that of the woman, whose
cruelty drove him to his death.
Nastagio invites his own beloved
and her family to witness a re-
enactment of the scene, as a result
of which Paola relents and agrees
to marry him (depicted in the
fourth panel in the set, currently
in a private collection in
Switzerland).

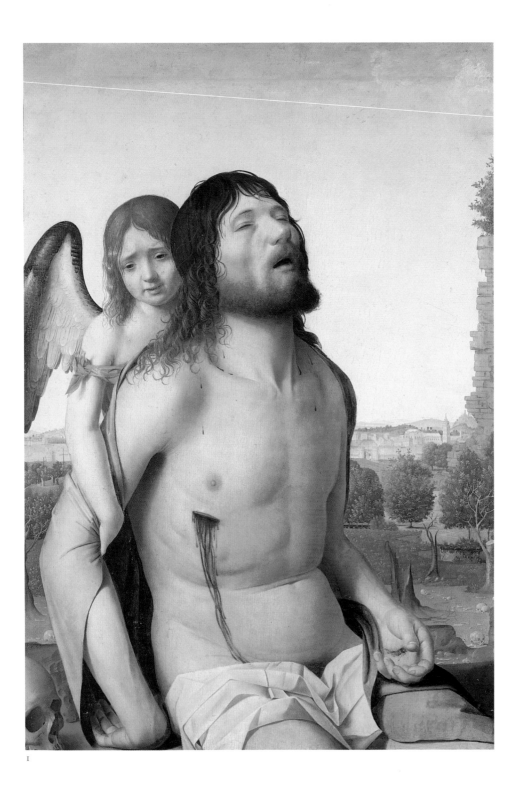

1

1

Antonello da Messina

Messina, c.1430–79
The Dead Christ supported by an Angel, c.1475/78
Panel, 74 × 51 cm
Acquired in 1965
Cat. no. 3092

2

Andrea Mantegna

Isola di Cartura, 1431–Mantua, 1506
The Death of the Virgin Mary, c.1461
Panel, 54 × 42 cm
From a chapel in the ducal palace at Mantua (?)
Acquired by Charles I of England, and after the king was beheaded in 1649 and his possessions were sold it was purchased on behalf of Philip IV of Spain
Cat. no. 248

In a room framed by heavy pilasters but looking out on to the lake of Mantua, the Apostles gather round the dying Virgin Mary. The skilfully constructed perspective is well co-ordinated with the precisely drawn and coloured figures. The overall effect is severe, though vivid and moving in its dignity. This painting is justly regarded as a masterpiece of the early Renaissance, with its detailed naturalism, radiant clarity and unshaken conviction.

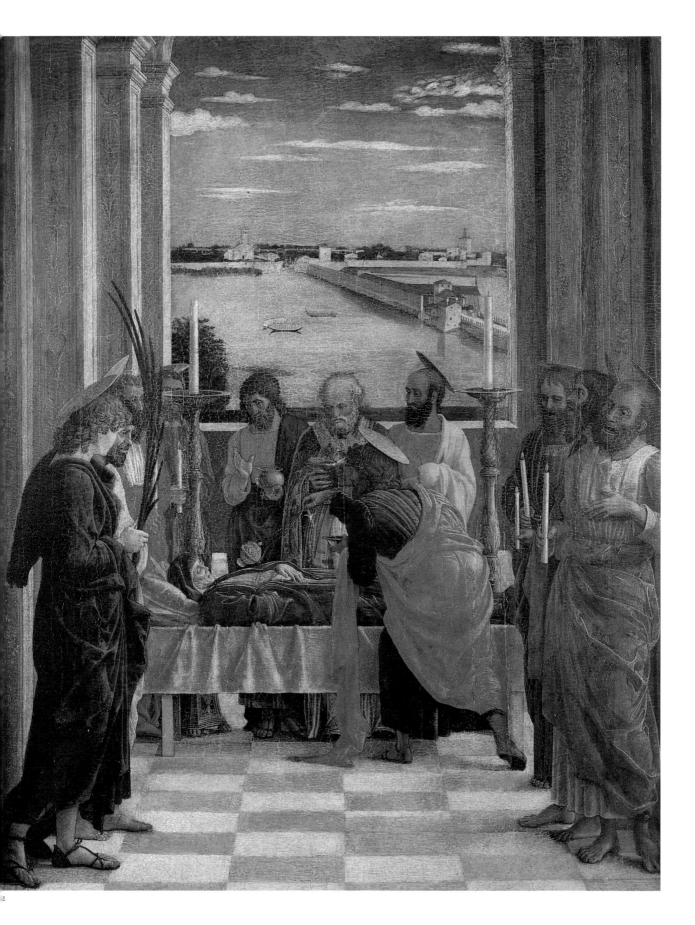

1

2

1
Bernardino Luini
Luino, c.1480/90–Milan, 1532
*The Holy Family with the infant
St John*
Panel, 100 × 84 cm
Philip II collection
Cat. no. 242

2
Raphael (Raffaello Sanzio)
Urbino, 1483–Rome, 1520
*The Madonna of the Fish (The
Virgin Mary with Tobias, the
Archangel Raphael and St Jerome),*
*c.*1514
Panel transferred to canvas,
215 × 158 cm
Presented to Philip IV in 1645 by
the Duke of Medina de las Torres
Cat. no. 297

3
Raphael (Raffaello Sanzio)
Urbino, 1483–Rome, 1520
*Lo Spasimo de Sicilia (Christ falls
on the Way to Calvary),* 1517
Panel transferred to canvas,
318 × 229 cm
From the church of Santa Maria
dello Spasimo, near Palermo
Philip IV collection
Cat. no. 298

This picture, transported from
Rome, bears the name of the
Sicilian church for which it was
commissioned and which was
dedicated to the grief and agony
(*spasimo*) of the Virgin Mary on
witnessing the suffering of Christ.
The real subject of Raphael's altar-
piece is the exchange of looks
between Christ – stumbling and
falling under the weight of the cross
– and his distraught mother, reach-
ing out her arms to him in vain.

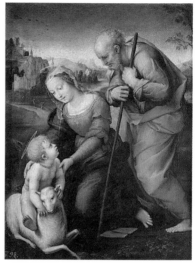

4

4
Raphael (Raffaello Sanzio)
Urbino, 1483–Rome, 1520
The Holy Family with a Lamb, 1507
Panel, 29 × 21 cm
In the royal collection by the
eighteenth century
Cat. no. 296

This small picture – designed for
private devotion – belongs to
Raphael's Florentine period, after
he moved to Florence from
Umbria before going to Rome.
At that time he was particularly
attracted to the style of Leonardo,
and of other artists such as the
young Michelangelo. However,
the delicate detail and serene
nature of this piece recall his
training in the workshop of the
famous Perugino. There are also
certain features that reflect his
knowledge of Flemish painting,
particularly in the landscape.

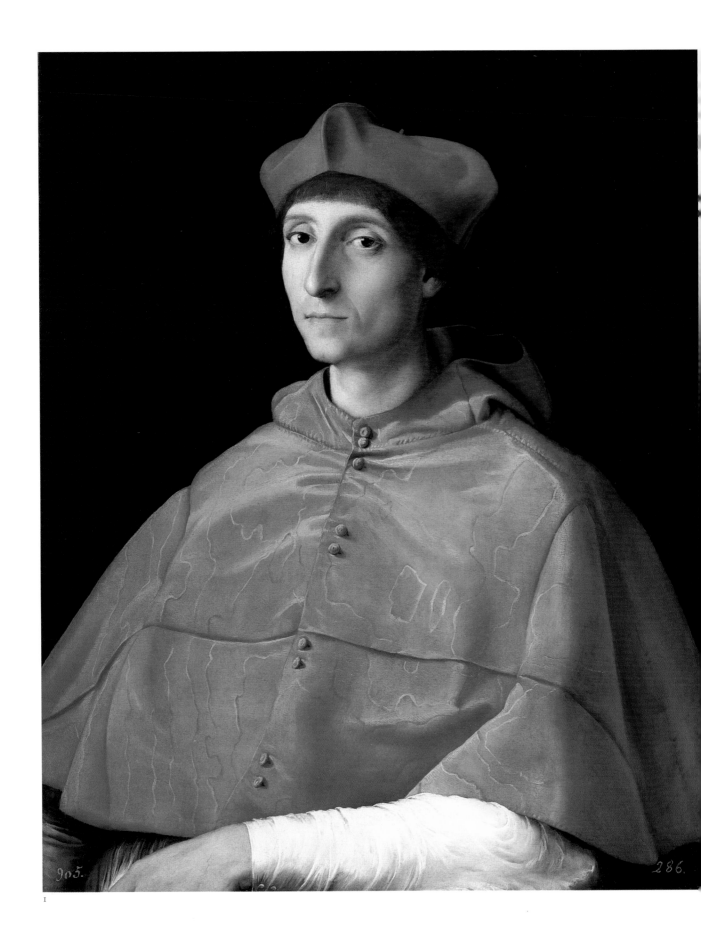

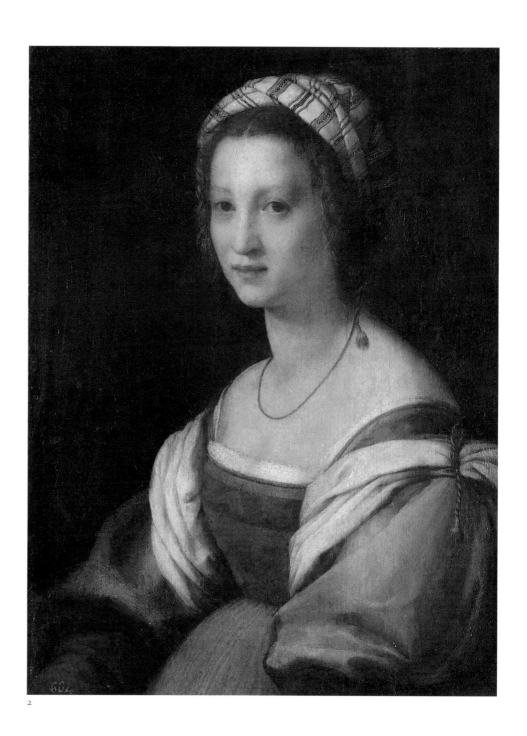

2

1

Raphael (Raffaello Sanzio)
Urbino, 1483–Rome, 1520
Portrait of a Cardinal, c.1510/12
Panel, 79 × 61 cm
Charles IV collection
Cat. no. 299

2

Andrea del Sarto
Florence, 1486–1530
*Lucrezia di Baccio del Fede, the
Artist's Wife*, c.1513/14
Panel, 73 × 56 cm
In the royal collection by the
eighteenth century
Cat. no. 332

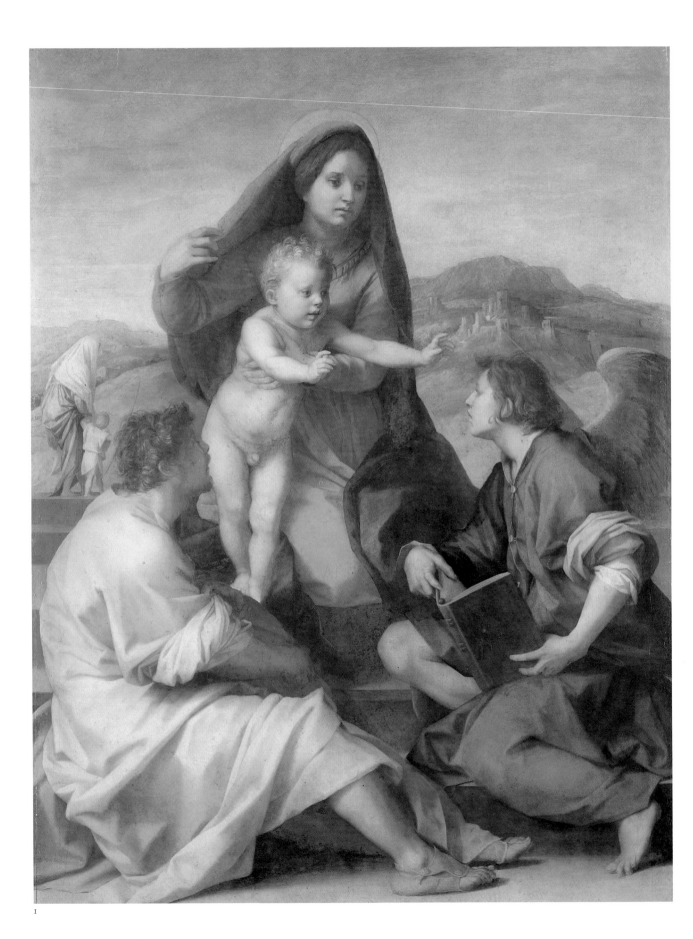

I

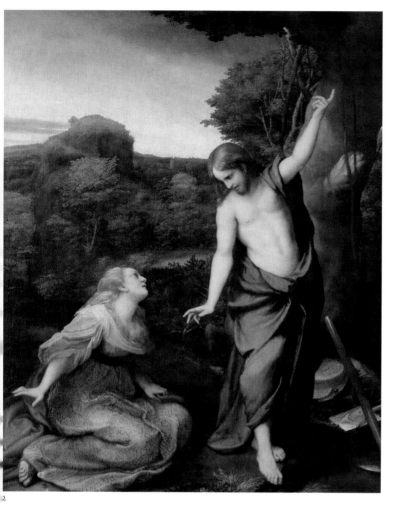

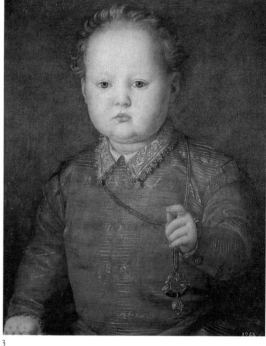

1
Andrea del Sarto
Florence, 1486–1530
The Virgin with a Saint and an Angel, c.1522/3
Panel, 177 × 135 cm
Acquired by Philip IV at the sale of the collection of Charles I of England in 1649
Cat. no. 334

2
Antonio Allegri, known as **Correggio**
Correggio, 1489–1534
Noli me tangere, c.1534
Panel transferred to canvas, 130 × 103 cm
Gift from the Duke of Medina de las Torres to Philip IV at the Escorial
Entered the Prado in 1839
Cat. no. 111

Untempted by Rome, Florence or Venice, Correggio worked in the northern Italian town of Parma and maintained his originality throughout the Renaissance, becoming one of the most significant precursors of seventeenth-century Baroque painting. However, he was undoubtedly receptive to the influence of Raphael and Leonardo in particular: his perception of ideal beauty and the structure of his compositions owe much to Raphael, while his handling of textures and light is due to Leonardo. In this picture he used the classic pyramidal composition of the High Renaissance, combined with a diagonal movement that anticipated the Baroque. The beautiful landscape evokes the light at dawn, when Mary Magdalene encountered Christ near the tomb.

3
Agnolo di Cosimo Mariano, known as **Bronzino**
Florence, 1503–72
Garcia de'Medici (?), c.1550
Panel, 42 × 38 cm
Royal collection
Cat. no. 5

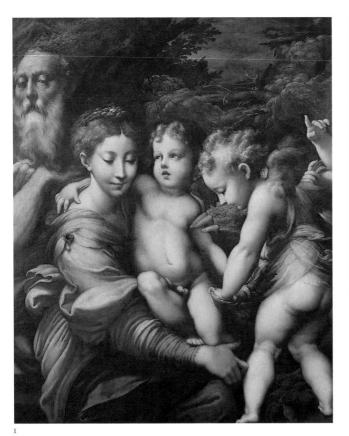

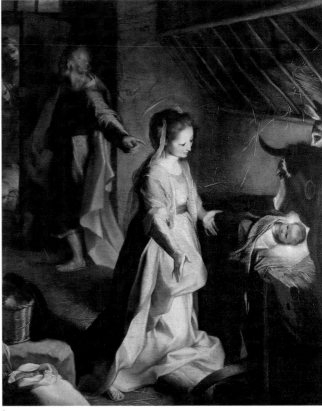

1
Francesco Mazzola,
known as **Parmigianino**
Parma, 1503–Casalmaggiore, 1540
*The Holy Family (Rest on the Flight
into Egypt)*, 1524
Panel, 110 × 89 cm
Royal collection
Cat. no. 283

2
Federico Fiori,
known as **Barocci**
Urbino, 1535–1612
The Adoration of the Child, 1597
Canvas, 134 × 105 cm
Presented to Queen Margarita de
Austria, wife of Philip III, by the
Duke of Urbino
Cat. no. 18

3
Attributed to **Giorgione (Giorgio
de Castelfranco)**
Castelfranco Veneto (?)–
Venice, 1510
*The Virgin and Child with St Antho-
ny of Padua and St Roch*, *c.*1510
Canvas, 92 × 133 cm
Presented to Philip IV by the
Duke of Medina de las Torres
Cat. no. 288

4
Giovanni Bellini
Venice, *c.*1430–1516
*The Virgin and Child with two
Saints*, *c.*1490
Panel, 77 × 104 cm
Philip IV collection
Cat. no. 50

Experts are divided on the attribu-
tion of this picture: it is thought by
some to be by the young Titian,
while others believe it to be one of
the last works by Giorgione.

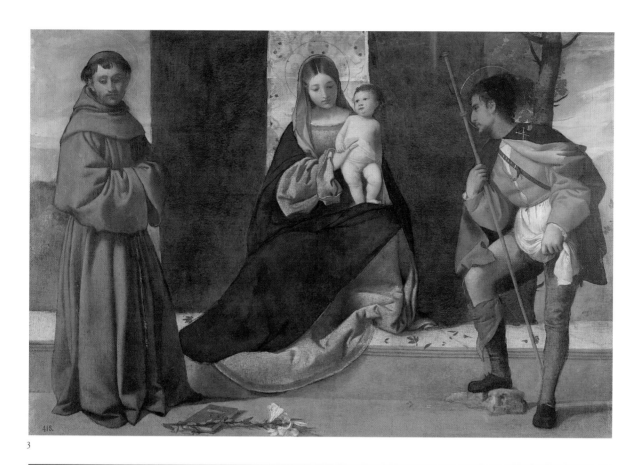

3

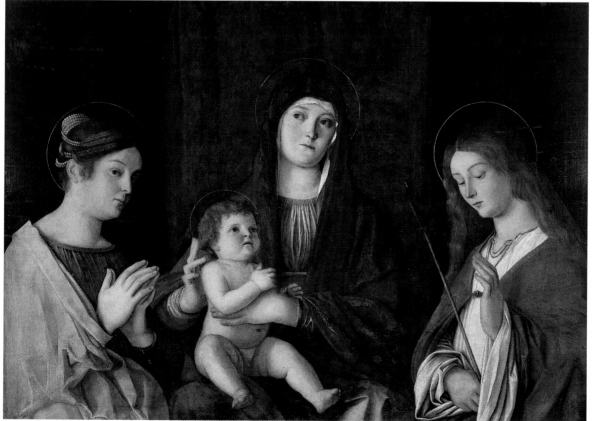

4

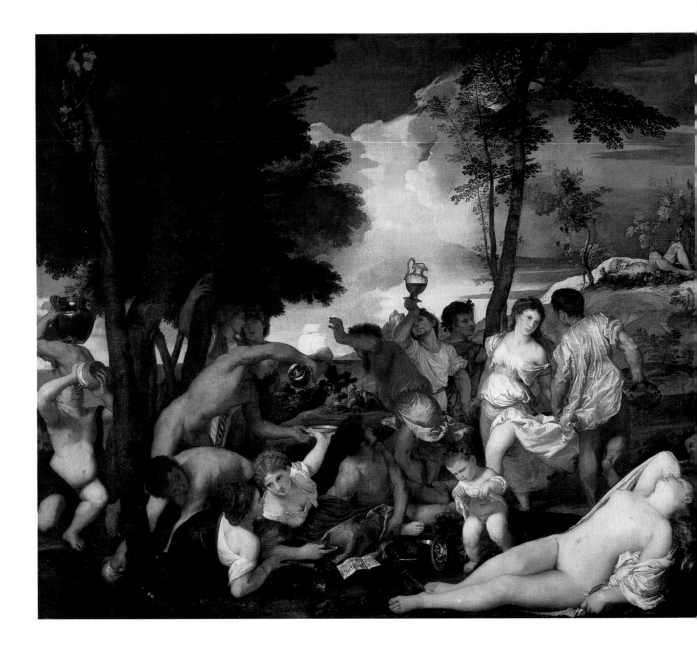

Titian (Tiziano Vecellio)
Pieve di Cadore,
c.1488/90–Venice, 1576
Bacchanal, c.1518/19
Canvas, 175 × 193 cm
From Ferrara castle
Presented to Philip IV by Nicolas
Ludovisi
Cat. no. 418

This was the last in a series of
magnificent paintings for Alfonso
d'Este, Duke of Ferrara; another
in the series, *The Worship of Venus*,
is also in the Prado, but the third
piece, *Bacchus and Ariadne*, is in
the National Gallery in London.
The subjects are taken from classi-
cal descriptions of certain works
of art. Here, Titian reproduces a
painting, seen in Naples by the

Sophist writer Philostratus in the
second century, which shows the
inhabitants of the Greek island of
Andros making merry on the river
of wine created by Dionysus
(Bacchus). This splendid opportu-
nity to emulate the past was not
lost on Titian, whose brilliant
naturalism and marvellous
colouring show him to be the
equal of Apelles.

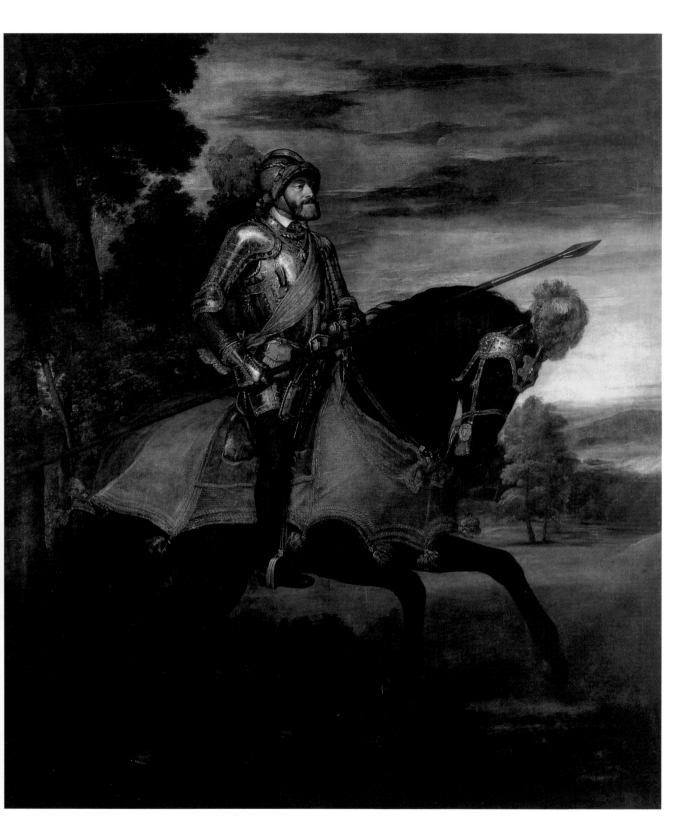

Titian (Tiziano Vecellio)
Pieve di Cadore,
c.1488/90–Venice, 1576
The Emperor Charles V at
Mühlberg, 1548
Canvas, 332 × 279 cm
Charles V collection
Cat. no. 410

This is one of Titian's most dramatic and monumental portraits, conveying not so much the personality of the subject as the high ideals of his imperial office. The emperor had defeated the Schmalkadic League of Protestant Princes at the battle of Mühlberg, and Titian portrayed him as the archetypal Christian knight overcoming the heretics – a kind of modern St George. As well as creating a memorable image, Titian showed his skill in handling textures, such as the diffusion of the evening sunlight through the landscape and the captivating sheen of the armour.

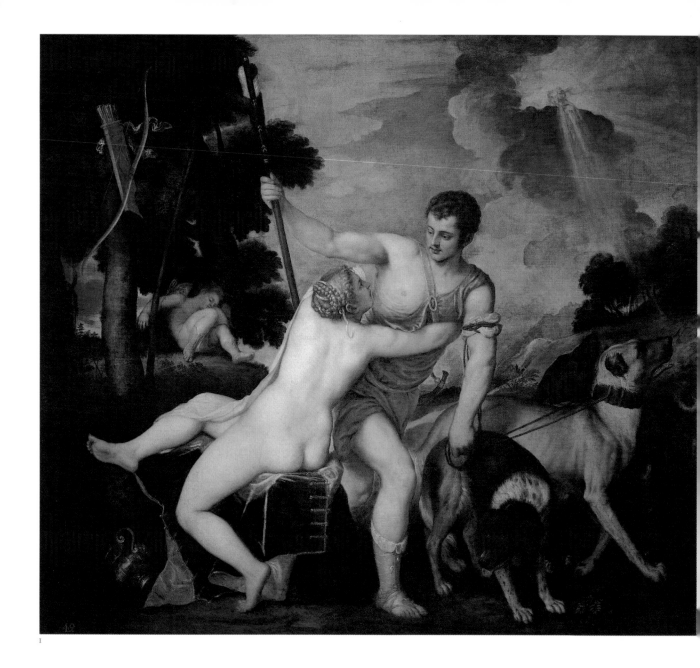

1

1
Titian (Tiziano Vecellio)
Pieve di Cadore,
c.1488/90–Venice, 1576
Venus and Adonis, 1554
Canvas, 186 × 207 cm
Philip II collection
Cat. no. 422

2
Titian (Tiziano Vecellio)
Pieve di Cadore,
c.1488/90–Venice, 1576
Danaë, 1553
Canvas, 129 × 180 cm
Philip II collection
Cat. no. 425

3
Titian (Tiziano Vecellio)
Pieve di Cadore,
c.1488/90–Venice, 1576
Venus and an Organ Player, 1545
Canvas, 148 × 217 cm
Presented to Philip III by the
Emperor Rudolf II (?)
Cat. no. 421

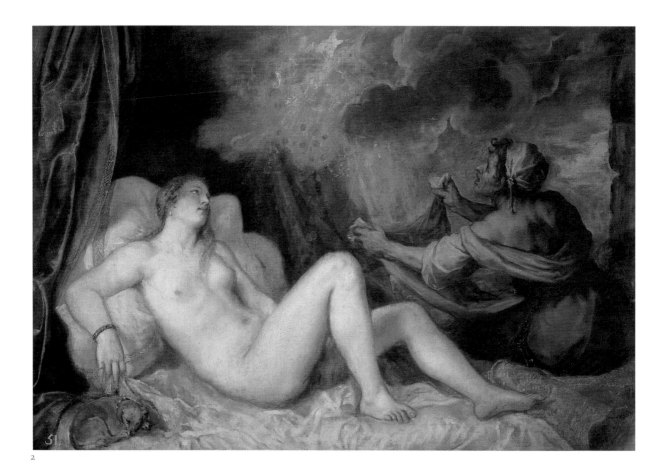

2

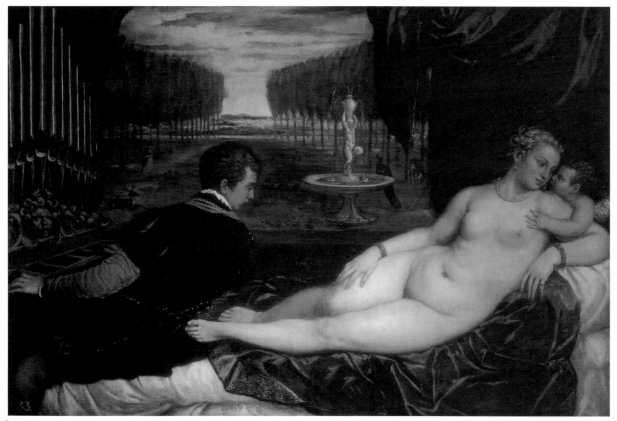

3

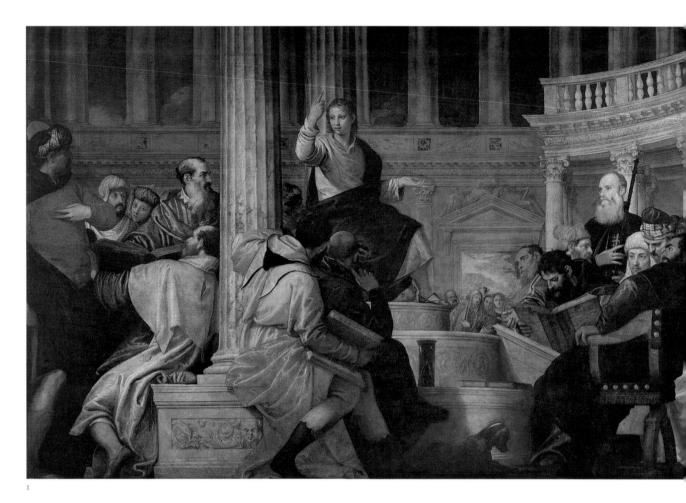

1

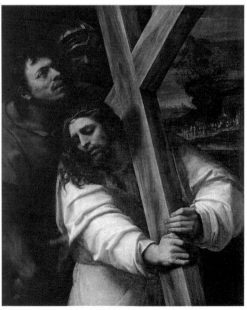

2

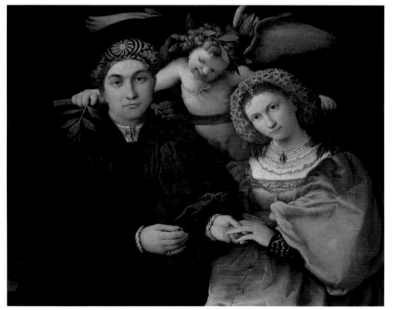

3

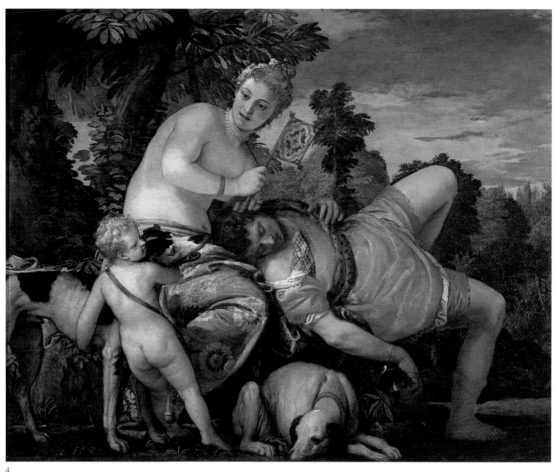

4

1
Paolo Caliari,
known as **Veronese**
Verona, 1528–Venice, 1588
Jesus among the Doctors in the Temple, 1558 (?)
Canvas, 236 × 430 cm
Philip IV collection
Cat. no. 491

2
Sebastiano Luciani,
known as **Sebastiano del Piombo**
Venice, c.1485–Rome, 1547
Christ on the Road to Calvary,
c.1528/30
Canvas, 121 × 100 cm
In the royal collection by the sixteenth century
Cat. no. 345

3
Lorenzo Lotto
Venice, c.1480–Loreto, 1556
Signor Marsilio and his Wife, 1523
Canvas, 71 × 84 cm
Philip IV collection
Cat. no. 240

4
Paolo Caliari,
known as **Veronese**
Verona, 1528–Venice, 1588
Venus and Adonis, c.1580
Canvas, 212 × 191 cm
Philip IV collection
Cat. no. 482

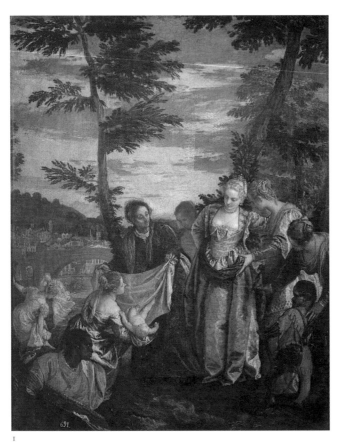

1

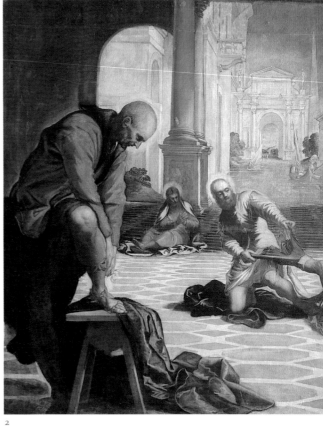

2

1
Paolo Caliari,
known as **Veronese**
Verona, 1528–Venice, 1588
The Finding of Moses, c.1580
Canvas, 50 × 43 cm
Philip IV collection
Cat. no. 502

This exquisite work in Veronese's
mature style shows all the elegance
and refinement for which the
painter was so famous and, above
all, his superb colouring in the
women's rich silks and the silvery
background. The wonderful light
effects are achieved by a delicate
and subtle juxtaposition of
colours that are cold and warm,
pale and dark.

2
Jacopo Robusti,
known as **Tintoretto**
Venice, 1519–94
Christ Washing the Feet of His Disci-
ples, c.1547
Canvas, 210 × 533 cm
Philip IV collection
Acquired in London in 1649 from
the collection of Charles I of
England
Cat. no. 2824

It was long supposed that this pic-
ture was painted for the church of
San Marcuola in Venice, but the
copy still in the church is more
like another version of the same
subject that is now in Newcastle.
However, there is no doubt about

the authorship of the canvas at the
Prado, which was most certainly
painted at around the same time.
Typical of Tintoretto throughout
his long career is the dramatic set-
ting, with long diagonal views that
transform the humble event into
an apocalyptic vision. The colour-
ing, however, is bright and sump-
tuous, and the modelling firm,
while the room is large and spa-
cious, and the lighting limpid and
still – signs that Tintoretto pro-
duced the painting at the start of
his career.

3
Jacopo Robusti,
known as **Tintoretto**
Venice, 1519–94
Portrait of a Venetian General,
c.1570/75
Canvas, 82 × 67 cm
Presented to Philip IV by the
Marquis of Leganés
Cat. no. 366

4
Jacopo Robusti,
known as **Tintoretto**
Venice, 1519–94
Portrait of a Woman revealing her
Breasts, c.1570
Canvas, 61 × 55 cm
Royal collection
Cat. no. 382

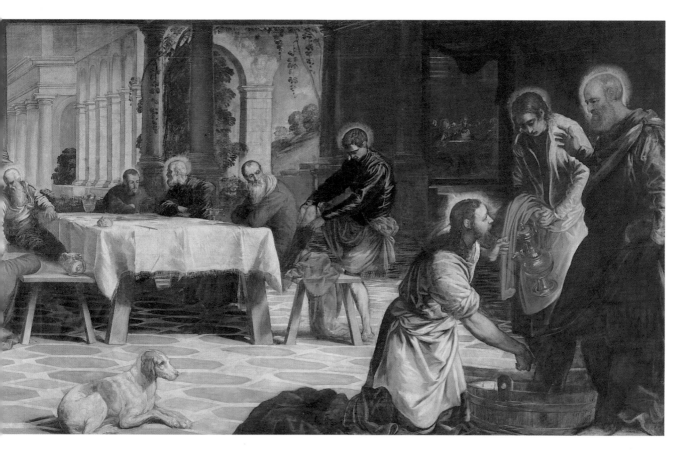

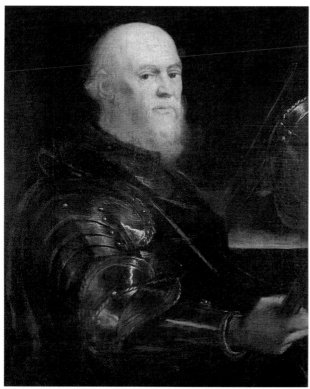

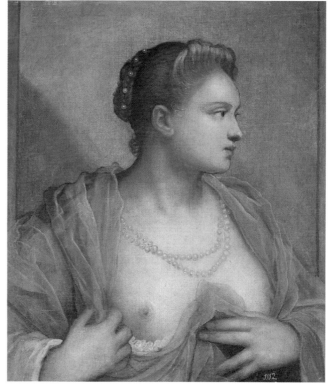

3

4

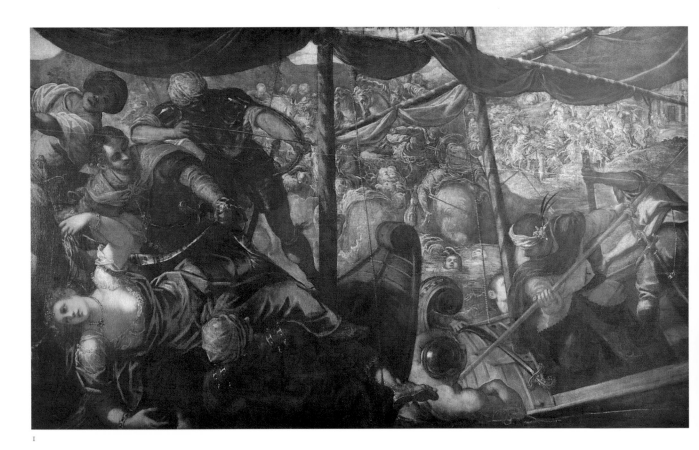

1

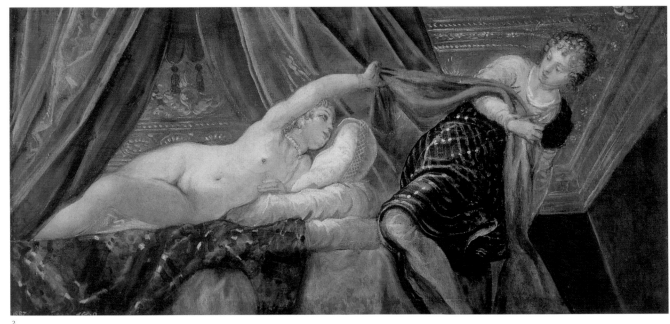

2

1
Jacopo Robusti,
known as **Tintoretto**
Venice, 1519–94
*Battle between Turks and
Christians*, c.1588/9
Canvas, 189 × 307 cm
Philip IV collection
Cat. no. 399

2
Jacopo Robusti,
known as **Tintoretto**
Venice, 1519–94
Joseph and Potiphar's Wife, c.1555
Canvas, 189 × 307 cm
Philip IV collection
Cat. no. 395

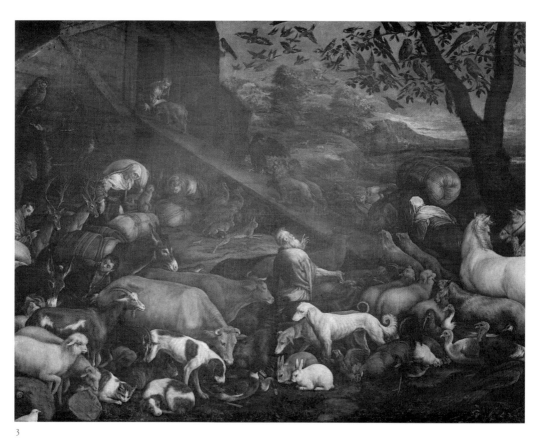

3

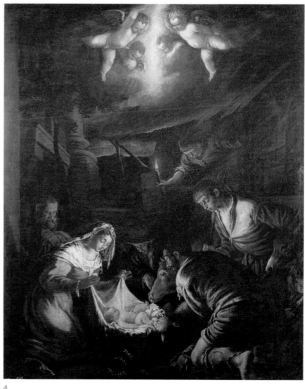

3
Jacopo da Ponte,
known as **Jacopo Bassano**
Dal Ponte, *c*.1510–Bassano, 1592
The Animals entering the Ark
Canvas, 207 × 265 cm
Royal collection
Cat. no. 22

4
Jacopo da Ponte,
known as **Jacopo Bassano**
Dal Ponte, *c*.1510–Bassano, 1592
or (his son) Francesco da Ponte,
known as Francesco Bassano
dal Ponte
The Adoration of the Shepherds
Canvas, 128 × 104 cm
In the collection of Queen Isabel
Farnese by 1746
Cat. no. 26

4

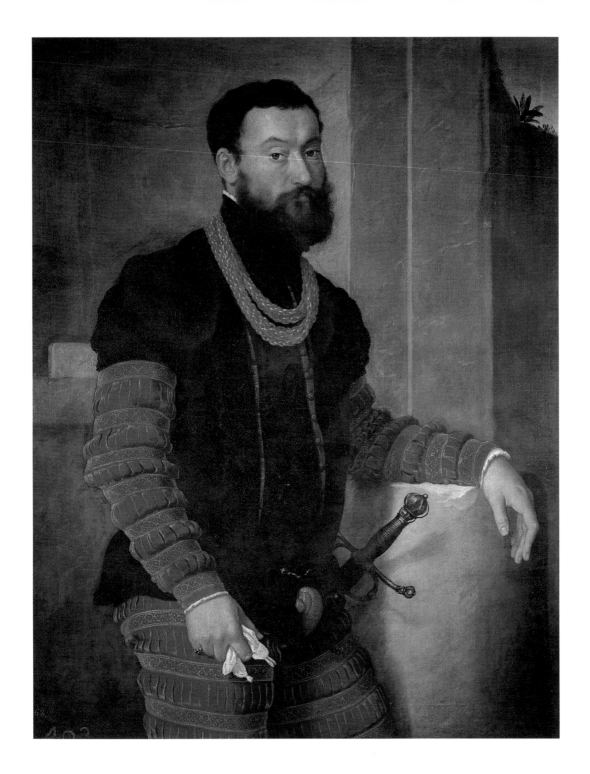

Giovanni Battista Moroni
Albino, c.1523–Bergamo, 1578
Portrait of a Soldier, c.1555/9
Canvas, 119 × 92 cm
Philip IV (?) collection
Cat. no. 262

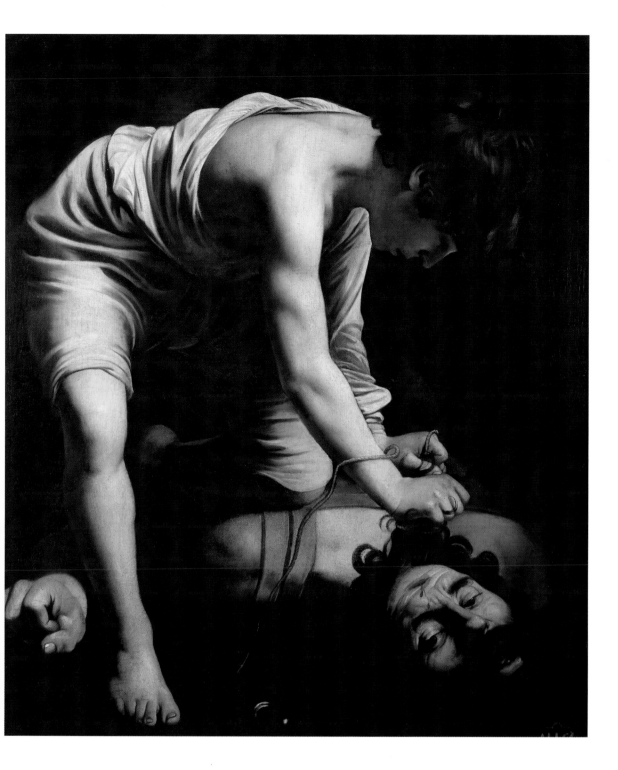

Michelangelo Merisi,
known as **Caravaggio**
Caravaggio, c.1570/71–Porto
Ercole, 1610
David and Goliath, c.1599/1600
Canvas, 110 × 91 cm
In the royal collection by the
eighteenth century
Cat. no. 65

Caravaggio is of particular impor-
tance in Spain, for he was respon-
sible for the origin of the realist
and 'tenebrist' style of painting
that later became so widespread
and popular in the works of such
artists as Ribera and Zurbarán.
This mature piece demonstrates
the fundamentals of his art: an
emphatic solidity produced by the
strong contrast between light and
shade; the immediacy created by

staging the action right in the fore-
ground and eliminating all super-
fluous space around it (a conven-
tional painter would probably have
left room for David to stand up, as
it were); and the absence of any
decorative elements of any kind –
by way of colouring or elegant pos-
tures – in order to concentrate
attention solely on the drama.

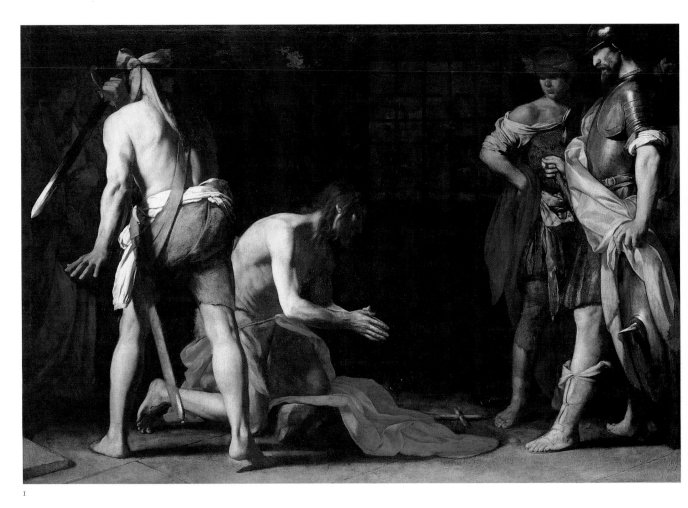

1

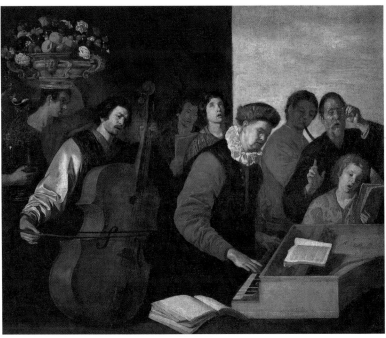

2

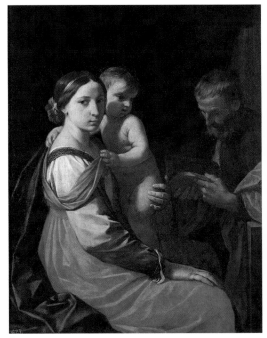

3

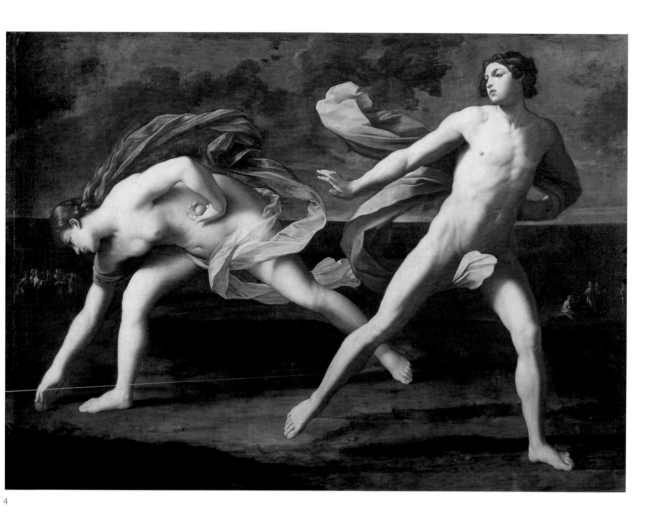

4

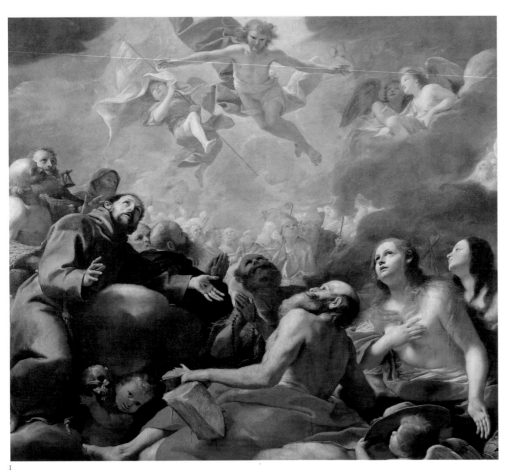

1

Mattia Preti
Taverna, Calabria, 1613–
La Valletta, 1699
Christ in Glory, c.1660
Canvas, 220 × 253 cm
Acquired in 1969
Cat. no. 3146

2

Paolo Porpora
Naples, 1617–73
Vase of flowers
Canvas, 77 × 65 cm
Philip IV (?) collection
Cat. no. 569

3

Orazio Gentileschi
Pisa, 1563–London, 1639
The Finding of Moses, c.1630/33
Canvas, 242 × 281 cm
Philip IV collection
Cat. no. 147

4

Francesco Albani
Bologna, 1578–1660
*Venus attended by Nymphs and
Cupids*, 1633
Canvas, 114 × 171 cm
Philip IV collection
Cat. no. 1

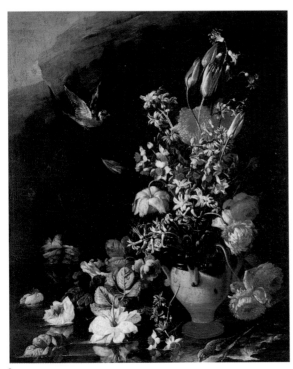

2

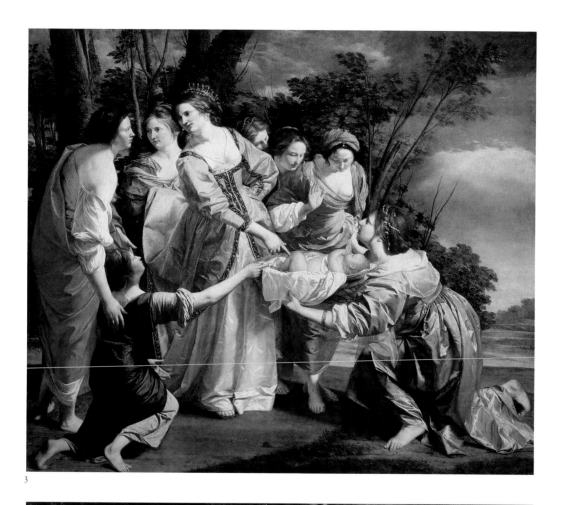

3

4

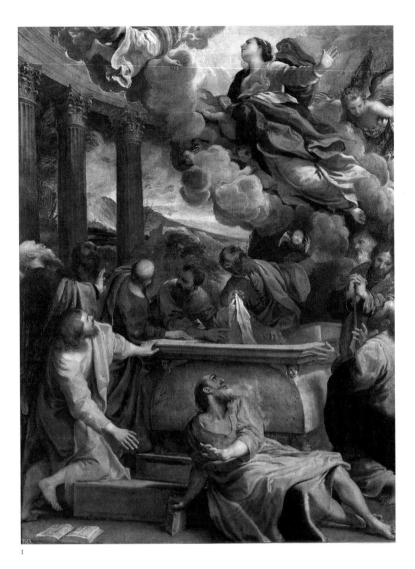

1

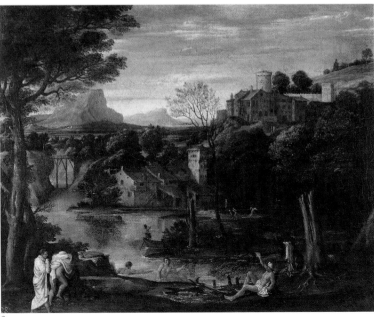

2

1
Annibale Carracci
Bologna, 1560–Rome 1609
The Assumption of the Virgin Mary,
c.1590
Canvas, 130 × 97 cm
Presented to Philip IV by the
Count of Monterrey
Entered the Prado in 1839
Cat. no. 75

2
Annibale Carracci
Bologna, 1560–Rome 1609
Landscape, *c*.1602
Canvas, 47 × 59 cm
In the collection of Philip V
by 1746
Cat. no. 132

3
Domenico Zampieri,
known as **Domenichino**
Bologna, 1581–Naples, 1641
The Sacrifice of Isaac
Canvas, 147 × 140 cm
Philip IV collection
Cat. no. 131

4
Giovanni Francesco Barbieri,
known as **Guercino**
Canto, 1591–Bologna, 1666
Mary Magdalene in Penitence
Canvas, 121 × 102 cm
In the collection of Queen Isabel
Farnese by 1746
Cat. no. 203

5
Guido Reni
Bologna, 1575–1642
Girl with a Rose
Canvas, 81 × 62 cm
Philip IV collection
Cat. no. 218

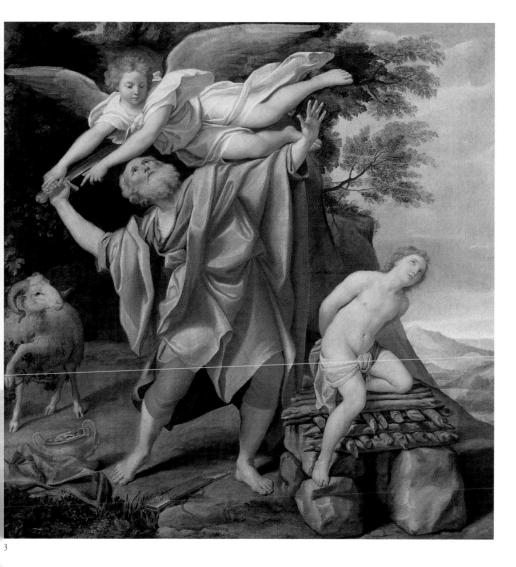

3

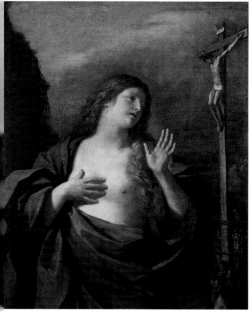

4

5

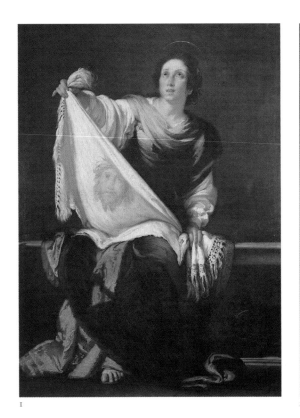

1

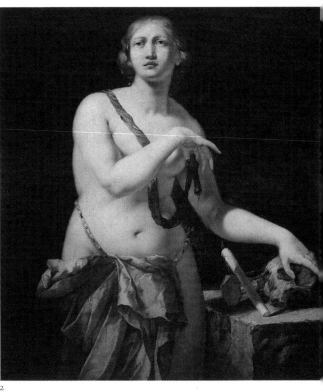

2

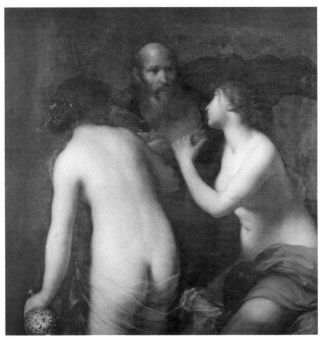

3

4

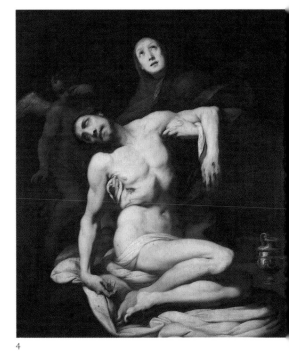

1

Bernardo Strozzi
Genoa, 1581–Venice, 1644
St Veronica, c.1625/30
Canvas, 168 × 118 cm
In the collection of Queen Isabel
Farnese by 1746
Cat. no. 354

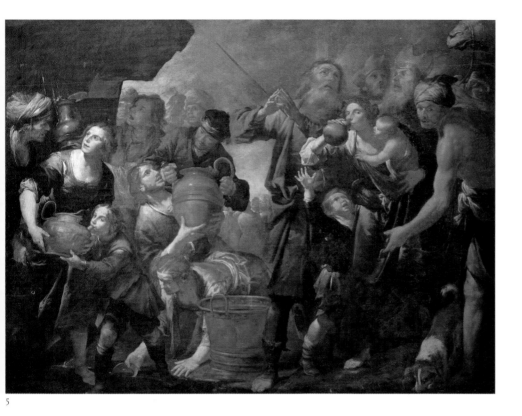

5

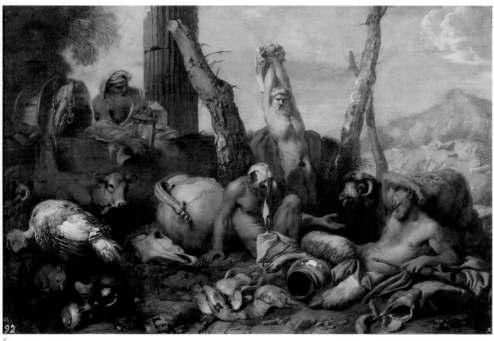

6

5
Gioacchino Assereto
Genoa, 1600–49
*Moses drawing Water from
the Rock*
Canvas, 245 × 300 cm
In the collection of Queen Isabel
Farnese by 1746
Cat. no. 1134

6
Giovanni Benedetto Castiglione
Genoa, 1610–Mantua, 1670
*The Fable of Diogenes searching
with a Lantern for a Good Man*
Canvas, 97 × 145 cm
Acquired from the collection of
Carlo Maratta
In the collection of Philip V
by 1746
Cat. no. 88

2
Antonio Zanchi
Este, 1631–Venice, 1722
Mary Magdalene in Penitence
Canvas, 112 × 95 cm
Donated in 1915 by Don Pablo
Bosch
Cat. no. 2711

3
Francesco Furini
Florence, 1600-46
Lot and his Daughters
Canvas, 123 × 120 cm
Presented to Philip IV by the
Duke of Tuscany
Cat. no. 144

4
Daniele Crespi
Busto Arsizio, 1597–Milan, 1630
Pietà, c.1626
Canvas, 175 × 114 cm
Charles II collection
Acquired in 1689 from the collec-
tion of the Marquis of El Carpio
Cat. no. 128

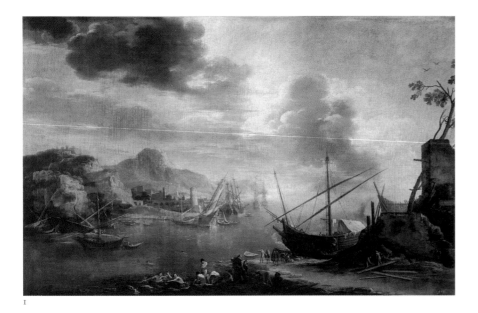

1

2

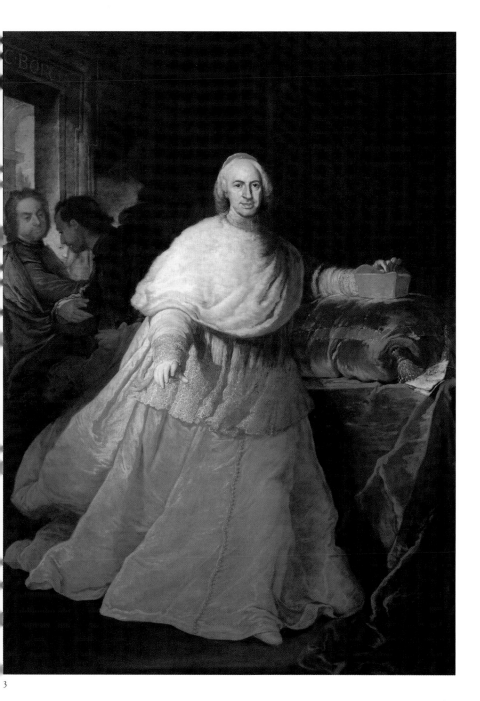

3

4

3
Andrea Procaccini
Rome, 1671–La Granja, 1734
Cardinal Borja, c.1721
Canvas, 245 × 174 cm
Bequeathed by the Count of
La Cimera in 1944
Cat. no. 2882

Throughout the eighteenth
century, numerous Italian
painters were employed by
Spanish patrons, and many of
them spent their working lives in
Spain. There is consequently a
large number of Italian paintings
of that period, including murals,
in the royal residences. Andrea
Procaccini became not only court
painter but also artistic adviser to
the first Bourbon king of Spain,
Philip V, and suggested the
purchase of many of the works
now in the Prado or in the Royal
Palace in Madrid.

4
Domenico Zampieri,
known as **Domenichino**
Bologna, 1581–Naples, 1641
A Triumphal Arch of Allegories,
c.1607/10
Canvas, 70 × 60 cm
Acquired from the collection of
Carlo Maratta. In the collection
of Philip IV by 1746
Cat. no. 540

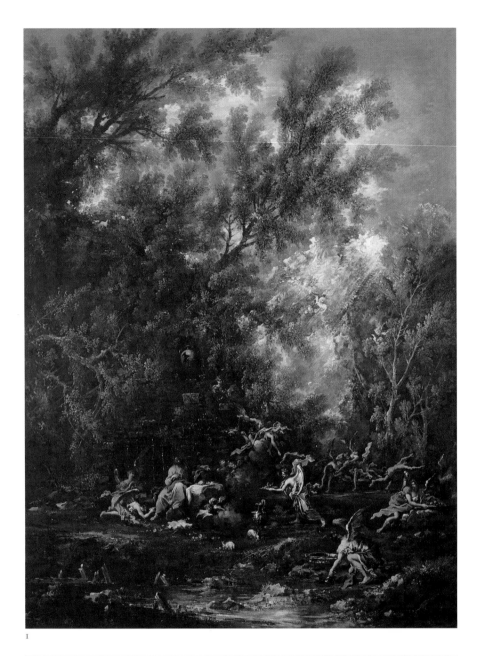

1

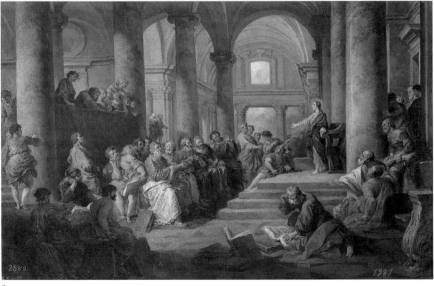

2

1
Alessandro Magnasco
Genoa, 1677–1749
(in collaboration with **Antonio Francesco Peruzzini**)
Angels Ministering to Christ,
*c.*1725/30
Canvas, 193 × 142 cm
Acquired in 1967
Cat. no. 3124

2
Giovanni Paolo Pannini
Piacenza, *c.*1691/2–Rome 1765
Jesus among the Doctors in the
*Temple, c.*1725
Canvas, 40 × 62 cm
Charles IV collection
In the Royal Palace of
Aranjuez in 1818
Cat. no. 277

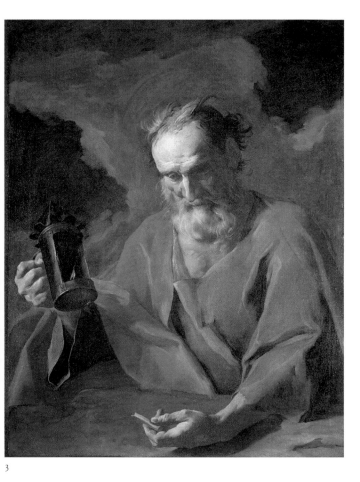

3

4

3
Giuseppe Antonio Petrini
Carona, 1677–1758
Diogenes
Canvas, 98 × 75 cm
Acquired in 1992
Cat. no. 7616

4
Jacopo Amigoni
Venice, c.1680/85–Madrid, 1752
The Marquis of La Ensenada,
c.1750/52
Canvas, 124 × 104 cm
Acquired in 1950
Cat. no. 2939

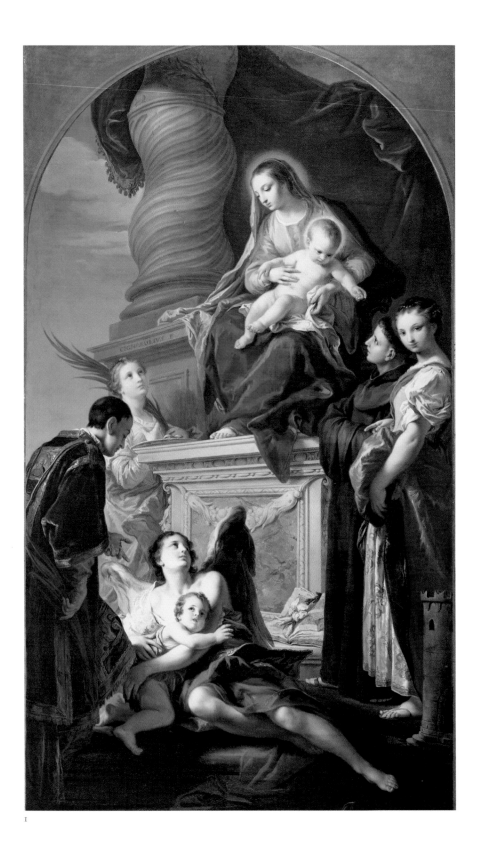

1

1

Giambettino Cignaroli
Verona, 1706–70
*The Virgin with the Child Jesus
and Saints*
Canvas, 314 × 171 cm
Commissioned in 1759 for the
high altar of the chapel in the
Palace of Riofrío
Later transferred to the Palace of
La Granja de San Ildefonso
Cat. no. 99

2

Gaspard van Wittel,
known as **Gasparo Vanvitelli**
Amersfoort, 1653–Rome, 1736
*View of the Piazzetta, Venice, from
San Giorgio*, 1698
Canvas, 98 × 174 cm
In the collection of Queen Isabel
Farnese by 1746
Cat. no. 475

3

Francesco Battaglioli
Modena, *c.*1725–Venice, *c.*1790
The Palace of Aranjuez, 1756
Canvas, 86 × 112 cm
Acquired in 1979
Cat. no. 4180

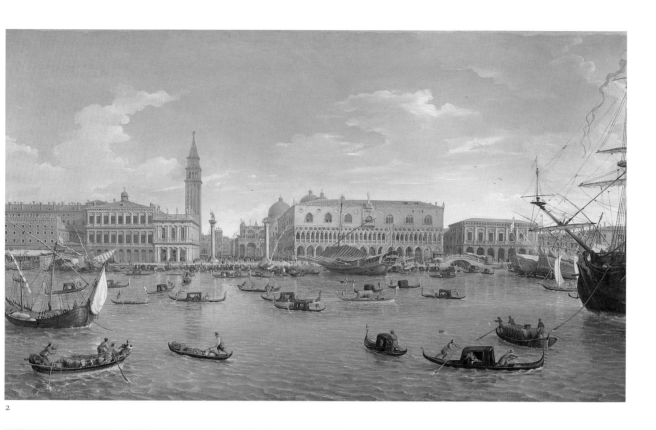

2

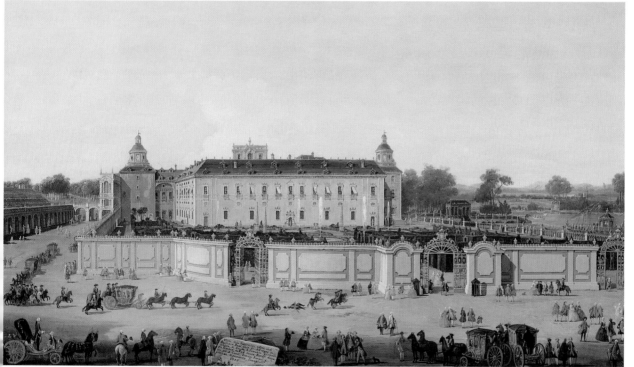

3

1

2
3

1
Giambattista Tiepolo
Venice, 1696–Madrid, 1770
*Queen Zenobia in the presence of the
Emperor Aurelian, c.1717*
Canvas, 250 × 500 cm
From the collection of the
Marquis of Casa Riera
Acquired in 1975
Cat. no. 3243

2
Giambattista Tiepolo
Venice, 1696–Madrid, 1770
One fragment of an altarpiece,
*The Vision of St Paschal Baylón: The
Angel Bearing the Eucharist*, 1769
Canvas, 185 × 188 and 153 × 112 cm
Charles III collection
Cat. no. 364

According to the inscription on
the engraving published by his
son (displayed alongside the
fragments), Tiepolo painted the
altarpiece in 1770, which would
make it his last work. However, in
a letter of 1769, Tiepolo himself
refers to it as finished. He had
arrived in Spain in 1762 to com-
plete the decoration of the Royal
Palace in Madrid for King
Charles III. In 1767 he wrote
saying that the decorations were
finished and asking for further
employment. Despite opposition
from certain members of the
court, he received a commission
for a series of seven paintings for
the new church of San Pascual
Baylón, of which this was one.
But the tide of taste was running
against the old master's late-
Baroque style, and no sooner had
the canvases been completed than
they were ripped out and replaced
by works in the new neoclassical
style by Mengs and others.

3
Gian Domenico Tiepolo
Venice, 1727–1804
Christ falls on the Way to Calvary,
1772
Canvas, 124 × 144 cm
From the church of San Felipe
Neri in Madrid
Entered the Museo de la Trinidad
in 1836 and later the Prado
Cat. no. 358

4
Giuseppe Bonito
Castellamare di Stabia,
1701–Naples, 1789
*The Turkish Ambassador
to the Court of Naples, with his
Entourage*, 1741
Canvas, 207 × 170 cm
In the collection of Queen Isabel
Farnese by 1746
Cat. no. 54

5
Pompeo Batoni
Lucca, 1708–Rome, 1787
The Duke of Gloucester, 1778
Canvas, 221 × 157 cm
In the royal collection by the
eighteenth century
Cat. no. 49

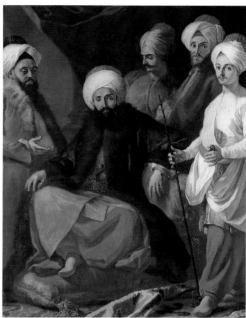

4

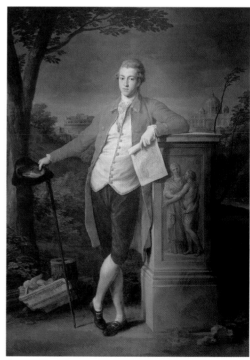

5

FLEMISH PAINTING

Along with the collections of Spanish and Italian painting, the Flemish collection occupies a distinguished position in the Prado. The earliest paintings in the collection originate not only from Flanders but also from Holland, since in fact there was no real distinction between the Dutch and Flemish schools until the beginning of the seventeenth century. However, from then on, due to the political autonomy of the regions that took the name of Holland, Dutch art followed a path of its own.

Owing to its particular history, Spain has always been known for its fabulous wealth of Flemish art – especially paintings and tapestry – ranging from the Primitive School of the fifteenth century to the height of the Baroque. This inheritance can be seen in royal palaces and in cathedrals and monasteries, as well as in public and private collections throughout the Iberian peninsula. The Prado Museum, with its vast and impressive collection of Flemish art, from masterpieces to minor works, fully displays the splendour of this exceptional legacy.

During the early the Middle Ages, the Iberian peninsula maintained very close ties with the North Sea countries, especially Flanders. These contacts were started and cemented through trading links with Castile, resulting in political collaboration that in turn culminated in marriage alliances during the reign of Ferdinand and Isabella. The Duke of Burgundy and Prince of Flanders, Philip the Fair, son of the Emperor Maximilian of Austria and Mary of Burgundy, married the Infanta Doña Joanna (who became known as 'Joanna the Mad'), daughter of Ferdinand and Isabella and later the heir to their realms; while Don John, Prince of Asturias, heir presumptive to his parents in Castile and Aragon, married Margaret of Burgundy, the sister of Philip. For various historical and family reasons, this territorial legacy fell in its entirety to Philip's elder son, Charles of Ghent, who in 1517 became Charles I of Spain and, in 1519, Charles V of the Holy Roman Empire.

As a result of the strong contacts between the Spanish and Flemish worlds until the eighteenth century, there was a similarly close relationship in the artistic sphere. Flemish artists such as Van Eyck and Rubens visited the peninsula, while Spanish painters such as Dalmau and Sánchez Coello travelled to the northern territories. The most important factor that strengthened the artistic ties between the two regions and did most to influence Spain's pictorial tradition was the enormous number of paintings purchased in the Low Countries that ended up in the various social estates – the Church, the nobility and the merchant class – many of which were specifically commissioned to decorate palaces, shrines and residences while others were simply purchased on the art market.

The social and religious upheavals that took place in the Low Countries during the second half of the sixteenth century and the war of independence in the northern provinces, which persisted throughout the first half of the seventeenth century (with the exception of the Twelve Year Truce), culminated in the Thirty Years War, which ended with the Peace of Westphalia in 1648 whereby Holland's full independence was recognized. Consequently, from the end of the sixteenth century onwards it was possible to speak for the first time of two clearly distinct schools of art, the Flemish and the Dutch.

It was during the reign of Philip II that the great influx of sixteenth-century Flemish masterpieces began, with the king ordering the acquisition of numerous works from a variety of schools. Among the gifts he received there is a panel attributed to Bernard van Orley titled *The Virgin of Louvain*, presented to him by the city in 1588 in gratitude for his help during the plague ten years earlier.

It is thanks to Philip II that the Prado possesses the world's most important collection of works by Hieronymus Bosch. The king achieved this by waiting patiently to purchase panels by Bosch one by one as they became available. *The Cure for Folly* and *The Seven Deadly Sins* were obtained in 1560 from the heirs of Don Felipe de Guevara, and the unparalleled *Garden of Earthly Delights* – the famous, enigmatic triptych that is another landmark of symbolic art – was obtained at the sale of the property of a natural son of the Duke of Alba. Two further triptychs, *The Adoration of the Magi* and *The Haywain*, were added to this collection, as was a later work, *The Temptation of St Anthony*.

During the seventeenth century, the Spanish monarchy maintained close cultural contacts with Flanders. These were intensified due to Spain's constant political intervention, and to the personal interests of Spanish kings and princes such as Philip IV, and the governors Isabel Clara Eugenia and Alberto de Austria. Between them all these patrons were responsible for commissioning numerous works by Flemish painters. The most powerful and wealthy within the Church and the aristocracy sought works by Rubens, who had established a large workshop that not only influenced the development of the Flemish school but also affected the course of European Baroque. As a consequence of this, the collection of his works in the Prado is particularly extensive and of exceptional quality. Much the same can be said of Rubens' collaborators, followers and pupils, as well as other painters influenced by his personality and artistic style.

The desire to decorate the palaces, residences and religious centres of the House of Austria with Flemish paintings led to an uninterrupted flow of works of art into Spain that continued for many years. Among the outstanding artists who produced these pieces were Rubens, of course, and later Van Dyck and Jordaens. The art of this period can be admired for the exuber-

ant richness of the still lifes, the bright, panoramic landscapes, the spectacular religious themes, the great historical events, the grandeur of classical mythology and allegories, the pomp of the portraits with their profound psychological insights, the grace and elegance of the genre paintings and the decorative vivacity of the animal pictures.

Rubens came to Spain twice. The first visit was in 1603, during the reign of Philip III, when he signed a contract with the court in Madrid to paint a set of panels known as *The Apostles* for the Duke of Lerma. Later in 1628, when Philip IV was on the throne, he returned at the peak of his maturity and undertook work for the king. Rubens and his workshop also produced a great number of canvases for the Spanish court, though it is sometimes difficult to ascertain how far Rubens himself actually contributed to these.

The crown acquired a large number of works at the sale of Rubens' property after his death in 1640. Amongst these are *The Supper at Emmaus, St George and the Dragon* and *Bacchus Disembarking on the Island of Andros*. Rubens was also asked to decorate the Torre de la Parada, the hunting lodge at El Pardo, and produced such remarkable pieces as *The Rape of Deidamia, Heraclitus,* and *Orpheus and Eurydice*. He also prepared many of the sketches for this ambitious decorative project, though many of them were carried out by his followers such as Cossiers, Symons and Jordaens. Rubens collaborated very closely with these and other painters on a variety of works; among those exhibited in the Prado are *Achilles Discovered*, in collaboration with Van Dyck, *Ceres and her Nymphs*, with Snyders, and *The Devotions of Rudolf I of Habsburg*, with Jan Wildens. It is appropriate that the Prado should also contain the last work that Rubens must have painted before his death, *Perseus and Andromeda*, which was left unfinished and was magnificently completed by Jordaens.

To this extensive collection, Philip IV added many hunting scenes by Paul de Vos and Snyders, as well as exquisite works by Jan 'Velvet' Brueghel. Among the most outstanding additions is a series by Brueghel depicting *The Five Senses*, presented by the Duke of Medina de las Torres; several works by Van Dyck, including two portraits, *The Cardinal-Infante* and *Martin Ryckaert;* religious scenes such as *St Jerome, The Crown of Thorns* and *Christ's Arrest in the Garden* (the latter three from the sale of the contents of Rubens' studio); as well as many other significant pieces by Rombouts, Teniers, Crayer, Jordaens and the Bruegels.

During the reign of Charles II the royal collections continued to grow. It was during this period that the delightful panels with sketches for tapestry cartoons, two by Rubens, and *The Holy Family* were acquired from the collection of the Marquis

of El Carpio, as well as *The Infant Jesus with St John* by Van Dyck.

Throughout the following century, Philip V, and especially his wife Isabel Farnese, collected with great enthusiasm and success. The queen purchased the series known as *The Apostles* by Rubens and several works by Van Dyck, including *St Francis* and *The Mystic Marriage of St Catherine*. Also acquired was the latter's famous portrait, *Sir Endymion Porter and the Artist*, together with important paintings by Jordaens, Arthois, Snayers, Teniers, Bril and the Brueghels.

Charles III made few acquisitions and it was his son, Charles IV, who accumulated interesting new works for the collection, such as those by Bloemen, Seghers, Teniers, Van Kessel the Elder, Brueghel and Craesbeeck. Many works were removed during the French invasion by Joseph Bonaparte, who lost several of them at the battle of Vitoria (some can be found in the Wellington Museum in London), while others were sold in England and the United States in the nineteenth century.

Since the foundation of the Prado in 1819, the Flemish School has gained some important additions. In 1865 Count Hugo donated *The Animals Triptych* by Van Kessel the Elder, and the Duchess of Pastrana donated Rubens' sketches for the Torre de la Parada, among other pieces, in 1889. The splendid bequest by Don Pablo Bosch provided several more valuable additions: *The Holy Family* by Van Orley, the exquisite *Rest on the Flight into Egypt* by Gerard David, and the unique *Head of a Bowman* by Bosch. In 1928, *Portrait of a Family* by Van Kessel the Younger was acquired, and in 1930 the large series of paintings on copper on religious themes by Francken entered the museum with the Fernández Durán bequest, as well as two paintings on copper on military themes by Meulener. Among more recent acquisitions are the equestrian portrait of the *Duke of Lerma* by Rubens in 1969, a *Pietà* by Jordaens in 1981, *Portrait of a Gentleman and his Sons* by Adrianz Thomasz Key in 1981, and several panels by Beuckelaert and Teniers, as well as tapestries by Snyders and Vos.

The Prado can thus offer visitors a splendid overall view of Flemish art in all its various stages of development from Gothic to Baroque, reflecting the great variety and artistic wealth of this truly exceptional national school.

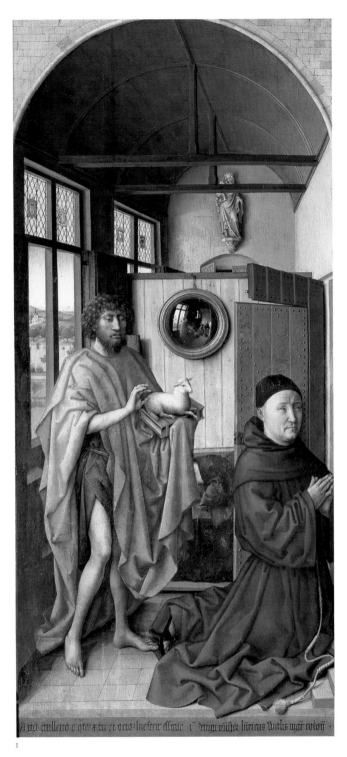

1

2

1

Robert Campin, also known as
the Master of Flémalle
Tournai, c.1378/9–1444
Left wing of the Werl altarpiece,
showing *St John the Baptist and
the Donor Heinrich von Werl*, 1438
Panel, 101 × 47 cm
Charles IV collection
Entered the Prado in 1827
Cat. no. 1513

2

Robert Campin, also known as
the Master of Flémalle
Tournai, c.1378/9–1444
Right wing of the Werl
Altarpiece, showing *St Barbara*,
1438
Panel 101 × 47 cm
Charles IV collection
Entered the Prado in 1827
Cat. no. 1514

The central panel of the triptych
to which these wings belonged
has been lost. The bench on
which St Barbara is seated and
the perspective of the whole room
can also be seen in Campin's
Annunciation, now at The
Cloisters, New York; even the
white towel and the jug and basin,
symbols of the Virgin's chastity,
have been used again, although
they are not attributes of St
Barbara. Her attribute, the tower
in which she was imprisoned, is
shown outside the window –
typical of the way in which the
early Flemish painters rationalized
abstract symbols in a natur- alistic
way. The mirror on the wall in the
left wing is borrowed from Jan
van Eyck's *Arnolfini and his Wife*,
in the National Gallery in London,
painted four years earlier.

3

Rogier van der Weyden
Tournai, c.1399/1400–
Brussels, 1464
The Virgin and Child
Panel, 100 × 52 cm
Acquired in 1899 from the
palace of Boadilla del Monte
Bequeathed to the Prado in 1938
by Don Pedro Fernández Durán
Cat. no. 2722

4

Frank van der Stockt
Brussels, 1420 (?)–95
Centre panel of a triptych,
showing *The Crucifixion*
Panel, 195 × 172 cm
From the convent of Los
Angeles, Madrid
Cat. no. 1888

3

4

Rogier van der Weyden
Tournai, c.1399/1400–
Brussels, 1464
The Descent from the Cross, c.1435
Panel, 220 × 262 cm
Philip II collection
Cat. no. 2825

After training at the workshop of Robert Campin, Rogier van der Weyden moved to Brussels in 1435 and shortly afterwards was appointed the city's official painter. By around 1450, when he is reported to have visited Italy, he had already earned an international reputation, and the style of his figures and compositions was imitated throughout northern Europe until the end of the fifteenth century.

This is one of his most influential and most copied works. The moving scene of the removal of Christ's body from the cross is compressed into a shallow box to imitate the effect that would have been achieved by a more costly painted wood sculpture.

However, to modern eyes, the absence of any distracting elements and the monumental figures serve to enhance the pathos. The work was and still is exceptional in the accuracy with which the surfaces are rendered and the eloquent and memorable expressions of sadness on the faces of the participants.

1
Adriaen Isenbrandt
Active after 1510; died in Bruges in 1551
The Mass of St Gregory
Canvas, 72 × 56 cm
Entered the Prado in 1822 from the
Royal Palace in Madrid
Cat. no. 1943

2
Gerard David
Oudewater, c.1450/60–Bruges, 1523
The Virgin and Child
Panel, 45 × 34 cm
Entered the Prado in 1839 from
the Escorial
Cat. no. 1537

With the death of Memling in 1494,
Gerard David became the leading
artist in Bruges. This small panel,
although perhaps not painted by the
master himself, shows the same
gentle delicacy that is apparent in his
work. The framing device, giving the
impression that the Virgin Mary is
standing at a window, follows a long
tradition in early Flemish painting.
The view through the window shows
an attractive country scene, and there
is a meticulously painted vase of
flowers on the sill – both landscape
and still lifes being specialities of the
Flemish School.

1

Dieric Bouts
Haarlem, c.1420–Louvain, 1475
Polyptique, showing *The Visitation,*
Nativity, Adoration of the Kings
and *The Annunciation, c.*1445
Entered the Prado in 1839 from
the Escorial
Cat. no. 1461

2

Hans Memling
Selingenstadt, *c.*1433–
Bruges, 1494
Detail from a triptych, showing
The Purification in the Temple,
*c.*1470
Panel, 95 × 145 cm (centre),
95 × 63 cm (wings)
Charles V collection
Entered the Prado in 1847
Cat. no. 1557

Hans Memling trained under
Rogier van der Weyden in
Brussels and later settled in
Bruges. He had a highly compe-
tent, clear, symmetrical and rich-
ly coloured style that lacked the
emotive force of his master and
the exquisite technical detail of
Jan van Eyck. The compositions
in this triptych are based on
models established by Van der
Weyden, but are characteristically
softer and less monumental.

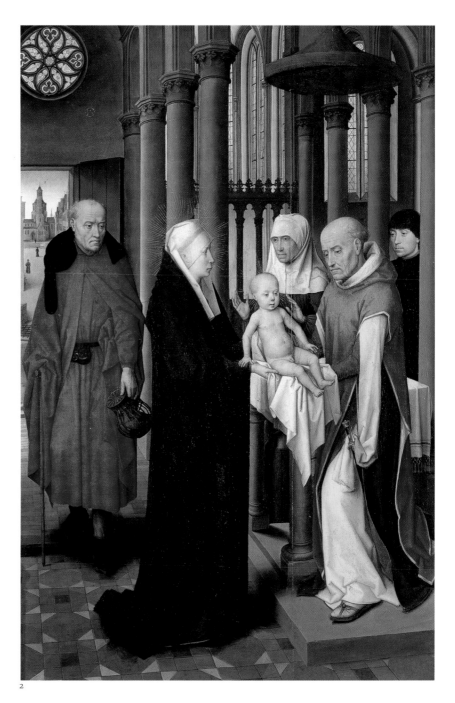

2

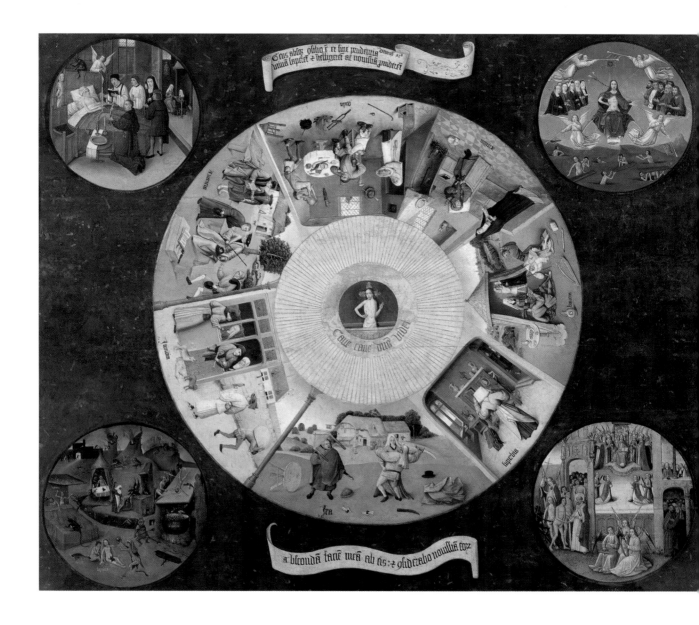

Hieronymus van Aeken,
known as **Bosch**
's Hertogenbosch, c.1450–1516
The Seven Deadly Sins, c.1480
Panel, 120 × 150 cm
Philip II collection
Cat. no. 2822

This is one of Hieronymus
Bosch's earliest known works
and it reflects the style and sub-
ject matter that were later to be
considered characteristic of his
art. It belonged to Philip II, who
kept it in his apartments at the
Escorial.

In the centre, fanning out
around the figure of Christ, are
seven scenes illustrating the
Seven Deadly Sins, each with its
appropriate inscription and com-
posed with the painter's usual
vivacity and sense of fantasy.
Anger is represented by a scene
of jealousy and conflict; in Pride,
a devil offers a mirror to a
woman; Lust shows two pairs of
lovers conversing inside a tent,
entertained by a buffoon, while
on the ground outside lie various
musical instruments, including a
harp which was to reappear in

The Garden of Earthly Delights;
Sloth is represented by a woman
dressed for church trying to
waken a sleeping man; Gluttony
shows a table spread with food
and around it people eating vora-
ciously; Avarice is depicted by a
judge being bribed; and Envy
illustrates the Flemish proverb
'Two dogs with one bone seldom
reach agreement'. At the corners
of the table are four circular
pictures portraying Death, the
Last Judgement, Hell and Glory.

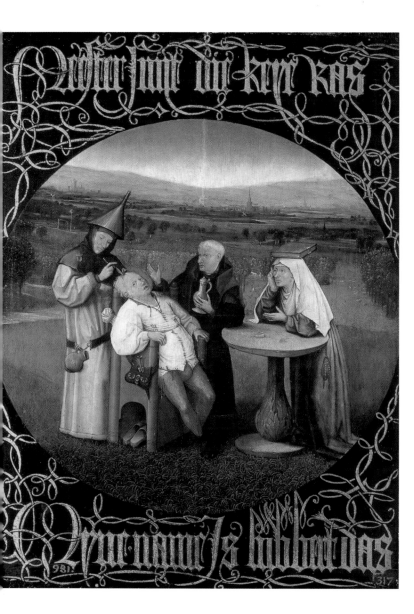

Hieronymus van Aeken,
known as **Bosch**
's Hertogenbosch, c.1450–1516
The Cure for Folly, c.1490
Panel, 48 × 35 cm
Philip II collection
Cat. no. 2056

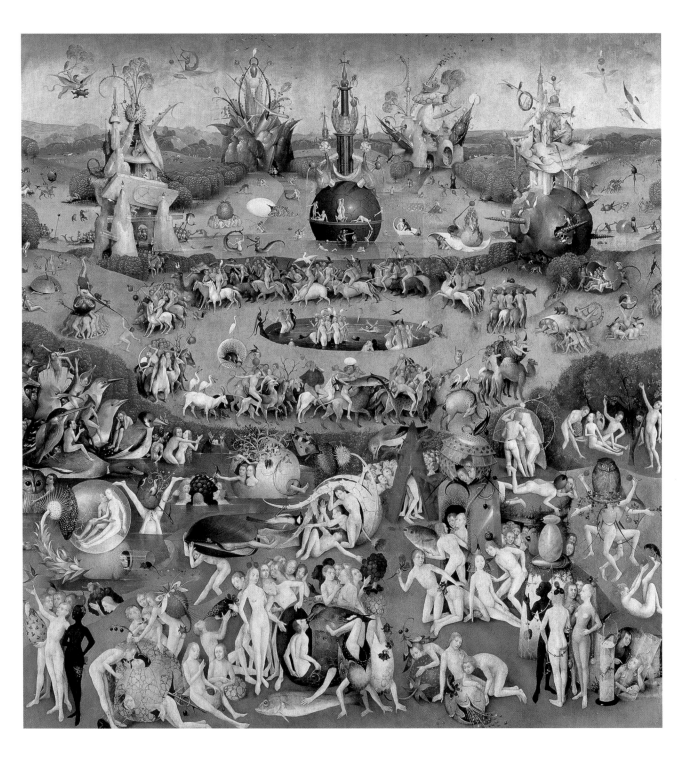

Hieronymus van Aeken,
known as **Bosch**
's Hertogenbosch, c.1450–1516
The Garden of Earthly Delights,
*c.*1510
Panel, 220 × 195 cm (centre),
220 × 97 cm (wings)
Philip II collection
Cat. no. 2823

The strange, enigmatic fantasies
that people the work of Bosch
earned him widespread fame,
even during his lifetime, and his
pictures inspired numerous
imitations. But nothing either in
his own or his contemporaries'
work equals the inventiveness of
The Garden of Earthly Delights, by
far his most famous painting.

Many attempts have been made
to relate these fantasies to the
realities of his own day. For
instance, some of the sexual
visions have been linked to the
creed of the heretical sect known
as the Adamites, which spread
throughout northern Europe
during the Middle Ages and
which advocated, at least in theory,

sexual freedom as it would have
existed in the Garden of Eden.
However, the most plausible line
of investigation considers many
of the images to be illustrations
of popular sayings, as in the case
of the lovers in the glass ball,
who would seem to represent the
proverb 'Pleasure is as fragile as
glass'. The same argument can

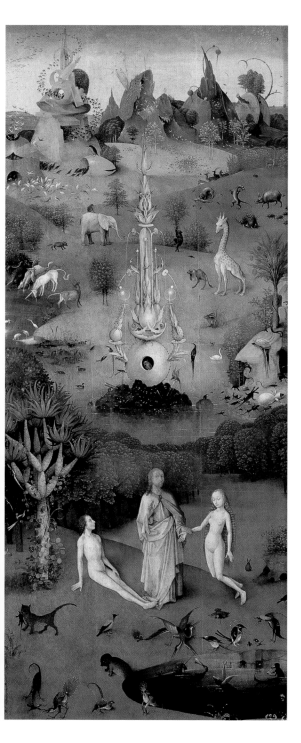

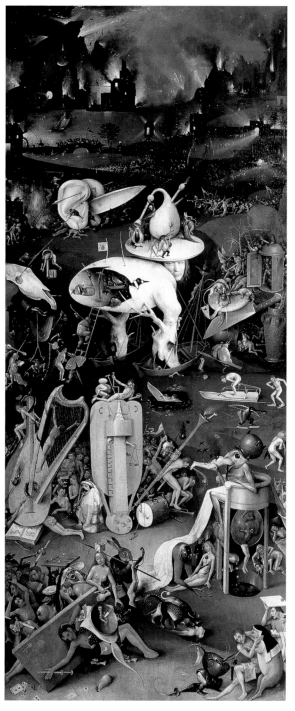

be applied to the relationship
with some of the fantasies
appearing in later works, such as
The Cure for Folly and *The
Haywain*, which in turn provide
a link with Brueghel's interpreta-
tion of proverbs in the mid-
sixteenth century, though without
the profusion of satanic elements
found in Bosch's work.

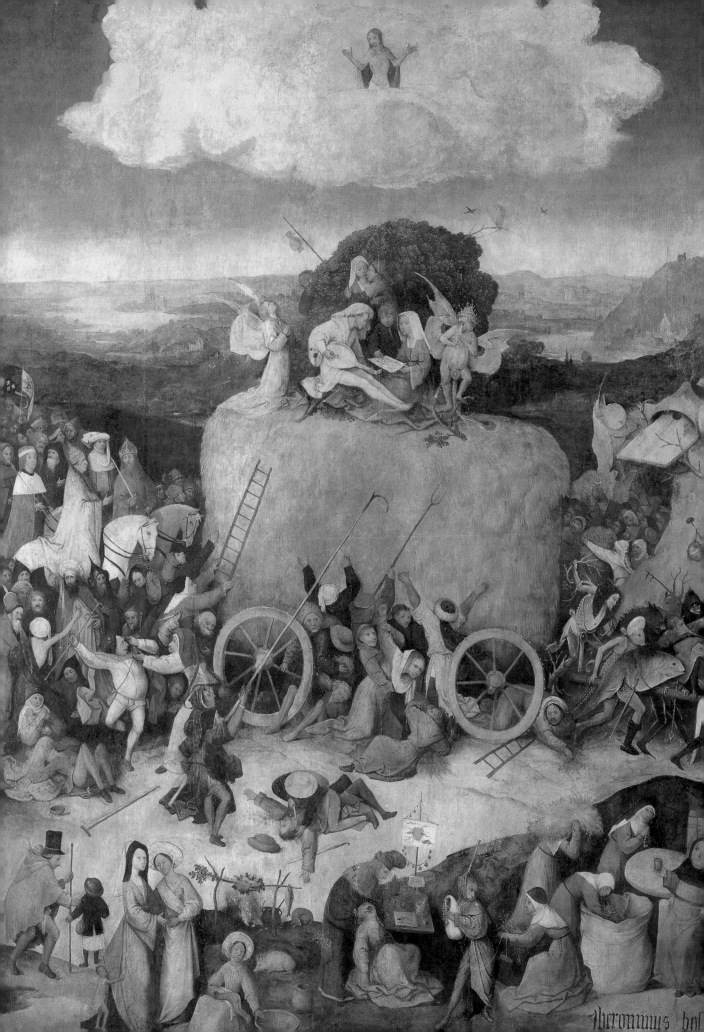

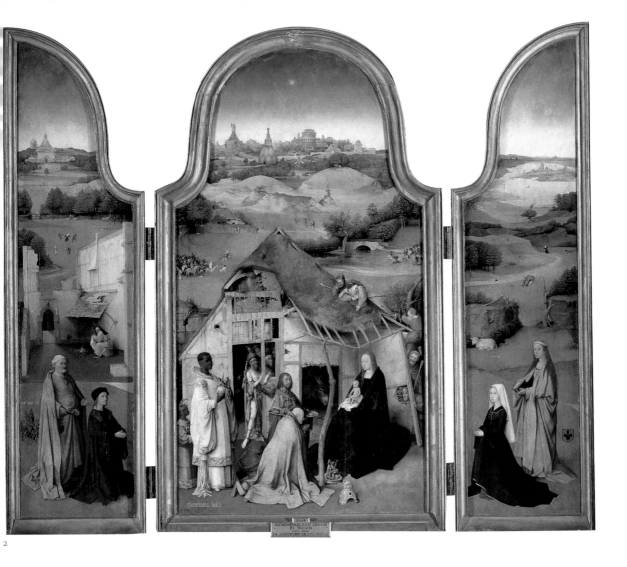

2

1

Hieronymus van Aeken,
known as **Bosch**
's Hertogenbosch, c.1450–1516
The Haywain, c.1495/1500
Panel, 135 × 100 cm (centre),
135 × 45 cm (wings)
Collection of Philip II
Cat. no. 2052

In 1486 Bosch joined the
Brotherhood of Our Lady, which
had close connections with the
extremely ascetic Brothers of the
Communal Life, founded at the
end of the fourteenth century.
The latter was a reforming move-
ment that particularly attacked
the corrupt medieval clergy and
saw worldly pleasures as a sure

road to hell. When closed, the
outside of the triptych shows the
Path of Life, perhaps alluding to
the ideals of the Brotherhood.

The centre panel is based on
the proverb 'The world is a
haystack from which each takes
what he can'. All manner of
people are shown taking what
they can from the haywain –
from the Pope (on horseback on
the left) down to the gypsy
woman (in the foreground)
sweet-talking a gullible young
woman while her child steals the
lady's purse. The picture is a
biting satire on a world that has
turned its back on God.

2

Hieronymus van Aeken,
known as **Bosch**
's Hertogenbosch, c.1450–1516
The Adoration of the Magi, c.1510
Panel, 138 × 72 cm (centre),
138 × 34 cm (wings)
Philip II collection
Entered the Prado in 1839
Cat. no. 2048

This late work, with husband and
wife donors on the left and right
wings, is an altarpiece with a tra-
ditional format and subject matter.
However, there are a number of
the intrusions that could be
expected of Bosch, not so much
the rather amusing shepherds
who have clambered on to the

roof to see the Child, as the
disturbing figure of the strangely
dressed king in the doorway of
the stable. His identity is by no
means clear. Is it Herod, or the
Antichrist, or simply some
strange individual mocking the
miraculous event or, on the con-
trary, brought to his senses by it?

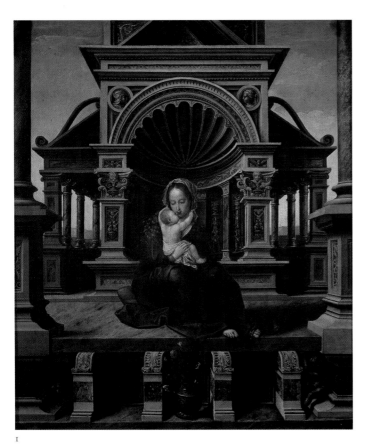

1

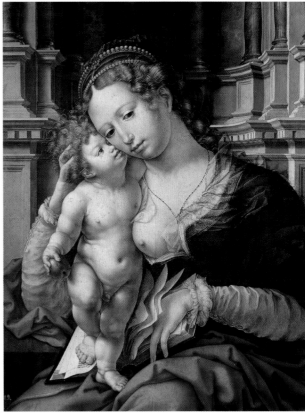

2

1
Bernard van Orley
Brussels, *c*.1492-1542
The Virgin of Louvain
Panel, 45 × 49 cm
Presented to Philip II by the city
of Louvain in 1588
Entered the Prado in 1839
Cat. no. 1536

2
Jan Gossaert,
known as **Mabuse**
Maubeuge, *c*.1478– Middelburg,
c.1533/6
The Virgin and Child, *c*.1527
Panel, 63 × 50 cm
Philip II collection
Cat. no. 1930

3
Joachim Patenier (landscape);
and **Quentin Massys** or **Metsys**
(figures)
Bouvignes, *c*.1480–Antwerp,
1530; Louvain,
c.1465/6–Antwerp, 1530
The Temptation of St Anthony
Panel, 155 × 173 cm
Philip II collection
Cat. no. 1615

4
Joachim Patenier
Bouvignes, *c*.1480–Antwerp, 1530
Charon Crossing the River Styx
Panel, 64 × 103 cm
In the royal collection by the
eighteenth century
Cat. no. 1616

A notable landscape artist,
Joachim Patenier worked in
Antwerp and often painted the
backgrounds for figures by other
masters such as Massys and
Isenbrandt. In his own works,
the landscape becomes the domi-
nant element, so that the figure
that justifies it, although situated
in the foreground, is often totally
eclipsed. He tried to give the
impression of vast panoramic

vistas, seen from an artificially
high viewpoint rather than a
natural one. Characteristic fea-
tures are the dramatic effects of
weather or fires that enliven the
landscape in a style reminiscent
of Hieronymus Bosch.

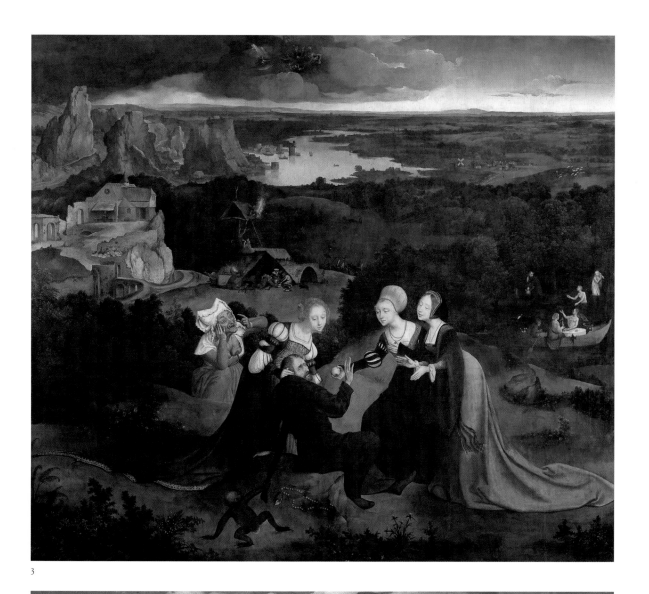

3

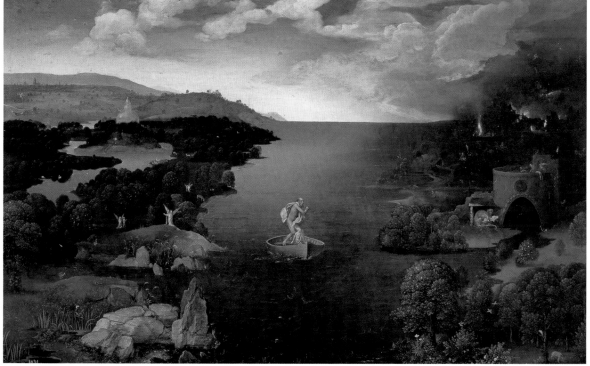

4

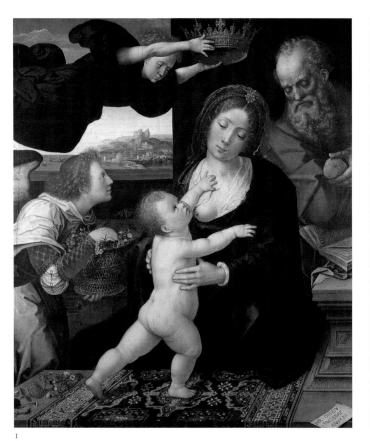

1

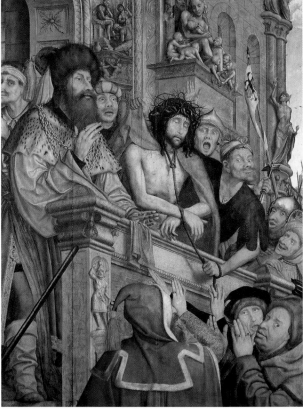

2

1
Bernard van Orley
Brussels, c.1491–1542
The Holy Family, 1522
Panel, 90 × 74 cm
From the convent of Las
Huelgas, Burgos
Bequeathed by Don Pablo Bosch
in 1915
Cat. no. 2692

2
Quentin Massys or **Metsys**
Louvain, c.1465/6–Antwerp, 1530
Ecce Homo, c.1515
Panel, 160 × 120 cm
Bequeathed in 1936 by Don
Mariano Lanuza
Entered the Prado in 1940
Cat. no. 2801

3
Anthonis Mor van Dashorst,
known as **Antonio Moro in Spain**
Utrecht, 1519–Antwerp, 1575
Queen Mary Tudor of England,
Second Wife of Philip II, 1554
Panel, 109 × 84 cm
Charles V collection
Cat. no. 2108

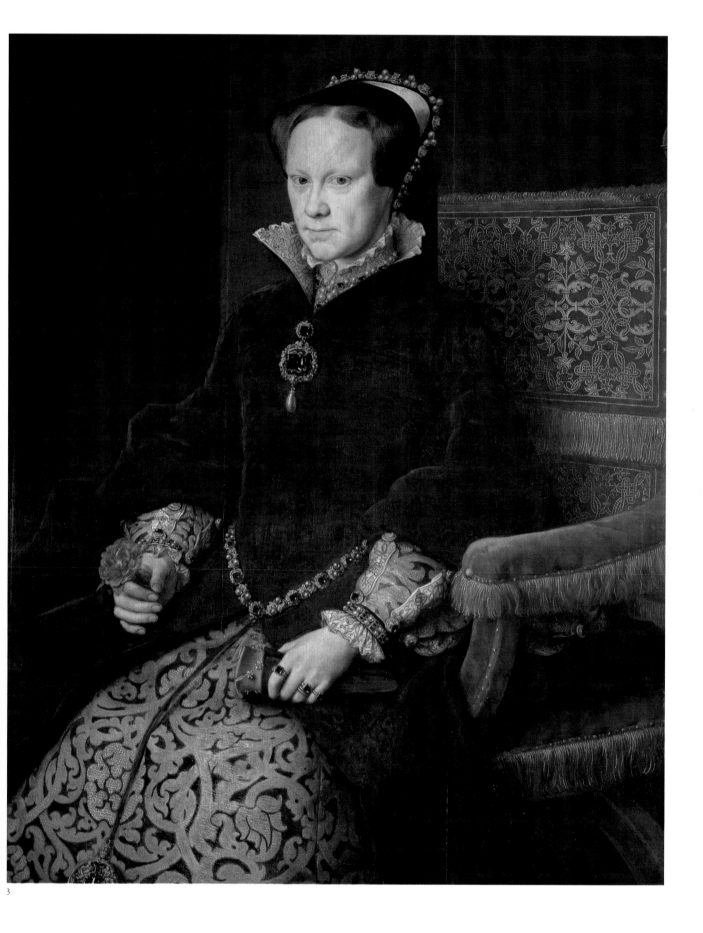

3

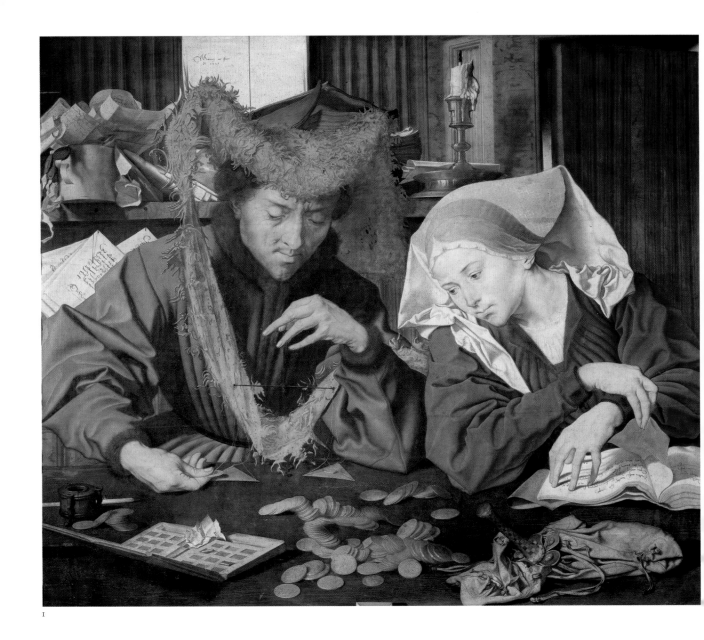

1

1
Marinus Claeszon van Reymerswaele
Roemeswaele, c.1497–after 1567
The Money-Changer and his Wife, 1539
Panel, 83 × 97 cm
Bequeathed by the Duke of Tarifa in 1934
Cat. no. 2567

2
Pieter Brueghel the Elder
Breda (?), c.1525/30–
Brussels, 1569
The Triumph of Death, c.1562
Panel, 117 × 162 cm
In the royal collection by the eighteenth century
Cat. no. 1393

3
Jan Cornelisz Vermeyen
Beverwilk, c.1500–Brussels, 1559
The Holy Trinity
Panel, 98 × 84 cm
Acquired in 1970
Cat. no. 3210

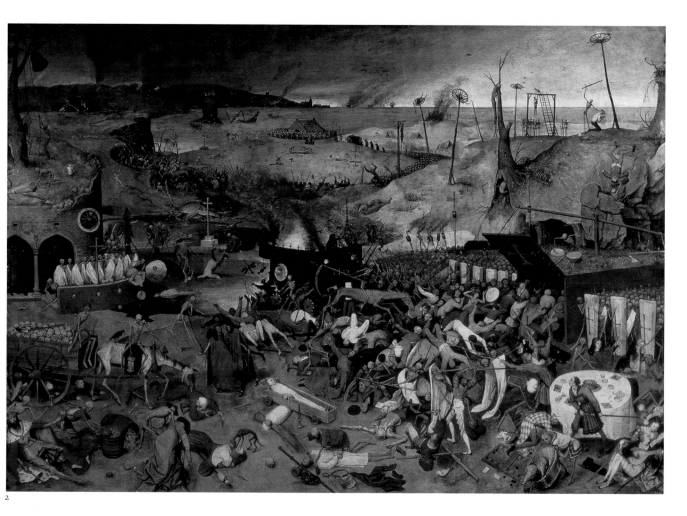

2

3

1

Frans Francken II
Antwerp, 1581–1642
Neptune and Amphitrite
Copper, 30 × 41 cm
In the royal collection by the
eighteenth century
At the Quinta del Duque del
Arco in 1794
Cat. no. 1523

2

Sir Peter Paul Rubens
Siegen, 1577–Antwerp, 1640
*The Duke of Lerma, c.*1603
Canvas, 283 × 200 cm
Acquired in 1869
Cat. no. 3137

Rubens painted this picture dur-
ing his first visit to Spain, using
it to show off his talents and to
attract the attention of the court.
It already has many features of
his mature Baroque style, which
would have been considered as
novel and striking by such an
exclusive audience. His way of
depicting the horse so that it not
only seems to be coming towards
the viewer but also about to
invade his space – an effect
achieved by the low viewpoint
and the absence of any other
elements in the foreground,
which recalls Caravaggio's
technique – was dramatic and
broke with the traditional profile
of equestrian portraits. Among
the other devices used by Rubens
to make the picture more
spectacular are the eccentric
colouring, the stormy lighting
and the rather disturbing
movements of the horse's mane
and the foliage on the trees.

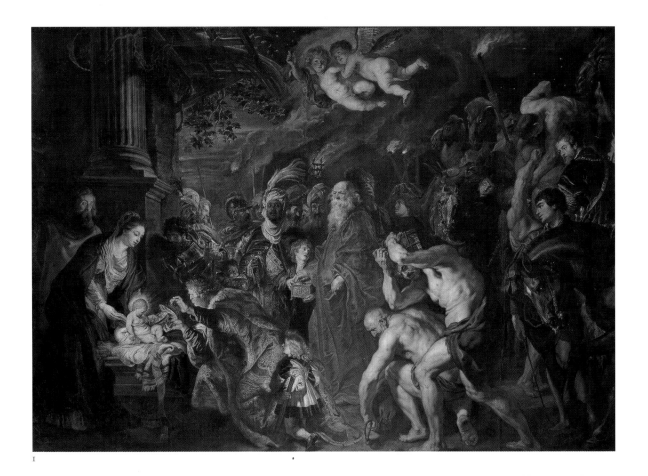

I

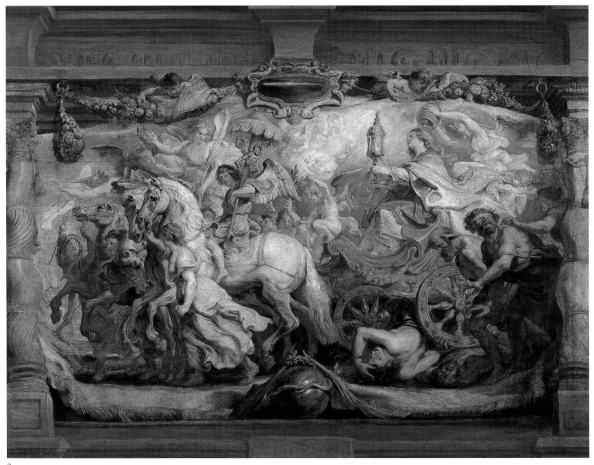

2

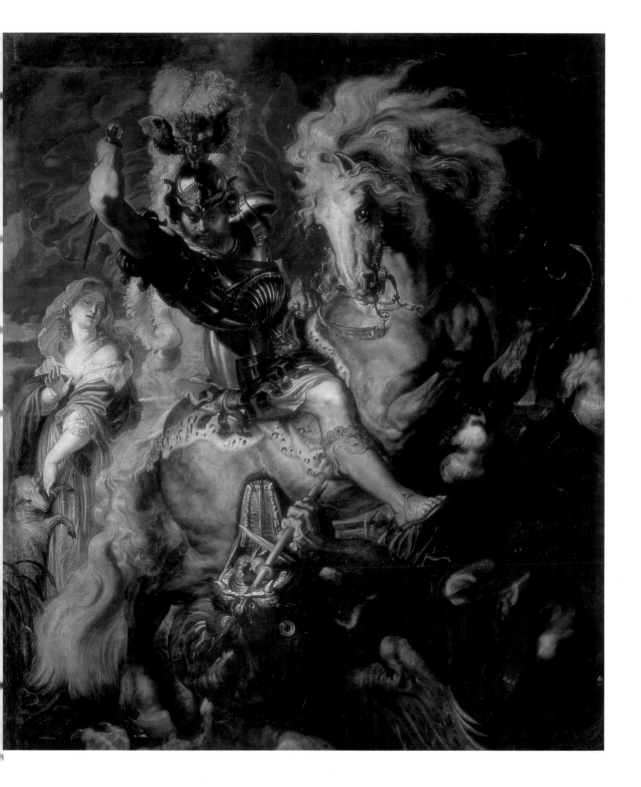

3

1

Sir Peter Paul Rubens
Siegen, 1577–Antwerp, 1640
The Adoration of the Magi,
c.1609; enlarged and repainted
in 1628
Canvas, 345 × 438 cm
Philip IV collection
Cat. no. 1638

2

Sir Peter Paul Rubens
Siegen, 1577–Antwerp, 1640
The Triumph of the Church over
Fury, Discord and Hate, c.1628
Sketch on panel for a tapestry,
86 × 105 cm
Philip IV collection
Cat. no. 1698

3

Sir Peter Paul Rubens
Siegen, 1577–Antwerp, 1640
St George and the Dragon, c.1606
Canvas, 304 × 256 cm
Acquired by Philip IV from the
artist's estate
Cat. no. 1644

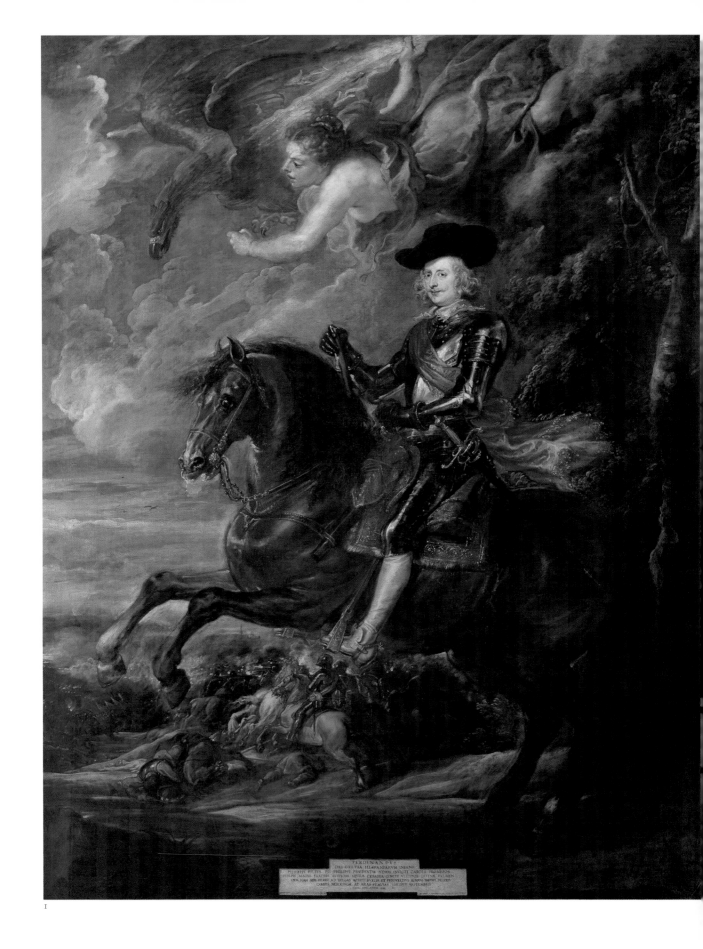

I

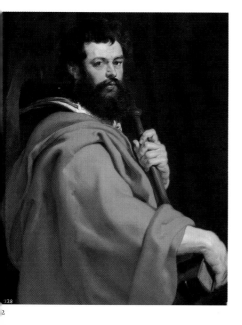

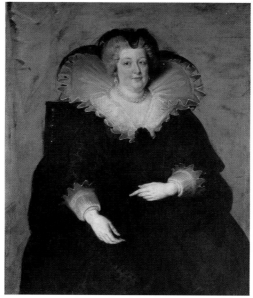

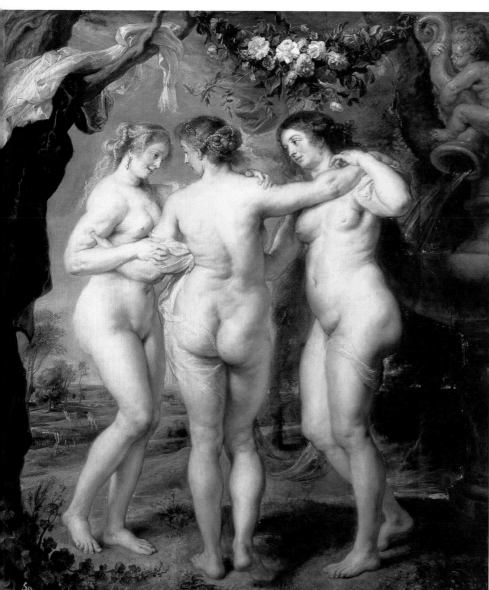

1
Sir Peter Paul Rubens
Siegen, 1577–Antwerp, 1640
*The Cardinal-Infante Don
Fernando, c.1634*
Canvas, 335 × 258 cm
Philip IV collection
Cat. no. 1687

2
Sir Peter Paul Rubens
Siegen, 1577–Antwerp, 1640
St James the Great, c.1612/13
Panel, 108 × 84 cm
In the collection of Queen Isabel
Farnese by 1746
Entered the Prado in 1829
Cat. no. 1648

3
Sir Peter Paul Rubens
Siegen, 1577–Antwerp, 1640
*Maria de'Medici, Queen of France,
c.1622*
Canvas, 130 × 108 cm
Acquired by Philip IV from the
artist's estate
Cat. no. 1685

4
Sir Peter Paul Rubens
Siegen, 1577–Antwerp, 1640
The Three Graces, c.1636/8
Panel, 221 × 181 cm
Acquired by Philip IV from the
artist's estate
Cat. no. 1670

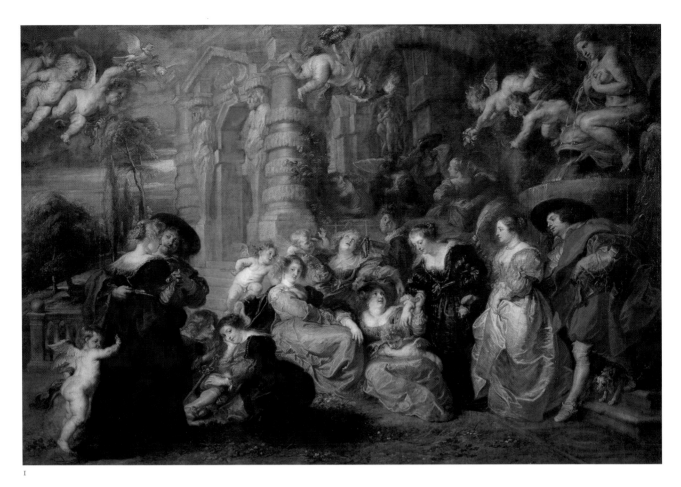

1

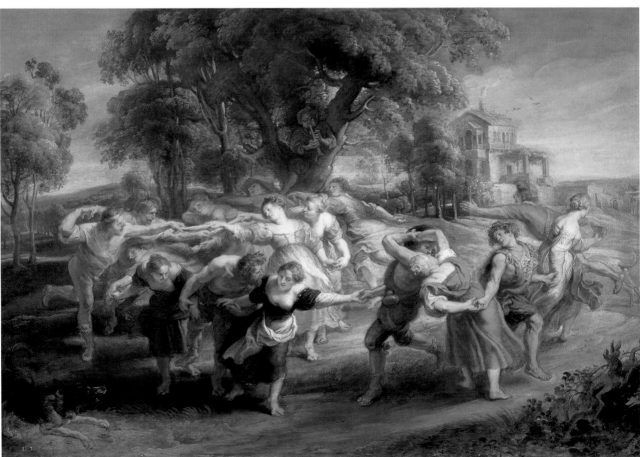

2

1
Sir Peter Paul Rubens
Siegen, 1577–Antwerp, 1640
*The Garden of Love, c.*1633
Canvas, 198 × 283 cm
Philip IV collection
Cat. no. 1690

This splendid vision of sensual
dalliance once hung in Philip
IV's bedchamber. The subject is
a traditional one of the Middle
Ages when, according to the con-
ventions of the time, lovers were
depicted in a garden, sometimes
accompanied by symbols and
moral messages. During the Italian
Renaissance the theme was
represented in *fêtes champêtres*,
such as the one in the Louvre attri-
buted to Giorgione or Titian. This
canvas by Rubens is an impor-
tant landmark in the tradition
that originated with these works
and extended to Watteau and
Pater in the eighteenth century.

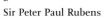

2
Sir Peter Paul Rubens
Siegen, 1577–Antwerp, 1640
A peasant dance
Panel, 73 × 106 cm
Acquired by Philip IV from the
artist's estate
Cat. no. 1691

3
Sir Peter Paul Rubens
Siegen, 1577–Antwerp, 1640
*Landscape with the Hunt of the
Calydonian Boar,* before 1636
Canvas, 160 × 260 cm
Philip IV collection
Cat. no. 1622

4
Sir Peter Paul Rubens
Siegen, 1577–Antwerp, 1640
*Saturn Devouring one of his Sons,
c.*1636/8
Canvas, 180 × 87 cm
Commissioned by Philip IV for
the Torre de la Parada
Cat. no. 1678

5
Sir Peter Paul Rubens
Siegen, 1577–Antwerp, 1640
Perseus and Andromeda, 1640
(completed by Jacob Jordaens)
Canvas, 265 × 160 cm
Philip IV collection
Cat. no. 1663

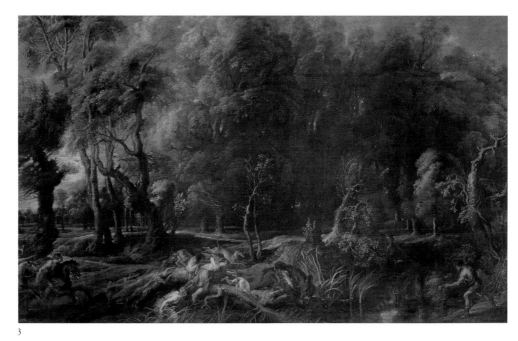

3

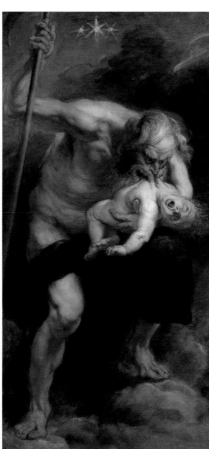

4

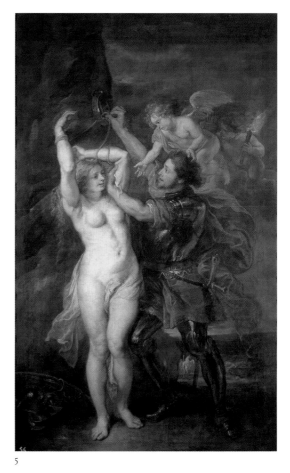

5

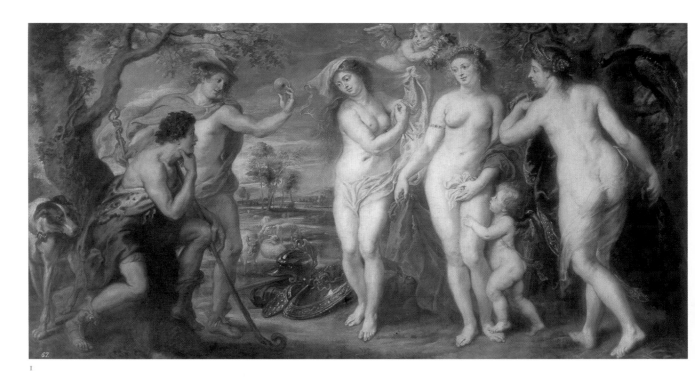

1

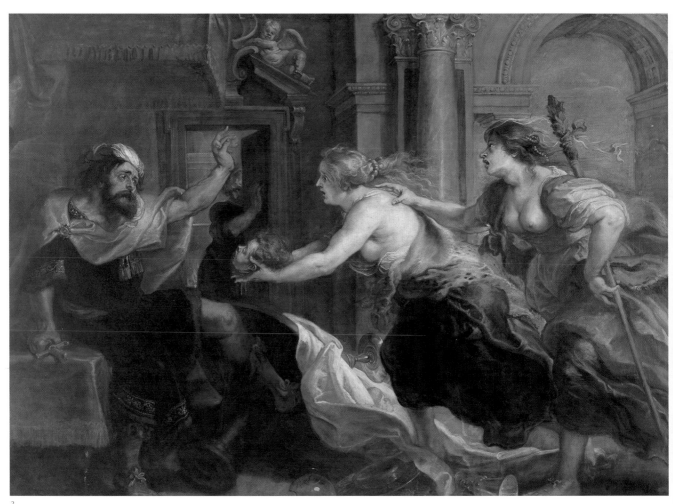

2

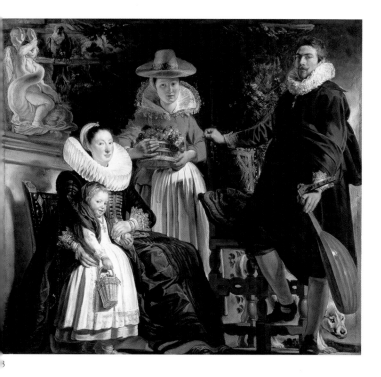

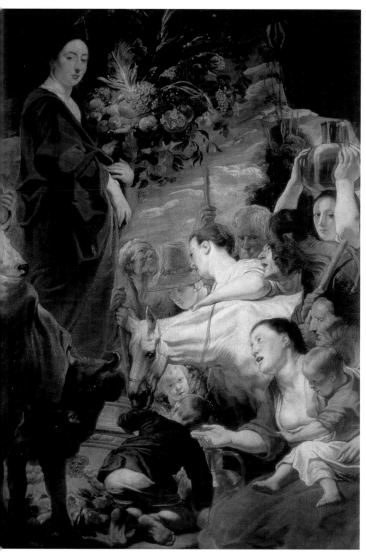

1

2

3

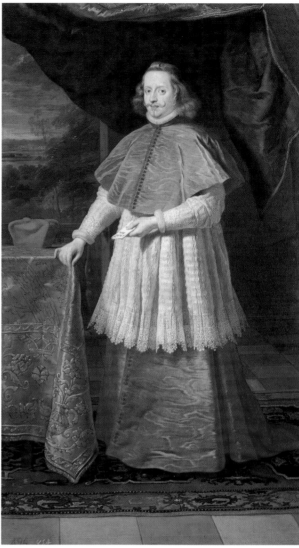

4

<table>
</table>

1	2	3	4
Jacob Jordaens	**Frans Pourbus**	**Frans Luyck**	**Gaspard de Crayer**
Antwerp, 1593–1678	Antwerp, 1569–Paris, 1622	Antwerp, 1604–Vienna, 1668	Antwerp, 1584–Ghent, 1669
The Love of Cupid and Psyche,	*Maria de'Medici, Queen of*	*Maria, Empress of Austria, c.*1646	*The Cardinal-Infante Don*
*c.*1630	*France,* 1617	Canvas, 215 × 147 cm	*Fernando,* 1639
Canvas mounted on a panel,	Canvas, 215 × 115 cm	Philip IV (?) collection	Canvas, 219 × 125 cm
131 × 127 cm	Royal collection	Cat. no. 1272	Philip IV collection
Philip IV collection	Cat. no. 1624		Cat. no. 1472
Cat. no. 1548			

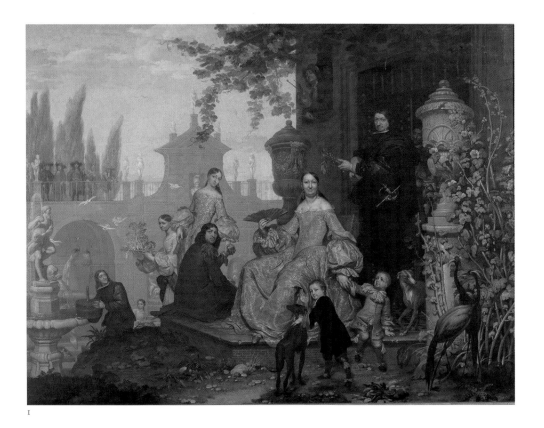

1

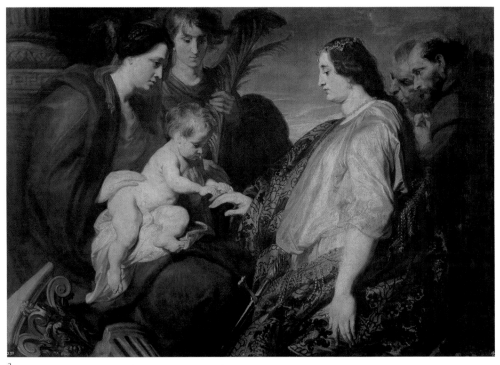

2

1
Jan van Kessel the Younger
Antwerp, 1654–Madrid, c.1708
Portrait of a Family, 1680
Canvas, 127 × 167 cm
Acquired in 1928
Cat. no. 2525

2
Sir Anthony Van Dyck
Antwerp, 1599–London, 1641
The Mystic Marriage of
St Catherine, c.1618/20
Canvas, 121 × 173 cm
In the royal collection by the
eighteenth century
Cat. no. 1544

3
Sir Anthony Van Dyck
Antwerp, 1599–London, 1641
Christ's Arrest in the Garden,
c.1618/20
Canvas, 344 × 249 cm
Acquired by Philip IV from the
estate of Sir Peter Paul Rubens
Cat. no. 1477

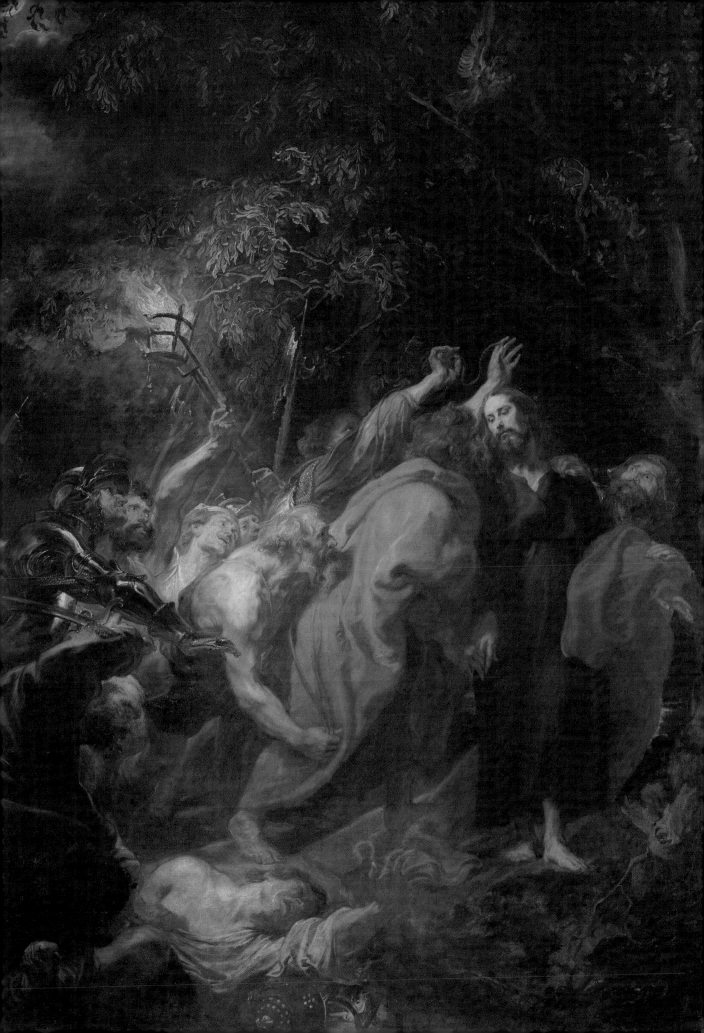

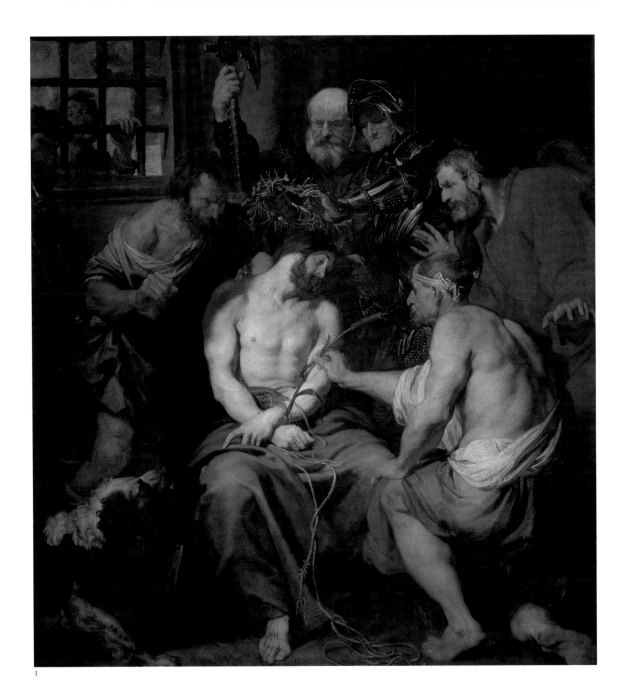

1

Sir Anthony Van Dyck
Antwerp, 1599–London, 1641
*The Crown of Thorns, c.*1618/20
Canvas, 223 × 196 cm
Philip IV collection
Entered the Prado in 1839
Cat. no. 1474

The contrast between the serenity
of Christ and the villainy of his
torturers is vigorously conveyed in
this early work by Van Dyck. As
so often, the artist drew his
inspiration from a famous picture
by Titian, whom he greatly
admired. However, the painting

also shows the influence of
Rubens, and the presentation is
typically Baroque: the viewer is
forced into the role of helpless
witness of the violence portrayed.
Van Dyck reinforces the effect
with magnificent textures – such
as the bare chest of Christ con-
trasting with the gleaming preci-
sion of the axe or the rippling
muscles of the tormentor beside
him.

2

Sir Anthony Van Dyck
Antwerp, 1599–London, 1641
*Martin Ryckaert, c.*1627/32
Canvas, 148 × 113 cm
Philip IV collection
Cat. no. 1479

3

Sir Anthony Van Dyck
Antwerp, 1599–London, 1641
*Sir Endymion Porter and the
Artist, c.*1632/41
Canvas, 110 × 114 cm
In the collection of Queen Isabel
Farnese by 1746
Cat. no. 1489

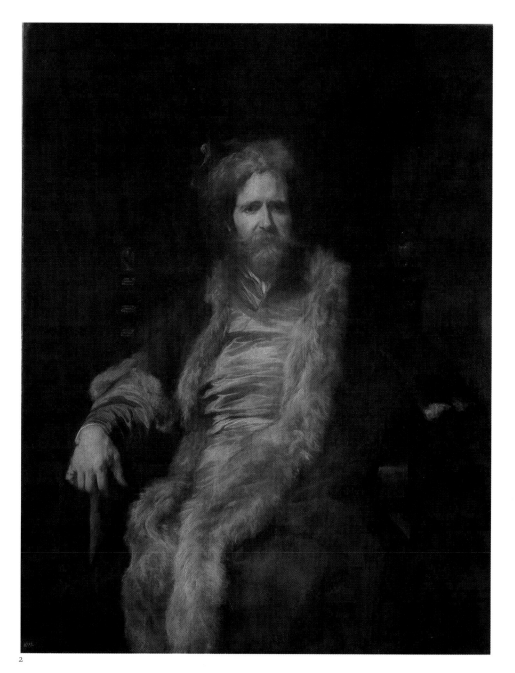

2

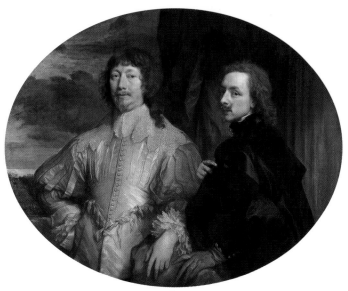

3

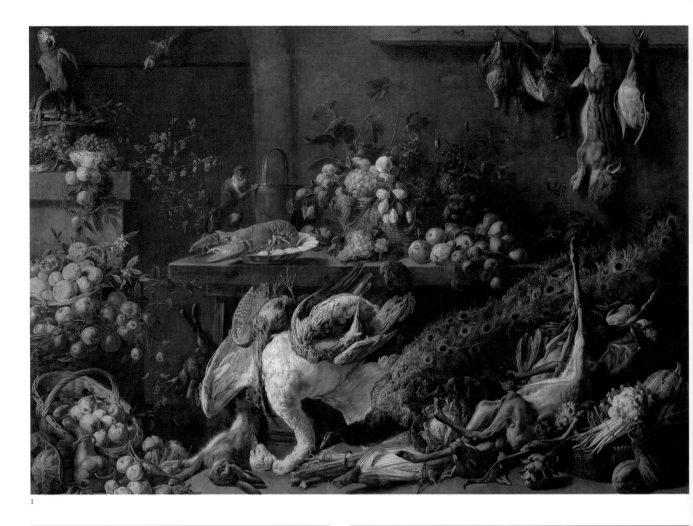

1

2

3

1
Adriaen van Utrecht
Antwerp, 1599–1653
Still life: A Pantry, 1642
Canvas 221 × 307 cm
In the collection of Queen Isabel
Farnese by 1746
Cat. no. 1852

2
Osias Beert
Antwerp, c.1580–1624
Still life
Panel, 43 × 54 cm
In the collection of Queen Isabel
Farnese by 1746
Cat. no. 1606

3
Clara Peeters
Antwerp, 1594–1659
Still life, 1611
Panel, 52 × 73 cm
In the collection of Queen Isabel
Farnese by 1746
Cat. no. 1620

4

5

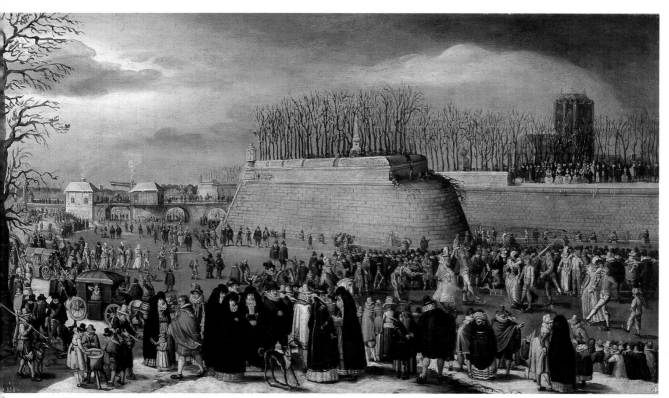

6

4	5	6
Jan Fyt	**Alexander van Adriaenssen**	**Denis van Alsloot**
Antwerp, 1611–61	Antwerp, 1587–1661	Mechlin, 1570–Brussels, 1628
Still life with a Dog	*Still life*	*Skating during Carnival, c.1620*
Panel, 77 × 112 cm	Panel, 60 × 91 cm	Panel, 58 × 100 cm
In the collection of Queen Isabel	Bequeathed to Philip IV by the	In the collection of Queen Isabel
Farnese by 1746	Marquis of Leganés in 1652	Farnese by 1746
Cat. no. 1529	Cat. no. 1343	Cat. no. 1346

1

1

Pieter Brueghel the Younger
Brussels, 1564–Antwerp, 1638
Winter Landscape with a Bird Trap
Panel, 40 × 57 cm
In the collection of Queen Isabel
Farnese by 1746
Cat. no. 2045

2

Jan Miel
Beveren-Was, 1599–Turin, 1663
Carnival in Rome, 1653
Canvas, 68 × 50 cm
Philip IV collection
Cat. no. 1577

2

3

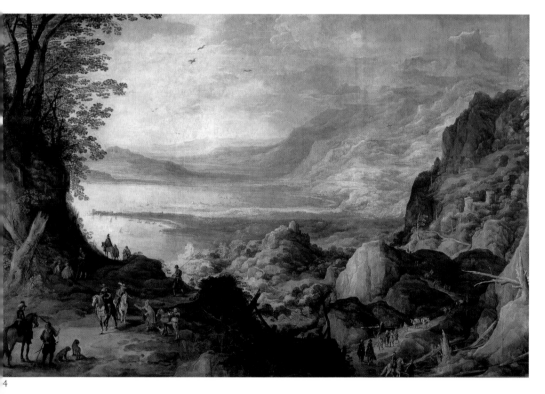

4

3
Jan ('Velvet') Brueghel the Elder;
and Sir Peter Paul Rubens
Antwerp, 1568–1625; Siegen,
1577–Antwerp, 1640
*The Vision of St Hubert, c.*1620
Panel, 63 × 100 cm
Bequeathed to Philip IV by the
Marquis of Leganés
Cat. no. 1411

4
Joos de Momper
Antwerp, 1564–1635
Landscape
Canvas, 174 × 256 cm
Cat. no. 1592

Joos de Momper continued the
tradition of panoramic landscapes
started by Patenier and Pieter
Brueghel the Elder. The familiar

formula of placing browns in the
foreground, greens in the middle
and light blues in the background
creates a sensation of ethereal
space – an effect that is intensified
by the dark forms of the birds
against the hazy blue and white of
the sky. In the foreground is the
usual group of picturesque figures.

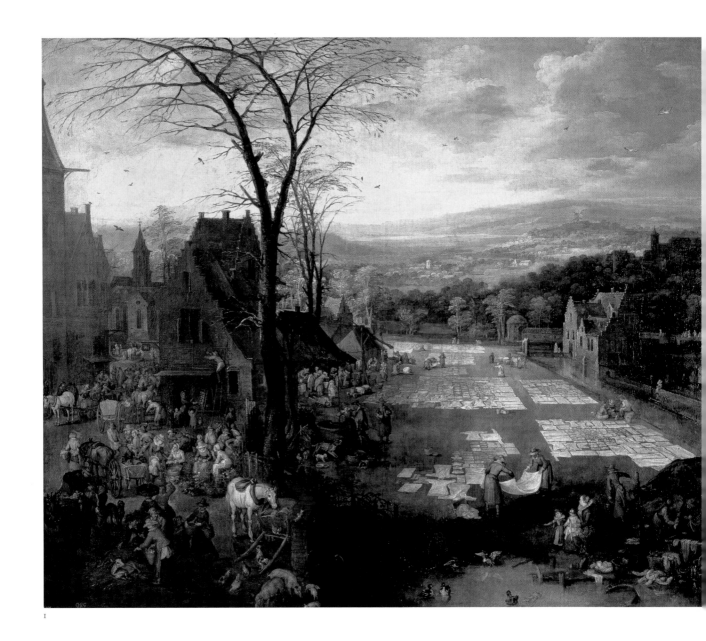

I

1

Joos de Momper (landscape); and
Jan ('Velvet') Brueghel the Elder
(figures)
Antwerp, 1564–1635; Antwerp,
1568–1625
*A Flemish Market and
Washing-place*
Canvas, 166 × 194 cm
In the royal collection by the
eighteenth century
Cat. no. 1443

2

Jan ('Velvet') Brueghel the Elder;
and **Sir Peter Paul Rubens**
Antwerp, 1568–1625; Siegen,
1577–Antwerp, 1640
The Sense of Sight, 1617
Panel, 65 × 109 cm
Presented to Philip IV by the
Duke of Medina Sidonia in 1636
Cat. no. 1394

3

Jan ('Velvet') Brueghel the Elder;
and **Sir Peter Paul Rubens**
Antwerp, 1568–1625; Siegen,
1577–Antwerp, 1640
*The Virgin and Child in a Garland
of Fruit and Flowers*, c.1614/18
Panel, 79 × 65 cm
Philip IV collection
Cat. no. 1418

4

Jan ('Velvet') Brueghel the Elder
Antwerp, 1568–1625
Vase of Flowers
Panel, 49 × 39 cm
Philip IV collection
Cat. no. 1423

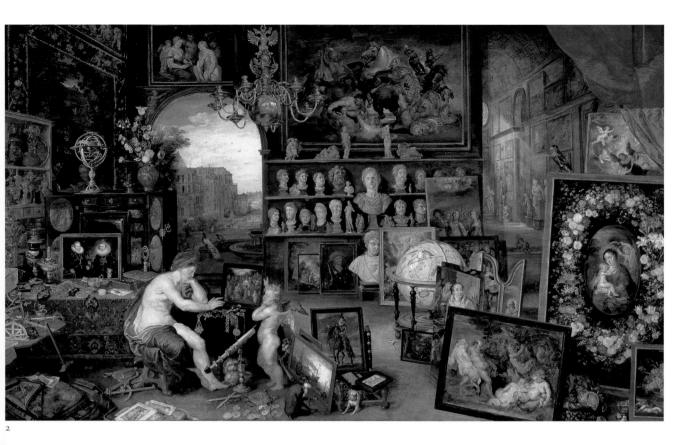

2

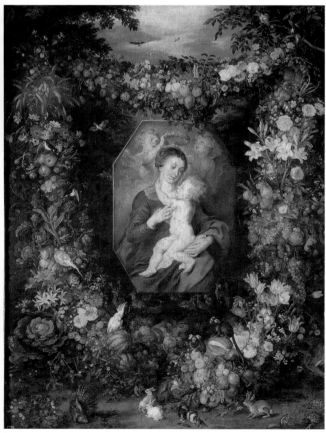

3

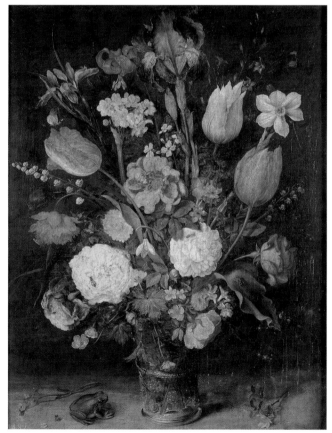

4

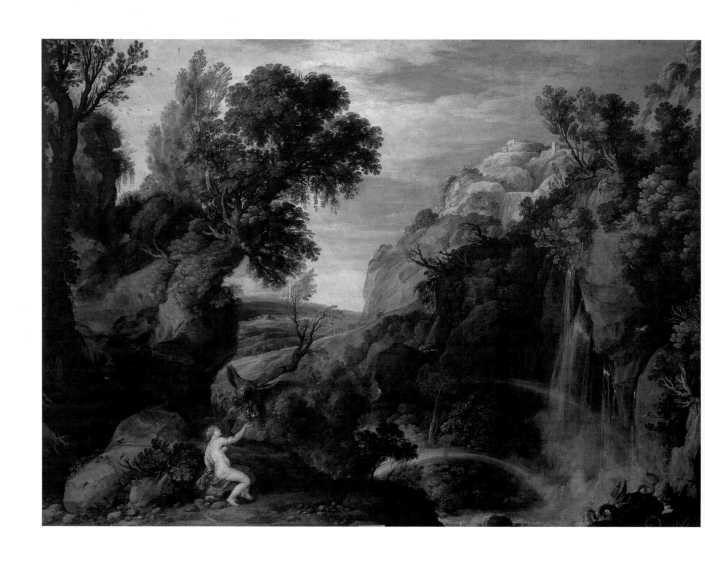

Paul Bril
and **Sir Peter Paul Rubens**
Antwerp, 1554–Rome, 1626;
Siegen, 1577–Antwerp, 1640
Landscape with Jupiter visiting
Psyche, 1610
Canvas, 93 × 128 cm
Philip IV collection
Cat. no. 1849

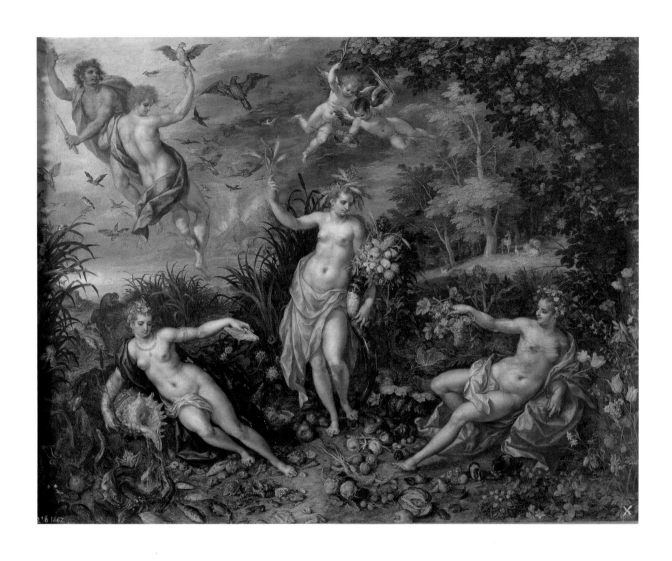

Jan ('Velvet') Brueghel the Elder
and **Hendrick de Clerck**
Antwerp, 1568–1625;
Brussels, (?) –1630
Horn of Plenty and the Four
Elements, c.1606
Copper, 51 × 64 cm
Philip V collection
Entered the Prado in 1824
Cat. no. 1401

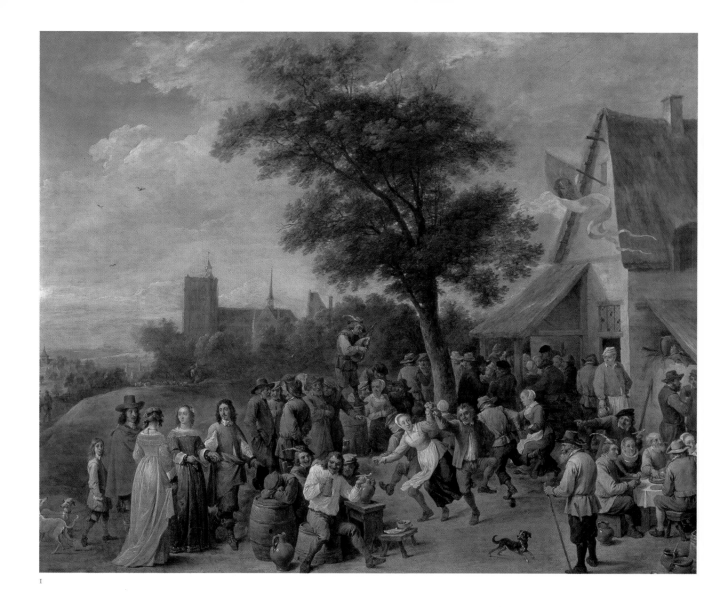

1

David Teniers the Younger
Antwerp, 1610–Brussels, 1690
Peasants Making Merry, c.1650
Canvas, 69 × 86 cm
Charles IV collection
Cat. no. 1785

2

David Teniers the Younger
Antwerp, 1610–Brussels, 1690
Carnival: 'Le roi boit'
Copper, 58 × 70 cm
In the royal collection by the
eighteenth century
Cat. no. 1797

3

David Teniers the Younger
Antwerp, 1610–Brussels, 1690
*The Archduke Leopold Wilhelm in
his Gallery, c.1647*
Copper, 106 × 129 cm
Presented to Philip IV by the
Archduke Leopold Wilhelm
before 1653
Cat. no. 1813

David Teniers was court painter
to the Archduke Leopold
Wilhelm of Habsburg, the
Governor of Flanders, as well as
being keeper of the Archduke's
outstanding collection of paint-
ings and sculpture. He produced
several of these gallery portraits.
The Archduke (in tall hat) is
depicted showing visitors round
his vast collection. Most of the
works are Venetian, almost half
of them by Titian; other Venetian
artists represented are Giorgione,
Antonello da Messina, Palma
Vecchio, Tintoretto, Bassano and
Veronese; there are also pictures
by Mabuse, Holbein, Barnardo
Strozzi, Guido Reni and Rubens.
The sculpture of Ganymede
supporting the table is a bronze
by Duquesnoy the Younger.
Teniers himself is portrayed in
the figure on the extreme left. It
has been suggested that
Velázquez borrowed the idea of
the half-open door at the back of
the picture for *Las Meninas*, and
to a certain extent the two
paintings both attempt to
illustrate the enlightened patron
and the consequent pride of the
court painter.

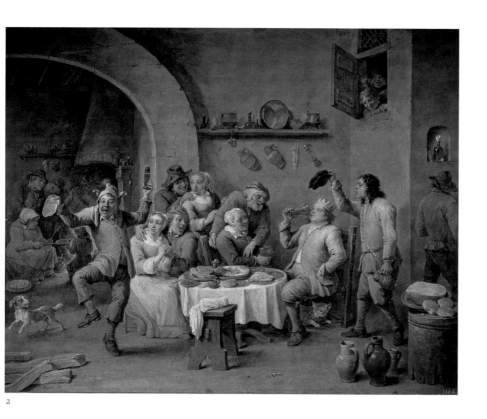

2

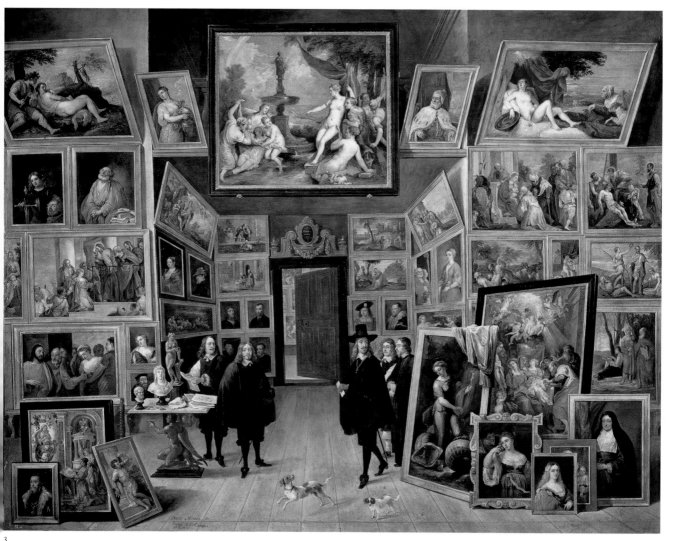

3

FRENCH PAINTING

The collection of French painting consists of more than 300 pictures and offers an incomplete but highly attractive perspective from the end of the sixteenth century to well into the nineteenth century, with the seventeenth and eighteenth centuries being particularly well represented.

The seventeenth century, which witnessed the rise of the Bourbons and the decline of the Habsburgs, as well as the long period of the Thirty Years War and Louis XIV's campaigns, was also, strangely enough, a time of matrimonial alliances between the French and Spanish royal families. Although these dynastic relations did not prevent armed conflicts, from time to time they did lead to the exchange of portraits and other gifts – though in general the hostilities between the two countries were one of the main obstacles to any kind of understanding at an aesthetic level.

In spite of this lack of communication, certain groups with access to both nations – merchants, sailors and travellers from other nations – seem to have introduced into Spain considerable numbers of prints of French paintings, which were later to influence, in some degree, Spanish artists of the period from Zurbarán to Goya. However, the official Spanish policy during this century was to acquire Italian and Flemish works of art. French art was anyhow practically unknown elsewhere in Europe at the time; it had no long tradition, nor indeed in the first part of the century any significant painters whose reputations might have caused their works to be sought by collectors. In some cases, however, a number of French pictures managed to enter Spain from Italy, where there was an active colony of French artists based in Rome. However, these pictures were apparently not bought as the work of French artists and nor did they bear the names of their real authors; they were passed off as Italian or Flemish, and in fact modern research has identified as French several canvases in the royal collection that until recently were catalogued as anonymous. One singular example is *The Martyrdom of St Lawrence* by Valentin, one of several works by the same artist that were catalogued in the royal collection in the Alcázar in Madrid under the names of other painters. A similar example is the work titled *The Poultry Seller* by the anonymous French painter known today as the 'Pensionante de Saraceni', which was long thought to be an Italian picture.

The completion of the Buen Retiro Palace in Madrid in 1634 called for a series of grand decorative schemes to reflect the power of the monarchy; accordingly, many foreign pictures of religious subjects were commissioned. These series of paintings 'of the anchorites' as they were called, were organized from Rome, probably through the Marquis of Castel Rodrigo, Spanish Ambassador to the Vatican; French painters – such as Claude Lorrain, Nicolas Poussin, Jean Le Maire and Gaspard Dughet – together with numerous Flemish and Dutch artists, contributed to this famous series. Claude Lorrain later produced another four canvases also for the Buen Retiro Palace. These various commissions form the nucleus of the French collection at present in the Prado, although during the reign of the Bourbons other works by the same artists were added.

The French collection also includes portraits that reached Madrid from other European courts with French painters in their service. Such is the case of the splendid equestrian portrait of Queen Christina, painted by Bourdon, which was sent to Philip IV from Sweden. Similarly, the Duke of Savoy, Charles Emmanuel II, sent Charles II a large family portrait with his newborn heir, by Dauphin, in order to show the king his son. Charles II also received a notable canvas entitled *St John the Baptist*, by Pierre Mignard, sent by his father-in-law the Duke of Orleans. Another example of an exchange between European courts was the consignment in 1655 by Anne of Austria (at the time regent of France) of a series of portraits of the French royal family – painted by Philippe de Champaigne, Charles and Henri Beaubrun and Jean Nocret – as part of the negotiations leading to the marriage between her son Louis XIV and the Infanta María Teresa, daughter of Philip IV.

The prospect of the last Spanish monarch of the House of Austria dying without an heir precipitated a major European crisis between 1700 and 1713, which was concluded by the Treaty of Utrecht. The claims of Louis XIV of France to the Spanish throne, based on the dynastic ties established during the seventeenth century, were recognized and, on the death of Charles II, the Duke of Anjou, grandson of Louis XIV, ascended the throne with the title of Philip V. So began the long reign of the Bourbon dynasty in Spain, which despite certain interruptions has lasted until the present day. The establishment of the new monarchy did not immediately alter the orientation towards Flemish and Italian art and, particularly as a consequence of the artistic tastes of Philip V's second wife, Isabel Farnese, the royal collection continued acquiring Italian paintings. However, this did not preclude an interest in French art, especially portraiture, and various French painters took up positions at the Spanish court. Among these were Michel-Ange Houasse – a mediocre portraitist but an exceptional landscape and genre painter – and Jean Ranc and Louis-Michel van Loo, both distinguished portrait painters whose works show the sovereigns and their sons and daughters up to the time of Ferdinand VI.

There were three fundamental factors that contributed to Philip V's interest in painting – the works inherited from his father, Le Grand Dauphin, which added considerably to the

royal collection; the building of the palace of La Granja near Segovia, for which many new works of art were commissioned; and the destruction of the Alcázar in Madrid, which despite its disastrous consequences and the loss of numerous pictures provided a stimulus for the acquisition of comparable works, the constant preoccupation of the monarchy during the eighteenth century.

Philip V acquired several important works by Poussin in Rotterdam, while other significant examples of classical French art came his way from the sale of the collection owned by the heirs of the painter Maratta in Rome. At the same time, the arrival from Paris of a number of excellent portraits of members of the House of Bourbon exposed the Spanish court to the work of the greatest portraitists of the time: Rigaud's famous painting of *Louis XIV* and Largillière's picture of *Maria Anna Victoria*. Also acquired around this time were two exquisite pieces by Watteau, chosen by Isabel Farnese, and *The Rest on the Flight into Egypt* by Stella, an example of the essential classicism of the previous century.

During the reign of Philip V, Madrid was transformed into a breeding ground for new artists who contributed to the renewal of the artistic traditions of the court. Many paintings of the royal palaces and grounds, genre scenes by Michel-Ange Houasse, as well as some of his religious paintings, portraits and mythological compositions, are from this period. Jean Ranc and later Louis-Michel van Loo succeeded Houasse as official court portraitists. Between them they produced such a vast number of portraits of the Bourbon royal family that the court in Madrid, which for many years had been only a receiver of French portraits, now began to export them. Ranc, a rather dry, *détailliste* painter, portrayed the Spanish royal family in a dignified style anchored in the aesthetic principles of the last years of the reign of Louis XIV, and mainly derived from the work of his teacher, Rigaud. In contrast, Louis-Michel van Loo, who was called to Madrid to take over from Ranc after the latter's death, introduced a spacious, decorative style of royal portraiture, representing the subjects in a more spectacular and at the same time more direct manner that nonetheless was somewhat archaic for its time. Van Loo's greatest achievement is the huge painting of *The Family of Philip V*, in which the king is surrounded by his wife and children as if they were a public institution. After the death of Philip V in 1746, Van Loo remained in Spain for another six years under his successor, Ferdinand VI, working on the Real Academia de San Fernando, which was finally opened in 1752.

With the sole but notable exception of Charles-Joseph Flipart, who lived in Spain for about 40 years and produced a large number of paintings, drawings and decorative works, there were few French artists working in Madrid during the reign of Ferdinand VI. However, in the reign of Charles III portraits arrived from other European courts, and the Prince of Asturias, the future Charles IV, who was a keen collector, ordered many foreign paintings and also bought pictures from French artists travelling in Spain. Unfortunately, this carefully assembled collection was not to remain intact for long: the Napoleonic invasion and the Peninsular Wars, with the inevitable sacking and looting, caused its dispersion, and consequently very few of the works have ended up in the Prado. However, the largest group – five landscapes by Vernet – testify to Charles IV's excellent taste and aesthetic sensibilities.

The founding of the Prado in 1819 raised hopes of new acquisitions, but although the Royal Museum received the works transferred from the royal palaces, which were to form the nucleus of its superb collection, the Prado almost entirely lacks any of the splendid paintings produced in France during the nineteenth century.

Acquisitions during the twentieth century have fared better. Two outstanding portraits by Oudry were acquired in 1930, *A Gallery in the Colosseum in Rome* by Hubert Robert in 1944, and other important works have been added during the second half of the century such as Vouet's *Time overcome by Youth and Beauty* in 1955, and a *Vanitas* by Linard in 1962.

Since 1970 the museum has acquired pieces from other periods, such as an anonymous sixteenth-century masterpiece which shows the influence of the Fontainebleau School, two mythological compositions by Jean-Baptiste Pierre, various pictures by Boucher, Lagrenée and Julien de Parme, and a delightful sketch titled *The Death of Calamus* by Beaufort. Another two excellent paintings have been added to the seventeenth-century section: *Moses and the Bronze Serpent* by Bourdon and *Blind Musician Playing the Hurdy-gurdy* by Georges de La Tour.

Considering the French collection as a whole, the seventeenth-century canvases perhaps form the most significant section, particularly as regards painting by French artists in Italy, while the eighteenth-century works constitute the central core of the achievements of French artists in Spain during that period. Finally, it should be noted that the collection of French portraits is unique not only for its remarkable artistic quality but also for its reflection of the historical circumstances that inspired its creation.

I

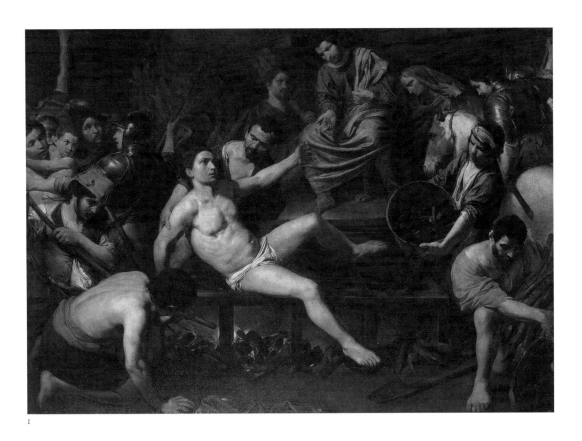

2

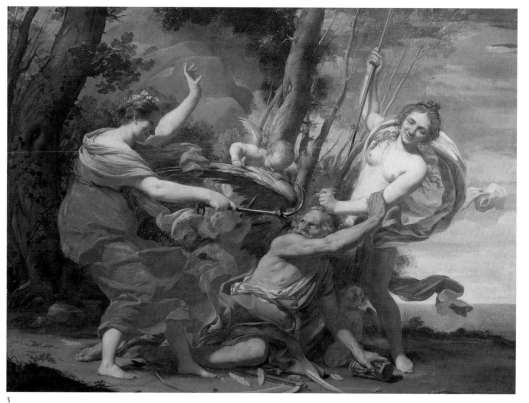

3

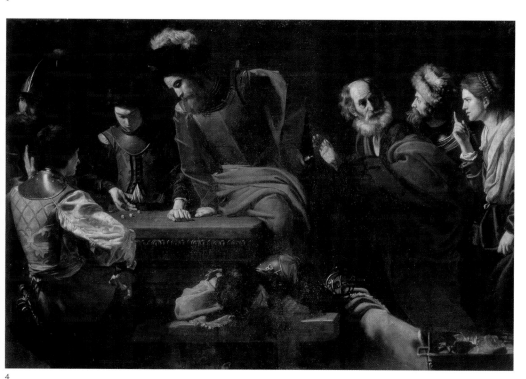

4

1
Valentin de Boulogne
Coulommiers-en-Brie,
1591–Rome, 1632
The Martyrdom of St Lawrence,
*c.*1621/2
Canvas, 195 × 261 cm
Philip IV collection
Cat. no. 2346

2
Anonymous master,
known as the **Pensionante de**
Saraceni
Active in Rome between 1610
and 1620
The Poultry Seller
Canvas, 95 × 71 cm
In the royal collection by the end
of the eighteenth century
Cat. no. 2235

3
Simon Vouet
Paris, 1590–1649
Time overcome by Youth and
Beauty, 1627
Canvas, 107 × 142 cm
Purchased in London in 1954
Cat. no. 2987

4
Nicolas Tournier
Montbéliard, 1590–Toulouse,
1638/9
*The Denial of St Peter, c.*1625
Canvas, 171 × 252 cm
Bequeathed to the Prado by Don
Pedro Fernández Durán in 1930
Cat. no. 2788

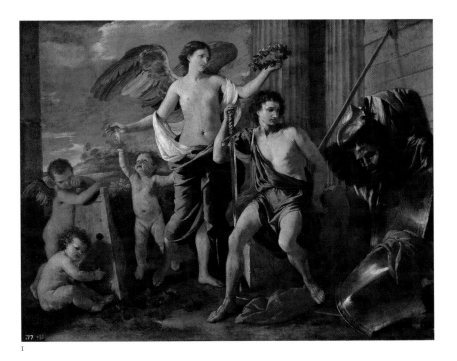

1

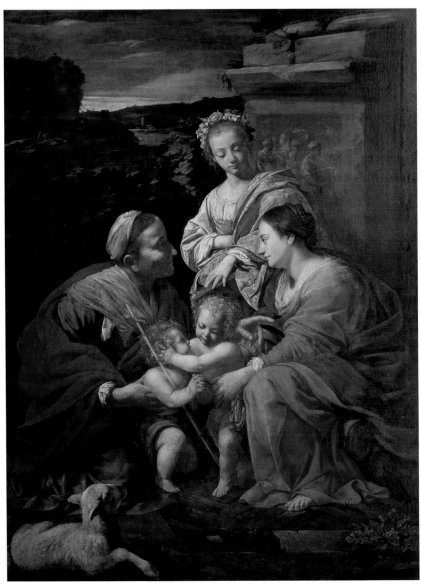

2

1
Nicolas Poussin
Les Andelys, 1594–Rome, 1665
The Triumph of David, c.1630
Canvas, 100 × 130 cm
Acquired by Philip V in 1724
from the collection of
Carlo Maratta
Cat. no. 2311

Nicolas Poussin was undoubtedly
the most important French artist
of the seventeenth century and
the most notable exponent of
Baroque classicism. Though he
worked in Rome for most of his
life, he had a great influence not
only in Italy but also in France.
His art reflects a profound
knowledge of classical antiquity
and the High Renaissance, of
classical sculpture and of the
paintings of Raphael and Titian.
With these sources he achieved a
singular combination of skill and
balance, developing original solu-
tions to traditional problems.
An example is this narration of a
biblical story, conceived in a
classical language, with Victory
crowning the hero.

2
Simon Vouet
Paris, 1590–1649
*The Virgin and Child, with St
Elizabeth, the Infant St John the
Baptist and St Catherine, c.1624/6*
Canvas, 182 × 130 cm
Provenance unknown
Cat. no. 539

3
Nicolas Poussin
Les Andelys, 1594–Rome, 1665
Parnassus
Canvas, 145 × 197 cm
Philip V collection
Acquired in Rotterdam in 1714
Cat. no. 2313

4
Jacques Courtois,
known as **Il Borgognone**
St-Hippolyte, 1621–Rome, 1676
*A Battle between Turks and
Christians*
Canvas, 96 × 152 cm
Provenance unknown
Cat. no. 2242

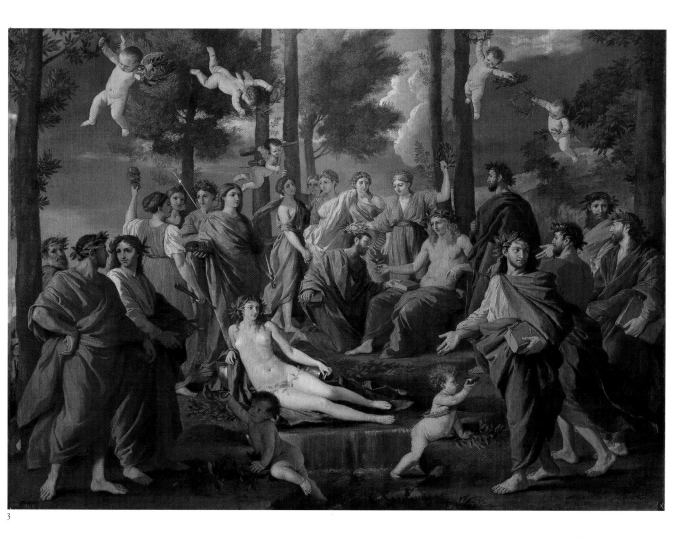

3

4

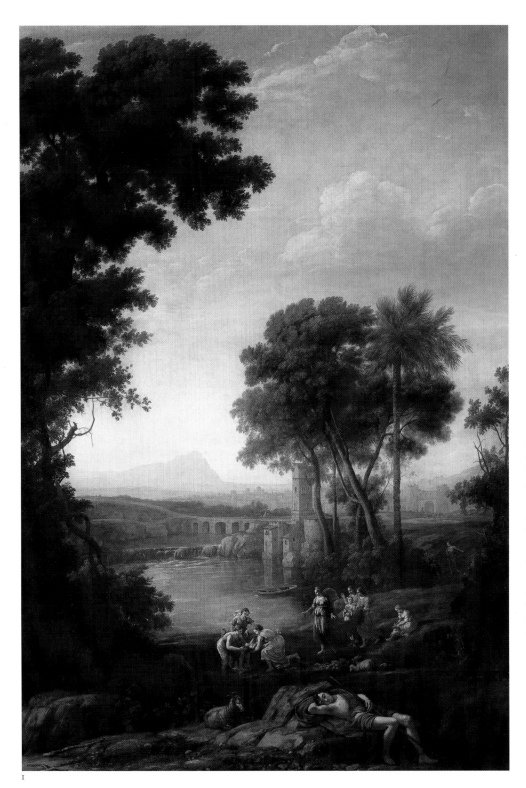

1

Claude Gellée,
known as **Claude Lorrain**
Chamagne, c.1600–Rome, 1682
*Landscape with the Finding of
Moses, c.1637/9*
Canvas, 209 × 138 cm
Philip IV collection
Cat. no. 2253

2

Claude Gellée,
known as **Claude Lorrain**
Chamagne, c.1600–Rome, 1682
*The Embarkation of St Paula
Romana at Ostia, c.1637/9*
Canvas, 211 × 145 cm
Philip IV collection
Cat. no. 2254

Claude Lorrain, sometimes
known simply as Claude,
perfected the creation of ideal
landscapes, set in a golden
classical antiquity of harmonious
architecture, weather, landscape
and society. This work, so typical
of his style, was commissioned
by Philip IV to decorate one of
the galleries in the Buen Retiro.
The embarkation is transformed
by the theatrical setting into an
act of Roman dignity, a heroic
adventure and a glorious example
for posterity.

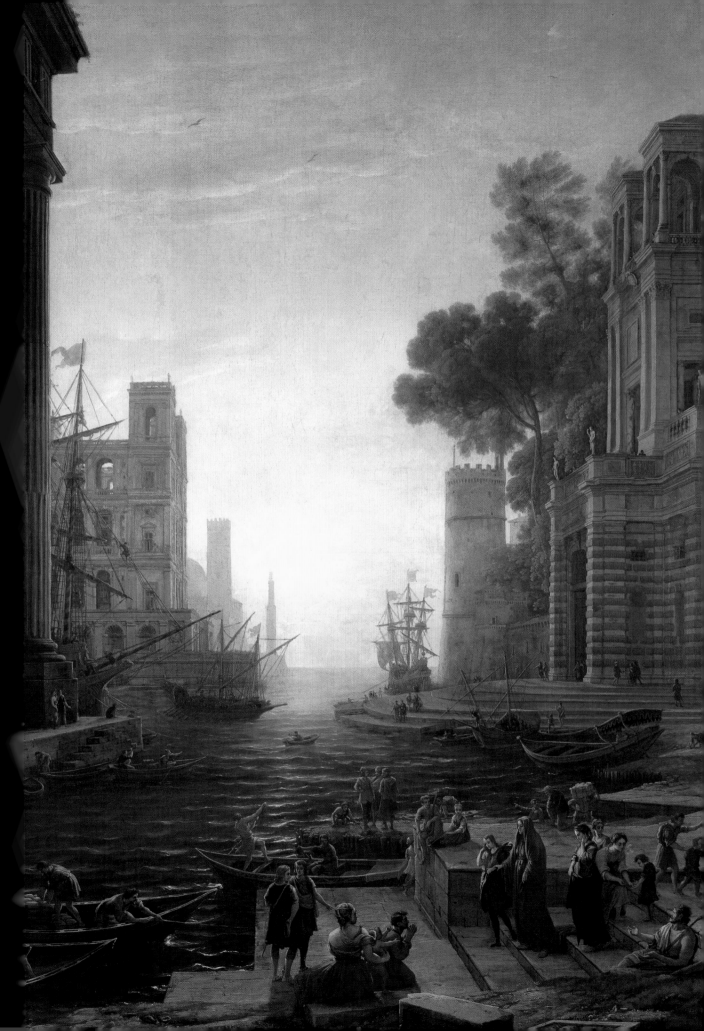

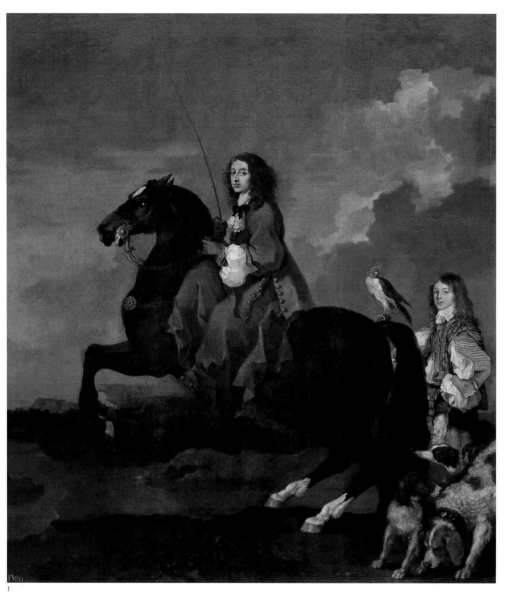

1
Sébastien Bourdon
Montpellier, 1616–Paris, 1671
Queen Christina of Sweden on Horseback, 1653
Canvas, 383 × 291 cm
Presented to Philip IV by Queen Christina of Sweden
Cat. no. 1503

2
Jean Le Maire
Dammartin, 1598–Gaillon, 1659
A Hermit among Classical Ruins, c.1635/6
Canvas, 162 × 240 cm
Philip IV collection
Cat. no. 2316

3
Hyacinthe Rigaud
Perpignan, 1659–Paris, 1743
King Louis XIV, 1701
Canvas, 238 × 149 cm
Philip V collection
Cat. no. 2343

4
Jacques Linard
Paris, 1600–45
Vanitas, c.1644
Canvas, 31 × 39 cm
Acquired in 1962
Cat. no. 3049

5
Sébastien Bourdon
Montpellier, 1616–Paris, 1671
Moses and the Bronze Serpent, c.1653/54
Canvas, 89 × 105 cm
Bequeathed by Mrs Katy Brunov in 1979
Cat. no. 4717

6
Philippe de Champaigne
Brussels, 1602–Paris, 1674
King Louis XIII, 1655
Canvas, 108 × 86 cm
Sent to Philip IV by his sister Anne, Queen of France
Cat. no. 2240

3

4

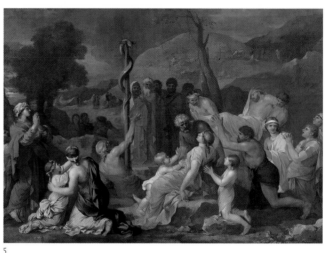

5

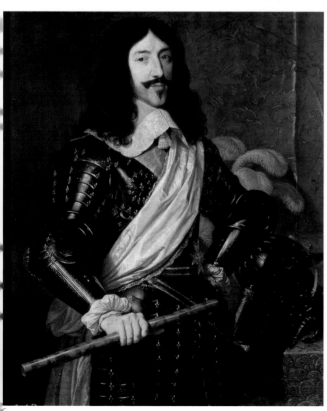

6

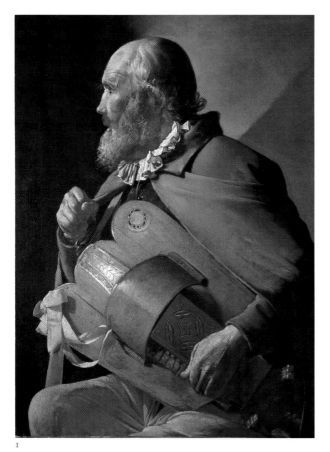

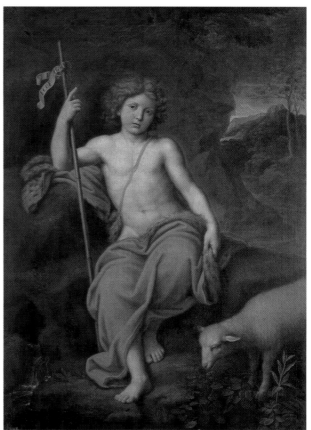

1

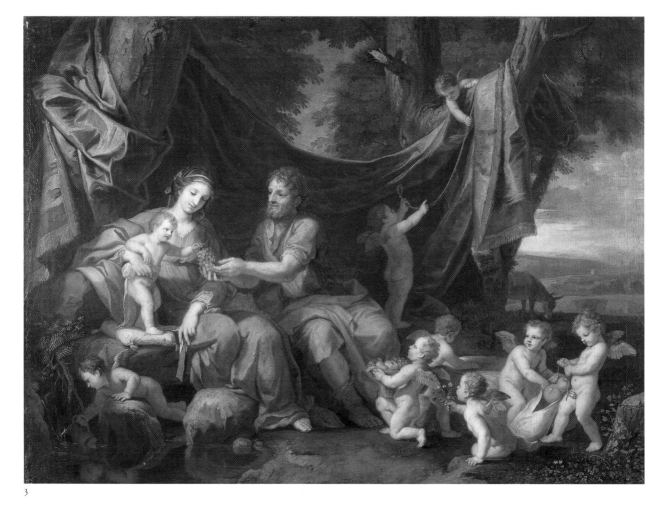

2

3

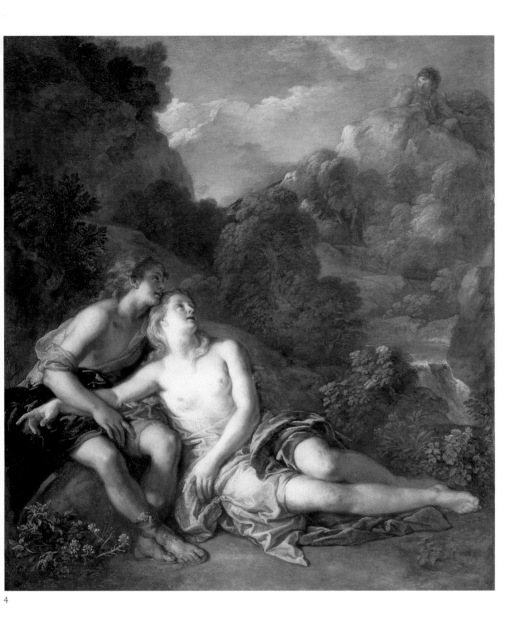

4

1
Georges de La Tour
Vic-sur-Seille, 1593–Lunéville, 1652
Blind Musician Playing the
Hurdy-gurdy, 1625/30
Canvas, 84 × 61 cm
Acquired in 1991
Cat. no. 7613

2
Pierre Mignard
Troyes, 1612–Paris, 1695
*St John the Baptist, c.*1687/8
Canvas, 147 × 109 cm
Gift of the Duke of Orleans in
1688 to his son-in-law Charles II
of Spain
Cat. no. 2289

3
Jacques Stella
Lyons, 1596–Paris, 1657
Rest on the Flight into Egypt, 1652
Canvas, 74 × 99 cm
Philip V collection
Cat. no. 3202

4
Charles de La Fosse
Paris, 1636–1716
*Acis and Galatea, c.*1704
Copper, 104 × 90 cm
In the royal collection by the
eighteenth century
Cat. no. 2251

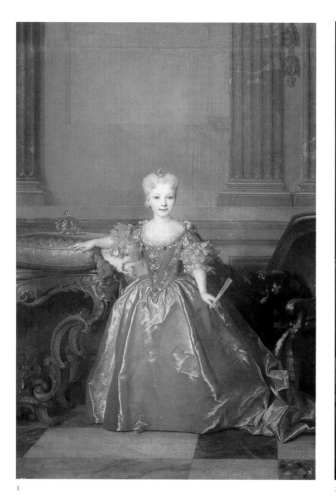

1

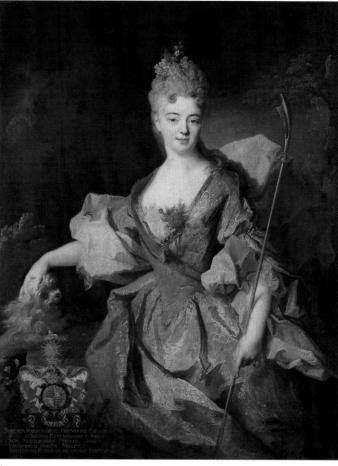

2

1
Nicolas de Largillièrre
Paris, 1656–1746
*The Infanta Maria Anna
Victoria*, 1724
Canvas, 184 × 125 cm
Philip V collection
Cat. no. 2277

Largillièrre was one of the
leading portraitists in Europe in
the late seventeenth century and
early eighteenth century. His
works combine the best of the
French, Flemish and English
Schools, and as well as portraits
he also specialized in landscapes
and still-lifes. Here, he has
skilfully endowed the young
Maria Anna with an air of royal
dignity; she was the daughter of
Philip V, betrothed to Louis XV
of France, but later became
Queen of Portugal after being
rejected by the French.

2
Jean-Baptiste Oudry
Paris, 1686–Beauvais, 1755
*Lady Mary Josephine Drummond,
Countess of Castellblanco*, c.1716
Canvas, 137 × 105 cm
Bequeathed by Don Pedro
Fernández Durán in 1930
Cat. no. 2793

3
Pierre Gobert
Fontainebleau, 1662–Paris, 1744
*The Duchess of Burgundy and her
Children*, c.1712
Canvas, 216 × 168 cm
Philip V collection
Cat. no. 2274

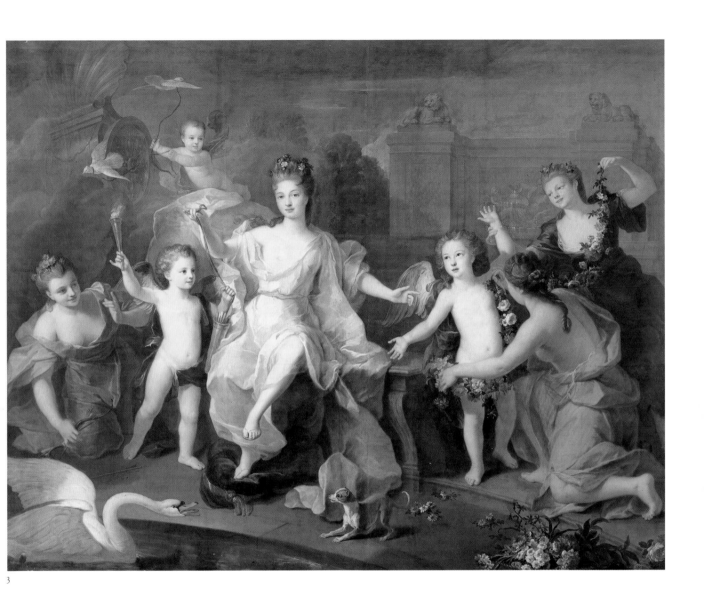

3

1

2

Antoine Watteau was the inven-
tor of a new spirit or trend which
was a precursor of the Rococo.
His delicate, misty scenes set in
a vivacious, sensual world were
imbued with a freshness and
distance and filled with lyricism.

3

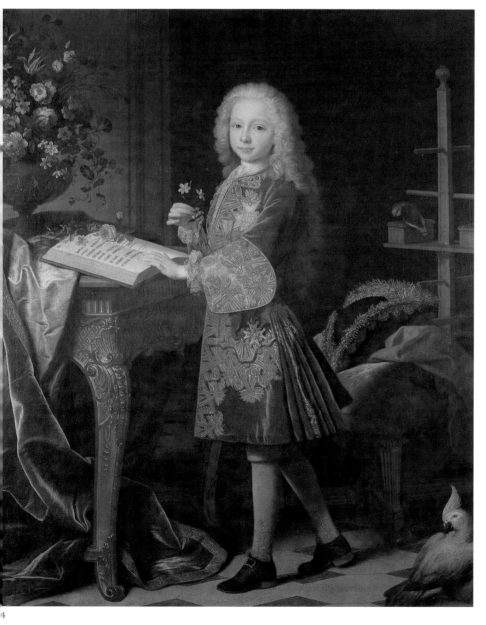

4

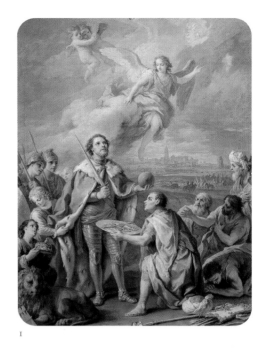

1

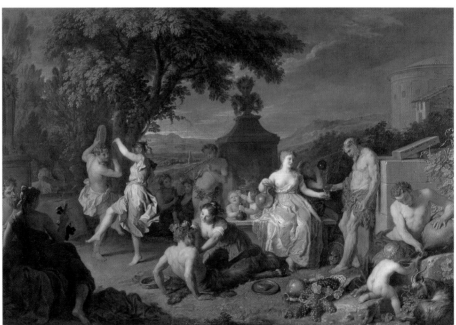

2

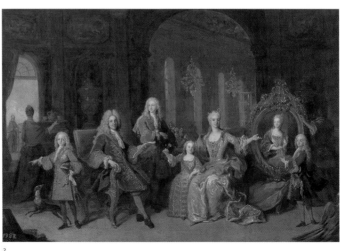

3

4

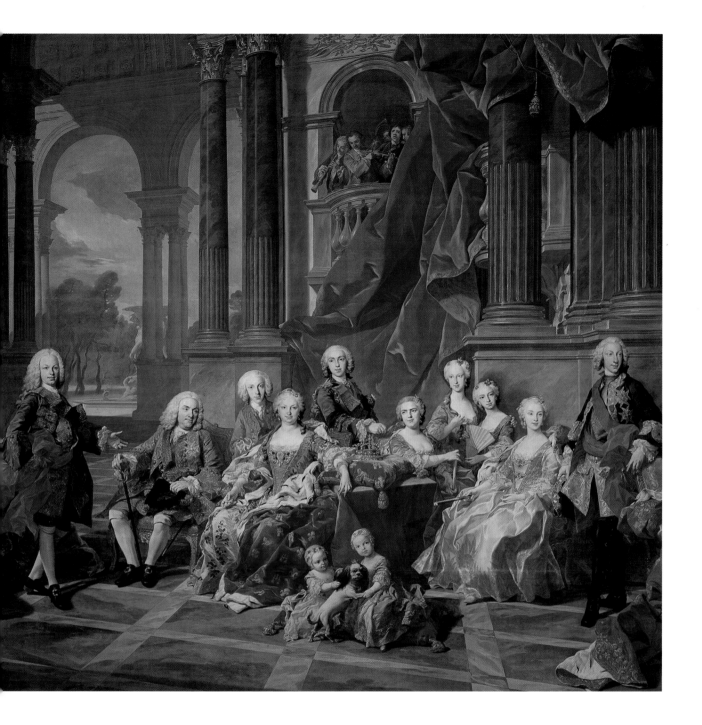

1
Charles-Joseph Flipart
Paris, 1721–Madrid, 1797
The Surrender of Seville to St Ferdinand, King of Spain, c.1756/7
Canvas, 72 × 56 cm
Collection of Ferdinand VI
Cat. no. 13

2
Michel-Ange Houasse
Paris, 1680–Arpajon, 1730
Bacchanal, 1719
Canvas, 125 × 180 cm
Philip V collection
Entered the Prado in 1820
Cat. no. 2267

3
Jean Ranc
Montpellier, 1674–Madrid, 1735
King Philip V and his Family, 1723
Canvas, 44 × 65 cm
Philip V collection
Cat. no. 2376

4
Louis-Michel van Loo
Toulon, 1707–Paris, 1771
The Family of Philip V, 1743
Canvas, 406 × 511 cm
Philip V collection
Cat. no. 2283

Philip V, the first Bourbon king of Spain, made a point of commissioning portraits from the most fashionable French artists. Louis-Michel van Loo, who came from a family of painters, soon became his favourite. This is a typical work by Van Loo, in which the sitters are decked out in a rich display of finery set off by the monumental architecture.

1

1
Jean Pillement
Lyons, 1728–1808
Landscape, 1773
Canvas, 56 × 76 cm
Charles IV collection
Cat. no. 2302

2
Hubert Robert
Paris, 1733–1808
A Gallery in the Colosseum in Rome
Canvas, 240 × 225 cm
Bequeathed by the Count of
La Cimera in 1944
Cat. no. 2883

2

3

3
Claude-Joseph Vernet
Avignon, 1714–Paris, 1789
Coastal scene with Italian gondola
Canvas, 59 × 109 cm
Charles IV collection
Cat. no. 2350

4
Antoine-François Callet and
workshop
Paris, 1741–1823
King Louis XVI, c.1783
Canvas, 273 × 193 cm
Presented to the Count of
Aranda by Louis XVI
Later acquired from the Duke of
Hijar by Isabella II, who donated
it to the Prado
Cat. no. 2238

4

1

1
Louis-Jean-François Lagrenée
Paris, 1724–1805
The Sense of Touch, 1775
Canvas, 86 × 135 cm
Purchased in 1982
Cat. no. 6771

2
François Boucher
Paris, 1703–70
Pan and Syrinx, c.1759/60
Canvas, 95 × 79 cm
Purchased in 1985
Cat. no. 7066

3
Jean-Baptiste-Marie Pierre
Paris, 1714–89
Jupiter and Antiope, c.1746/9
Canvas, 114 × 178 cm
Purchased in 1970
Cat. no. 3218

4
Hubert Drouais
La Roque, 1699–Paris, 1767
The Dauphin Louis de Bourbon,
c.1744
Canvas, 68 × 57 cm
Philip V collection
Cat. no. 2377

5
Jacques-Antoine Beaufort
Paris, 1721–Rueil, 1784
The Death of Calamus, 1779
Panel, 21 × 19 cm
Purchased in 1979
Cat. no. 6073

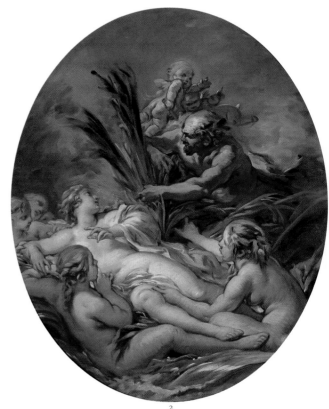

2

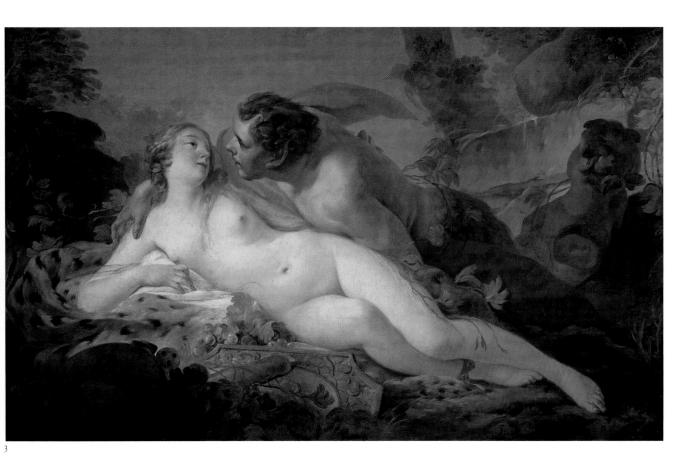

3

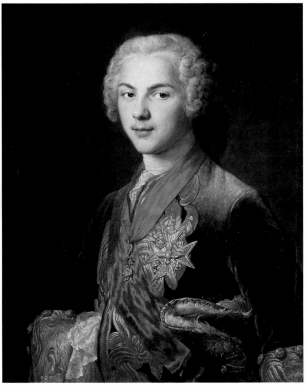

4

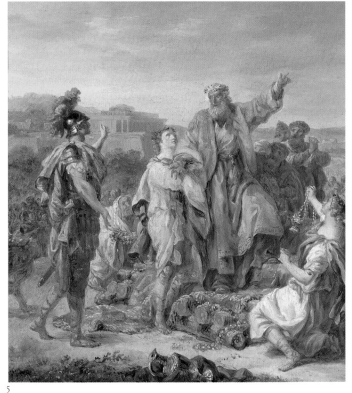

5

DUTCH PAINTING

Throughout the early Middle Ages and for a large part of the sixteenth century, the Low Countries effectively formed a single country sharing common characteristics. Under the government of Charles V, although maintaining their own economy, the Low Countries were integrated into the mosaic of states that were dominated by the House of Austria and co-ordinated from Spain. However, even at that time the different forms of artistic expression between the north and the south were very evident.

During the last three decades of the sixteenth century the Low Countries underwent major political upheavals and suffered a period of instability as a result of the spread of the religious doctrines of the Reformation, which had a profound influence in the northern provinces and, although to a lesser extent, also in the south. The ensuing revolt of the northern provinces resulted in the creation of a new country – Holland – which developed independently from Spanish control after its recognition in the Peace of Westphalia in 1648. Long before this critical date, however, the defining characteristics of this society had already been formed, and with them an aesthetic that tended towards an austere and very specific form of expression, little inclined to fantasy and well suited to patronage by burghers, artisans and merchants. Moreover, rather than producing paintings for the Church or the aristocracy, as was still the case in the south, the artists worked in smaller formats, more suited to the smaller domestic space of their clients, and with subjects far removed from the heroic myths so favoured by the aristocracy. Art thus adapted itself to a sober, competitive, capitalist society.

The presence of Dutch painters in the Rome of Caravaggio at the beginning of the seventeenth century, and their subsequent return to their native land to redefine the realism of Dutch art, resulted in an intimate type of genre painting depicting domestic interiors, street scenes and tavern settings in a detailed, naturalistic manner. During this period Dutch painters developed various pictorial forms, including landscape, still life and animal pictures, and both single and group portraits notable for their insight into the character of the sitters. Painting in the second half of the century was more diversified, developing towards a richer, more decorative form pervaded by the Baroque.

The hostility between Holland and Spain up to the middle of the seventeenth century naturally meant that it was difficult for Dutch paintings to enter Spanish collections. Throughout the second half of the century, relations were still strained despite diplomatic alliances against France, and differences in taste and culture meant that there was still virtually no Dutch art in Spain. Consequently, almost all the works in the Prado are the result of later acquisitions, and it is impossible ignore the absence of works by Frans Hals, Vermeer, Hobbema and other masters.

During the seventeenth century, a few pieces by Dutch artists entered the royal collections, such as the four female portraits by Adriaen Cronenburch, imbued with great dignity and presence. The splendid landscapes by Both and Swanevelt date from the reign of Philip IV and were acquired in Rome for the decoration of the Buen Retiro Palace, as were two religious works by Steenwijck the Younger and *The Doubting St Thomas* by Stomer. By the reign of Philip V and Isabel Farnese, the eighteenth-century fashion for small Dutch paintings was well established, and the king and queen made many purchases, including works by Droochslott, Schoeff and Poelenburgh together with a number of scenes by Wouwermans. However, it was Charles III who was responsible for acquiring the magnificent Rembrandt, *Sophonisba*, bought in 1769 at the sale of the property of the Marquis of La Ensenada. Charles IV also purchased numerous interesting Dutch works, among them pieces by Breenberg, Schalken, Bramer, J. G. Cuyp and Wtewael, Metsu's *The Dead Hen*, tavern scenes by Van Ostade and an outstanding *Vanitas* by Steenwyck. During the Peninsular Wars, the works of this school, which Charles had so carefully collected, were dispersed, and those now in the Prado are only the remnants of the collection he amassed.

Since the opening of the Prado in 1819, the gaps have not been filled, although certain generous donations have been received: for example, Potter's *Cows and Goat* was bequeathed to the museum in 1894 by the Marquis of Cabriñana; the three still lifes by Heda and another by Claesz entered the museum with the Fernández Durán bequest in 1930; a portrait of a general by Backer was a gift of the Count of Pradere in 1934; while a new Schalken was presented by the Duke of Arcos in 1935. In the years following the Civil War, and until quite recently, several works were purchased on the art market: two portraits by Mierevelt and, in 1953, a landscape attributed tentatively to Van Goyen; *The Adoration of the Shepherds* by Benjamin Gerritsz Cuyp, in 1954; the excellent portrait of Petronella de Waert by Ter Borch and a still life by Rycknals; and later a couple of portraits of a man and his wife by Caspar Netscher, a portrait of a lady by Pickenoy and an animal painting by Melchior Hondecoeter.

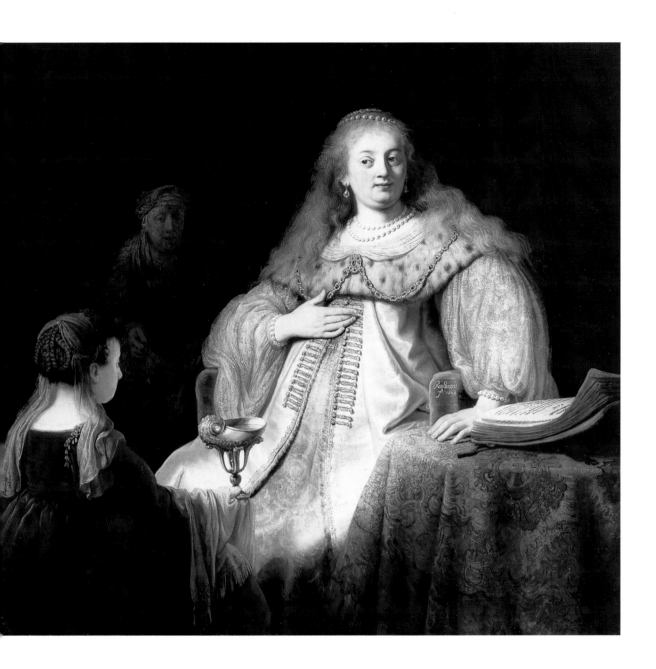

Rembrandt Harmensz. van Rijn
Leyden, 1606–Amsterdam, 1669
Sophonisba, 1634
Canvas, 142 × 153 cm
Acquired in 1769 for Charles III
by Mengs from the collection of
the Marquis of La Ensenada
Cat. no. 2132

This is the only certain work by
Rembrandt in the Prado. He
painted it when he was 28, in the
year of his marriage to Saskia,
daughter of an Amsterdam
antique dealer, and she was
probably the sitter. The lighting
derives from Caravaggio, and was
perhaps learned by Rembrandt
during his apprenticeship with

Pieter Lastman, who had been
enthusiastic about the new
technique. Rembrandt employs it
here to intensify the texture, to
emphasize the strongly modelled
face, the head of the servant and
the ghostly figure in the
background, but above all to
focus attention on the lavish
fabrics and ornate cup.

1

2

3

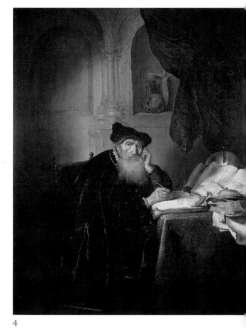

4

1
Pieter van Steenwyck
Active in Delft in the mid-
seventeenth century
Vanitas
Panel, 34 × 46 cm
Charles IV collection
Cat. no. 2137

2
Philips Wouwermans
Haarlem, 1619–68
Scene in front of an Inn
Panel, 37 × 47 cm
In the collection of Queen Isabel
Farnese by 1746
Cat. no. 2151

3
Jan Davisz de Heem
Utrecht, 1606–Antwerp, 1684
Still life
Panel, 49 × 64 cm
Provenance unknown
Cat. no. 2090

4
Solomon Koninck
Amsterdam, 1609–56
A Philosopher, 1635
Panel, 71 × 54 cm
Acquired in 1953
Cat. no. 2974

6

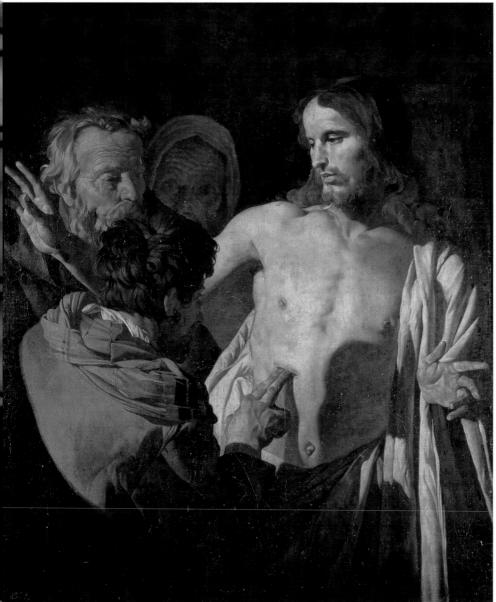

5
Caspar Netscher
Heidelberg, *c.*1639–
The Hague, 1684
Lambert Witsen, 1679
Canvas, 49 × 40 cm
Acquired in 1991
Cat. no. 7607

6
Caspar Netscher
Heidelberg, *c.*1639–
The Hague, 1684
*Mrs. Nuyts, Wife of
Lambert Witsen,* 1679
Canvas, 49 × 40 cm
Acquired in 1991
Cat. no. 7608

7
Mathias Stomer
Amersfoort, *c.*1600–
Messina, after 1650
The Doubting St Thomas
Canvas, 125 × 99 cm
In the royal collection by the
seventeenth century
Cat. no. 2094

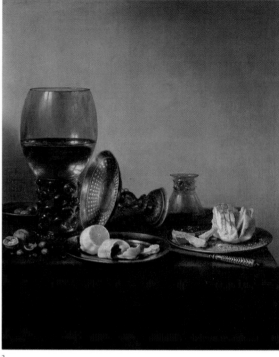

1

Jan Both
Utrecht, c.1615–52
Baptism of the Eunuch at the Court of Queen Candace,
*c.*1640/41
Canvas, 212 × 155 cm
Philip IV collection
Cat. no. 2060

2

Leonaert Bramer
Delft, 1596–1674
Abraham and the Three Angels,
1630
Canvas, 47 × 74 cm
Charles IV collection
Cat. no. 2069

3

Pieter Claesz 'Claeszon'
Steinfurt, c.1596–Haarlem, 1661
Still life, 1637
Canvas, 83 × 66 cm
Bequeathed by Don Pedro
Fernández Durán in 1930
Cat. no. 2753

4

Gerard Ter Borch
Zwolle, 1617–Deventer, 1681
Petronella de Waert, 1679
Panel, 40 × 32 cm
Acquired in 1982
Cat. no. 6892

GERMAN PAINTING

When considering the German collection in the Prado, it is important to note that the gaps and interruptions are not due solely to the idiosyncrasies of the royal collectors but also to the almost insoluble difficulties with which any museum is faced when attempting to classify and co-ordinate artistic development in Germany as a whole. Frequent wars, traditional political divisions and religious conflicts, together with the many other complicated events that make up the stormy history of Germany, have contributed to the formation of a complex mosaic of artistic styles that is difficult to represent in any consistent way with a limited number of works.

Throughout the fifteenth century in Germany a pictorial movement developed that was influenced by the early Flemish painters and was in fact a continuation of the admirable international style of the previous century, which had flourished from The Hague to Bohemia and Austria. Many of the works of this period are markedly expressionist and have a tendency to overblown effects and a sense of contained violence, all of which endow the subjects with a tense, dramatic quality that was often to reappear in later German art. However, even though a somewhat expressionistic tone can be traced through all the various phases of German painting – towards the end of the Gothic period, during the Baroque and at the culmination of the Rococo – the idea of a common *geist* or spirit does not necessarily operate at a local level. Local traditions, the fragmentation of the states that formed the German lands, as well as the different degrees of assimilation of foreign influences, all contributed to the extreme complexity of the German art scene, which was further accentuated by historical forces: the Reformation, the Counter-Reformation, dynastic crises, the personal interests of the princes, the Thirty Years War, French interference, the power of Austria, the expansion of Prussia and the eighteenth-century Enlightenment.

Despite the close dynastic relations between Spain and the Empire during the sixteenth and seventeenth centuries, there were no corresponding artistic relations, and the German schools are therefore only thinly represented in the Prado. Both the Emperor Charles V and his son Philip II were more inclined towards the innovative Italian and traditional Flemish paintings, and perhaps quite consciously rejected German art on account of its expressionistic and pessimistic nature, a spirit that was so foreign to the Mediterranean world. It is also possible that they viewed the anti-classicism of German art as a reflection of the internal disintegration of Germany, caused by the religious conflicts arising from the emergence of Protestantism. This would explain the dearth of German art in the royal collection at that time, and it was not until the seventeenth century that there was any increase – albeit a modest one – in the number of German paintings acquired by the Spanish sovereigns.

Nevertheless, the estate of Queen Mary of Hungary, sister of Charles V, contributed two panels painted by Lucas Cranach the Elder in collaboration with his son, as well as others representing hunting scenes at the castle of Torgau in honour of Charles V. From Philip II came the two panels by Baldung Grien, the elegant *Three Graces* and the sombre *Three Ages of Man*. There are also four fine paintings by Dürer. His two panels of *Adam* and *Eve* were a gift from Queen Christina of Sweden to Philip IV, who also purchased the wonderful *Self-portrait* at the sale of the possessions of Charles I of England – a perfect example of the masterly technical precision of Dürer's portraits. The fascinating *Portrait of a Gentleman* had also been the property of the unfortunate Charles I.

With the exception of an interesting work by Elsheimer from the seventeenth century and various pastoral themes by 'Rosa de Tivoli' (Philip Peter Roos), no new pictures were acquired by the Spanish sovereigns until the beginning of the eighteenth century, when Isabel Farnese bought two sixteenth-century portraits attributed to Amberger. Two landscapes by Vollardt bequeathed by Don Pedro Fernández Durán in 1930 are good examples of German Rococo. Neoclassicism is well represented in the museum in the work by Anton Raffael Mengs, who was summoned by Charles III to decorate the Royal Palace in Madrid and became a powerful figure at court. A painter of meticulous religious scenes and of exquisite porcelain-like portraits, his works usually reflect the refined court milieu that cultivated early neoclassicism. A painting by Angelica Kauffman entered the Prado with the Errazu bequest in 1925. In it, neoclassical concepts are combined with the influence of British portrait painting in an elegant feminine style in keeping with the late eighteenth century.

Finally, mention must be made of an important addition to the collection, *The Virgin and Child with the Infant St John* by Lucas Cranach the Elder, received in 1988 from a private Spanish collection.

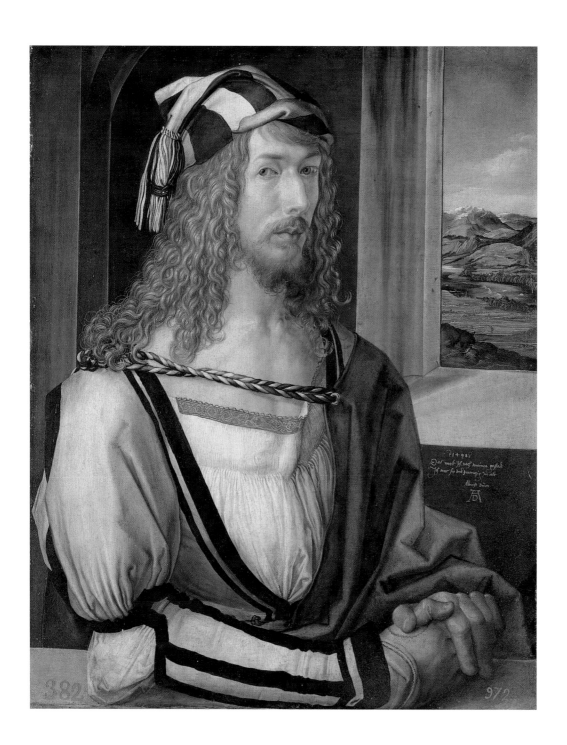

Albrecht Dürer
Nüremburg, 1471–1528
Self-portrait, 1498
Panel, 52 × 41 cm
Philip IV collection
Acquired in London in 1649 at
the sale of the collection of
Charles I of England
Cat. no. 2179

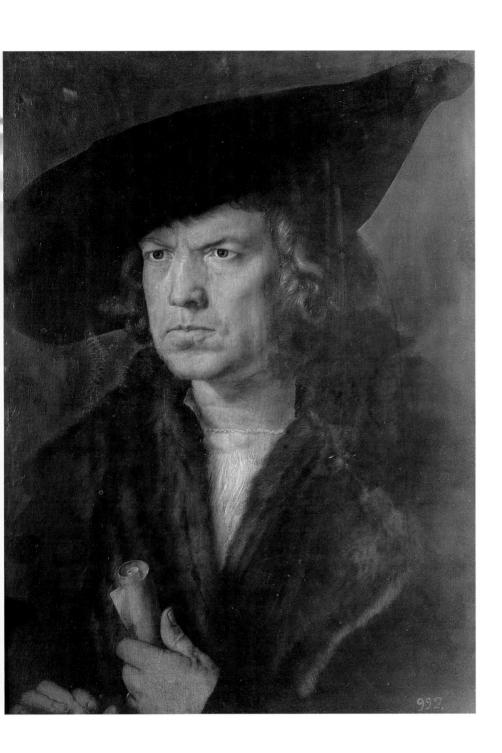

Albrecht Dürer
Nüremburg, 1471–1528
Portrait of a Gentleman, 1524
Panel, 50 × 36 cm
In the Alcázar, Madrid, in the
seventeenth century
Cat. no. 2180

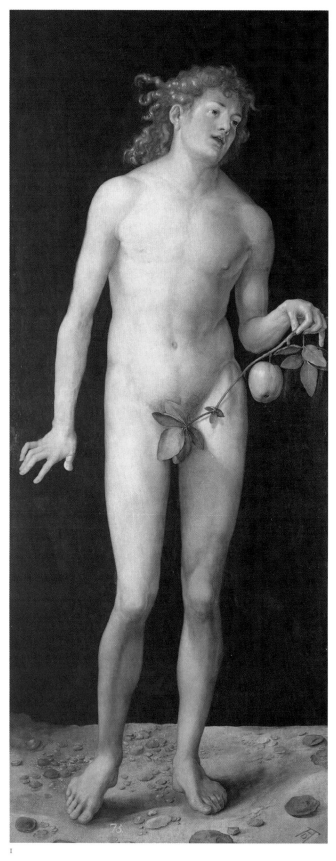

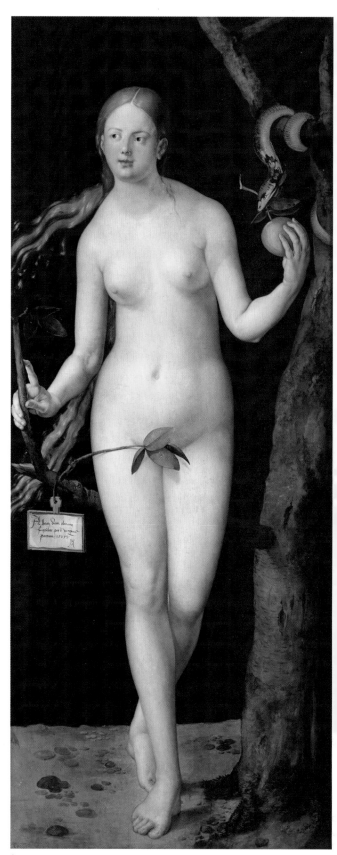

1

2

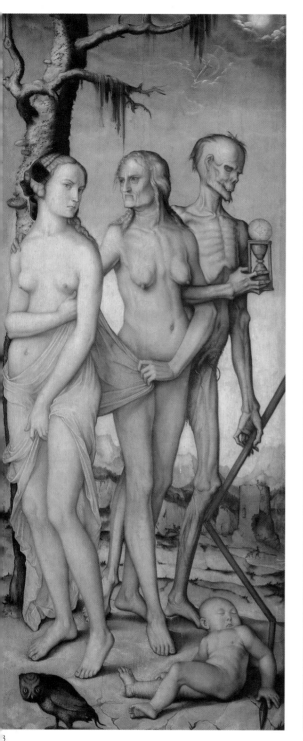

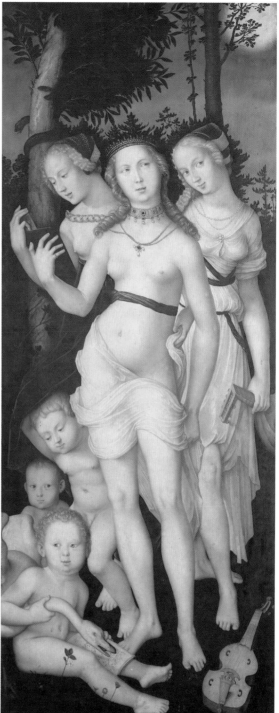

3

4

1
Albrecht Dürer
Nüremburg, 1471–1528
Adam, 1507
Panel, 209 × 81 cm
Presented to Philip IV by Queen
Christina of Sweden
Cat. no. 2177

2
Albrecht Dürer
Nüremburg, 1471–1528
Eve, 1507
Panel, 209 × 81 cm
Presented to Philip IV by Queen
Christina of Sweden
Cat. no. 2178

3
Hans Baldung Grien
Gmünd, *c.*1484/5–Strasbourg, 1545
The Three Ages of Man, 1539
Panel, 151 × 61 cm
Presented to Jean de Ligne by the
Count of Solms in 1547
Later in the collection of Philip II
Cat. no. 2220

4
Hans Baldung Grien
Gmünd, *c.*1484/5–Strasbourg, 1545
The Three Graces, 1539
Panel, 151 × 61 cm
Presented to Jean de Ligne by the
Count of Solms in 1547
Later in the collection of Philip II
Cat. no. 2219

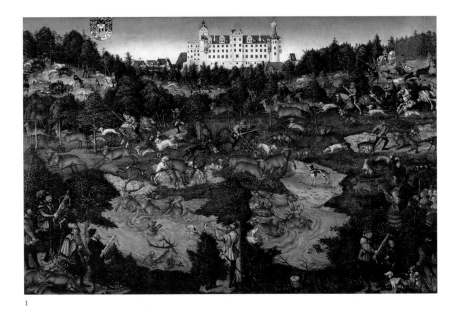

1

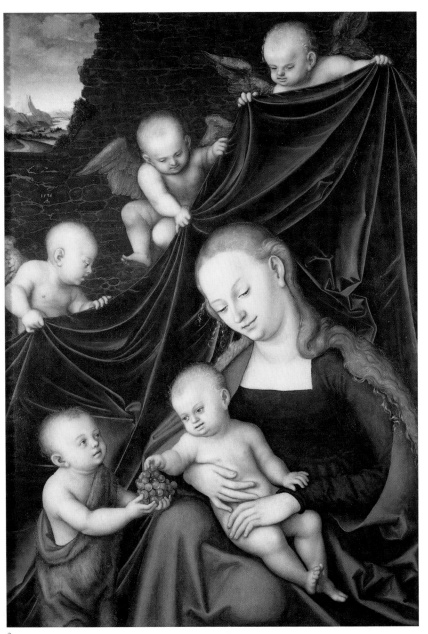

2

1
Lucas Cranach the Elder;
in conjunction with his son
Lucas Cranach the Younger
Kronach, 1472–Weimar, 1553;
1515–86
*Hunt at Torgau Castle in honour
of Charles V*, 1544
Panel, 114 × 175 cm
Inherited by Philip II from the
collection of Queen Mary
of Hungary
Cat. no. 2175

2
Lucas Cranach the Elder
Kronach, 1472–Weimar, 1553
*The Virgin and Child with the
Infant St John*, 1536
Panel, 121 × 83 cm
From the collection of the
Duchess of Valencia
Entered the Prado in 1988
Cat. no. 7449

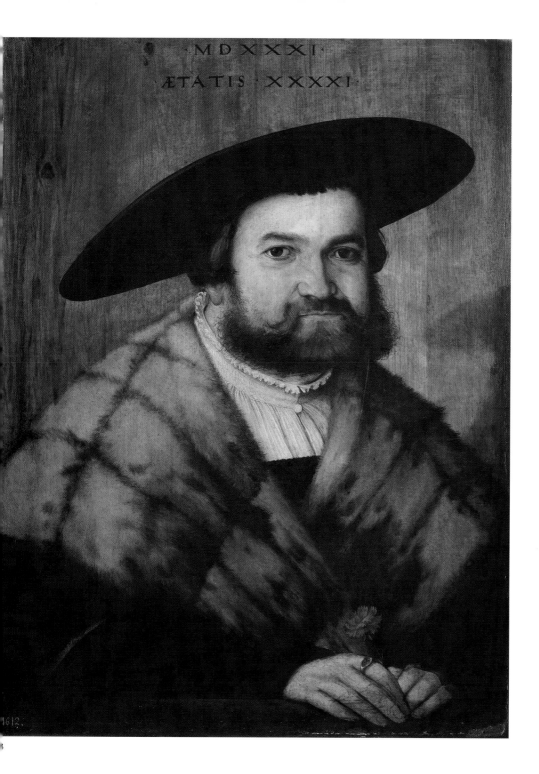

·MDXXXI·
ÆTATIS·XXXXI·

Christoph Amberger
Augsburg, *c*.1505– Augsburg, 1562
The Augsburg Silversmith Jörg
Zörer, 1531
Panel, 78 × 51 cm
In the collection of Queen Isabel
Farnese by 1746
Cat. no. 2183

1

2

3

1
Anton Raffael Mengs
Aussig, 1728–Rome, 1779
King Charles II, 1761
Canvas, 154 × 110 cm
Charles III collection
Cat. no. 2200

2
Anton Raffael Mengs
Aussig, 1728–Rome, 1779
*The Archduke Ferdinand and
Archduchess Anne of Austria*, 1770
Canvas, 147 × 96 cm
Charles III collection
Cat. no. 2192

3
Adam Elsheimer
Frankfurt, 1578–Rome, 1610
Ceres and Stellio
Copper, 30 × 25 cm
In the Alcázar, Madrid,
before 1734
Cat. no. 2181

4
Anton Raffael Mengs
Aussig, 1728–Rome, 1779
The Adoration of the Shepherds,
1770
Panel, 258 × 191 cm
Charles III collection
Cat. no. 2204

Mengs is one of the key figures
in the transition from the Rococo
to neoclassicism. Emerging from
a Rococo milieu, he favoured
more severe compositions that
evoked classical and High
Renaissance art. At the court in
Madrid, he overshadowed Tiepolo,
the last great painter in the
Baroque tradition. However, the
most impressive features of
Mengs' work – its enamel colours
and brittle textures – are essen-
tially Rococo. This particular pic-
ture – with a self-portrait of the
artist on the left – was painted in
Rome for the Spanish royal
collection and delivered in 1771.

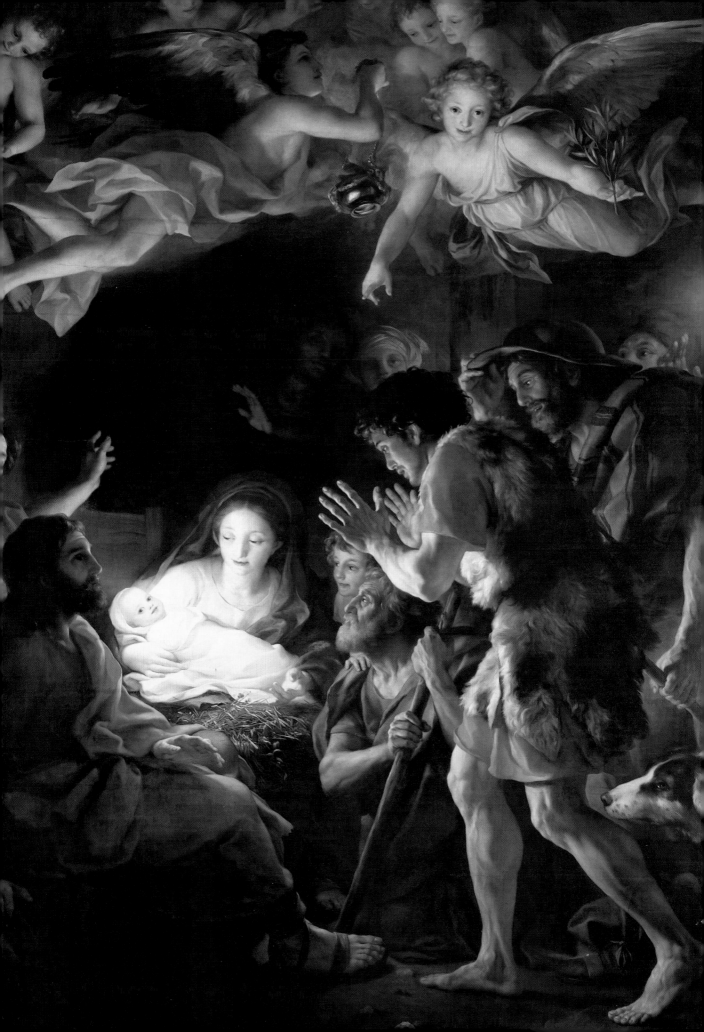

BRITISH PAINTING

The British collection, which also includes Irish works, is the most recently formed section in the Prado. When discussing its history it should be remembered that England and Scotland were two independent kingdoms until 1707, when the Act of Union formally marked the absorption of Scotland into the new identity of Great Britain. Recurring political differences between Spain and England, which lasted from the sixteenth century until the early nineteenth century, and the resulting absence of matrimonial ties between the respective royal families – until the marriage of Alfonso XIII to Victoria of Battenberg in 1906 – together with a lack of contact between the leading families of both countries, produced a historical background essentially inimical to any dissemination of British art in Spain. Another reason was perhaps the fact that British painting in general was little known abroad until the twentieth century. As a consequence of these historical circumstances, no English or Scottish paintings, except for a few anonymous works, are recorded in the royal inventories. Even after the Prado was founded in 1819, very few British paintings entered the royal collection, apart from some Victorian portraits, and these were assigned to the royal palaces rather than to the museum. In fact, the main British paintings in the Prado have been acquired during the course of the twentieth century through purchases or donations.

Although Britain certainly possessed important indigenous talent, especially in the field of English miniatures, the larger canvases commissioned during the sixteenth and seventeenth centuries tended to be executed by foreign artists. The Prado possesses many examples of pictures of this type, such as the magnificent portraits from Van Dyck's English period and various works by Anthonis Mor van Dashorst and Rubens, which are catalogued in the Flemish collection. Unfortunately, however, there are no works by artists such as Peter Lely or Godfrey Kneller or their contemporaries, which would be of value in assessing the background from which the British art of the eighteenth and nineteenth centuries emerged.

However, during the twentieth century the museum has obtained a number of representative paintings, which give some idea of the work of British artists from the eighteenth century onwards. There are two portraits, *An Unknown Clergyman* and *James Bourdieu*, by Reynolds, and two others by his great contemporary, Gainsborough, but there are no large single or group portraits, or portraits of women, by either artist. Other portraits in the museum are by Romney, Cotes, Raeburn, Philips and Gordon. Special mention should be made of the two portraits by Lawrence, which bridge the eighteenth and nineteenth centuries. The first is the elegant if somewhat pretentious *John Fane, 10th Earl of Westmorland*, and the second the exquisite *Miss Martha Carr*. To these should be added the distinguished figure of *Anthony Gilbert Storer* by Martin Archer Shee, another of whose paintings is also in the museum. The two serve as good examples of the sober precision of early nineteenth-century British artists. Landscapes of the eighteenth and nineteenth centuries complete the collection, the most notable of which are those by David Roberts.

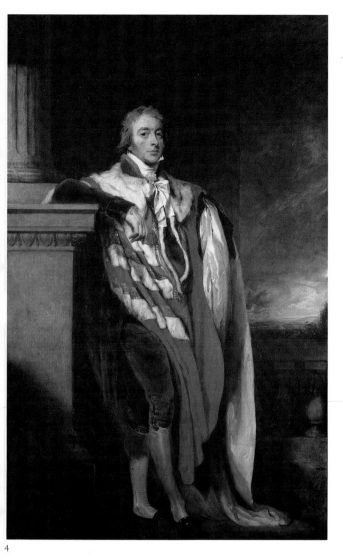

4

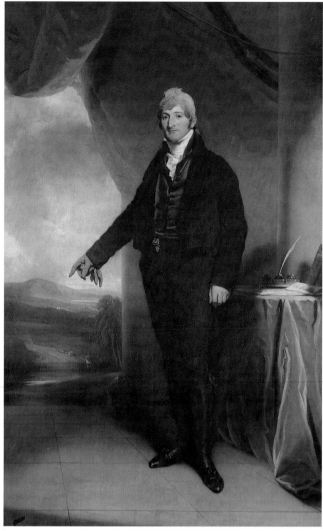

5

1
George Romney
Dalton-in-Furness,
1734–Kendal, 1802
Master Ward
Canvas, 126 × 102 cm
Acquired in London in 1958
Cat. no. 3013

2
Henry Raeburn
Stockbridge, 1756–Edinburgh, 1823
Mrs Maclean of Kinlochaline
Canvas, 75 × 63 cm
Acquired in 1966
Cat. no. 3116

3
Thomas Lawrence
Bristol, 1769–London, 1830
Portrait of Miss Martha Carr
Canvas, 76 × 64 cm
Purchased in London in 1959
Cat. no. 3012

4
Thomas Lawrence
Bristol, 1769–London, 1830
*John Fane, 10th Earl of
Westmorland*
Canvas, 247 × 147 cm
Purchased in London in 1958
Cat. no. 3001

5
Martin Archer Shee
Dublin, 1769–Brighton, 1850
Anthony Gilbert Storer, 1815
Canvas, 240 × 148 cm
Purchased in 1957
Cat. no. 3014

INDEX OF ILLUSTRATIONS BY ARTIST'S NAME